# Ship Models

**THE THOMSON COLLECTION**
**AT THE ART GALLERY OF ONTARIO**

# Ship Models

## THE THOMSON COLLECTION
### AT THE ART GALLERY OF ONTARIO

Simon Stephens

CURATOR, SHIP MODEL AND BOAT COLLECTIONS,
THE NATIONAL MARITIME MUSEUM, GREENWICH, LONDON

SKYLET PUBLISHING /
THE ART GALLERY OF ONTARIO

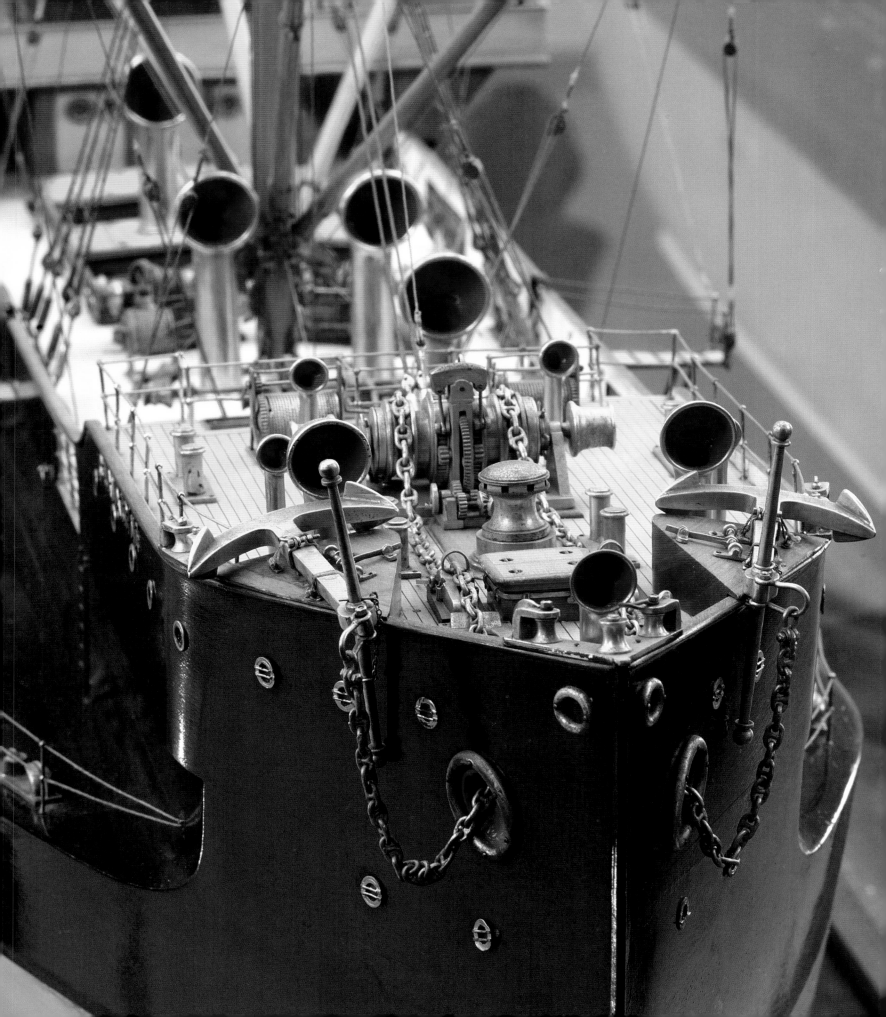

# Contents

Detail of no. 60
**British turret-decked steamer:**
*Clan Alpine*

# Foreword

KENNETH ROY THOMSON, 2nd Baron Thomson of Fleet, or Ken as we all knew him, was an extraordinary human being. He built upon his father's legacy to construct one of the most successful global business empires. He amassed with an ever-growing passion what is undoubtedly the finest collection of art ever in private hands in Canada. He was the catalyst for and the enabler of Transformation AGO, and he still retained the common touch. Ken derived great joy from his interaction with people from all walks of life – whether pointing out to total strangers intriguing bargains at the local Loblaws, or sending a photograph (perhaps not of museum quality) he had taken of you with his basic camera at an event the night before.

At a lunch following a TD board meeting after Ken flipped one of his brightly coloured signature ties over his shoulder to avoid attracting the soup of the day, I asked him how he became interested in art. He began seriously collecting in 1953 when he spotted two miniature ivory busts in a Bournemouth antique shop. Shortly thereafter, Ken became excited by the prospect of acquiring an exquisite boxwood figure and was admonished by his advising dealer: "You must not look like that when you see it. You must control yourself and look very solemn. You will put the price up with enthusiasm like that." Ken took the advice to heart, but it was an enduring struggle to restrain his natural enthusiasm for marvellous works of art.

Over the years, Ken developed an ever more discerning and refined eye, but his guiding rule in acquiring art was, "If your heart is beating,

you know it was made for you." I remember Ken confessing that, while assembling his collection, he viewed the Art Gallery of Ontario as a competitor but, as time passed, he came to envisage the AGO as the ideal vehicle for keeping the collection intact and exhibiting it to the people of Canada so that they could experience the same pleasure as he did from his art. "It might make people see and enjoy objects previously unfamiliar to them. . . . It might open up their horizons. I do not see how you can walk past these beautiful objects, look at them, and not see the glory of art and its creation." Accordingly, Ken determined to donate his unsurpassed collection and to work with Matthew Teitelbaum and Frank Gehry to transform the Art Gallery of Ontario.

Ken wanted the works displayed in an atmosphere where the viewer could feel "at home." At one time, he contemplated music in the galleries, and he liked the idea of a series of rooms that led one into the other so that people could walk through "chapters" of his collection.

Ken remained intimately engaged in the Gehry project to the end. He continued to purchase works of art to enhance the quality of the Thomson Collection and with exceeding generosity took steps time after time to encourage the realization of Transformation AGO at the highest level. I remember Ken leaning over at a curatorial discussion of the David Milne exhibition in 2005 and saying, "I don't want to jinx it, Charlie, but I think our project is going to be the best." That seemed appropriate, because everything about Ken Thomson was the best.

A. CHARLES BAILLIE, O.C.
PRESIDENT, ART GALLERY OF ONTARIO

# Introduction

MY FATHER COMMUNED WITH OBJECTS. The journey lasted a lifetime. The pursuit was manic and often solitary. My father channelled his energies and unravelled passions that allowed him a solace few could possibly comprehend. Deep friendships developed around this journey of perception and discovery. The facets seemed endless and were reflected. The legacy was a collection of objects that defied linear logic.

Some collectors derive pleasure from the status of ownership; others sustain interest through economic motives. The inherent value of an artwork is gauged by the heart. Experience is often visceral and radiates to one's core. The journey of an art collector is compelled by complex internal forces, from melancholy to wonderment.

My father's course evolved over the years and interactions around art became the barometer of life. He would extract the deepest pleasure from human companionship; artists, collectors, dealers, researchers and any soul with whom he might share his enthusiasm were enlisted for their visceral response to Group of Seven sketches or a Gothic diptych. My father's letters attest to the profound role of communication in his daily life. The art often turned out to be incidental to the friendships that lasted a lifetime. In all spheres the essence of my father's spirit was immersed within the act of consideration, rather than the prospect of possession. The formations of these collections represent a lifetime's journey inspired by the human condition.

The objects within the various collections remain tangible evidence of an immense ambition around the visual experience. My father followed his innermost convictions and had the courage to press his feelings. In some instances, he stood alone as a precursor to the subject or established new thresholds of value. The dogged determination drew the admiration of friends and foes alike, as primal competitive instincts emerged from this gentle soul. My life with father in this realm created a unique bond between us. The human spirit was constantly engaged in all its myriad of shapes and forms. The imprint was quite extraordinary, as the journey became an exploration of the human condition. Father's curiosity seemed insatiable and the objects were conductors through which the widest spectrum of human spirit coursed. The pursuit of art allowed father to make sense of the world and celebrate life in all its resplendent forms.

DAVID THOMSON

THE COLLECTING OF SHIP MODELS can be traced back to the early seventeenth century. Notable collectors included Samuel Pepys, King Charles I and King George III. Samuel Pepys, Secretary to the Navy Board and famous diarist, was moved to write on August 11, 1662: "Mr Deane, the assistant [shipwright] at Woolwich came to me . . . . He promises me also a model of a ship, which will please me exceedingly, for I do want one of my owne."

The kind of model that interested Pepys would today be classified as a 'Navy Board' model, taking its name from the idea that these models were made for the Navy Board, the department of the British Navy responsible for the design and building of ships. In fact it is rather unlikely that all 'Navy Board' models were made for the Board's inspection. More probably they were desired as keepsakes, as in Pepys's case, as objects of delight as well as professional interest. The term is used to describe seventeenth-century models which are only partially planked, showing in stylized fashion the exposed frames below the waterline. In this 'Navy Board' differ from the later 'Georgian' models, which are fully planked and often very fully decorated, resembling the full-size vessel in every particular.

Any model that pretends to be accurate to its real-life equivalent must be built to scale. Early models were built at the standard scale of 1:48 or ¼ inch: 1 foot, that is, at the same scale as the plan used for building the ship itself. The ratio of 1:48 produced a plan that was manageable on the one hand and large enough on the other to carry the necessary detail. This scale continued to be used even after the advent of iron and steel as the materials for shipbuilding. After the Second World War, however, the scale of 1:96 was used almost universally, partly because the size of ships had generally increased and at 1:48 a model might be huge. One can of course immediately intuit the scale of a model by looking at features like doorways on the superstructure.

The great majority of ship models made in modern times are 'builder's models', models constructed by or for a shipowner or shipyard (some firms had their own specialist model shop) as a sales tool, for exhibition in boardrooms and at trade fairs. Builder's models of the twentieth century can exert just as much fascination as the older models of wooden ships, and offer no less precious evidence of the past, since they do not merely evoke and document but make real in a three-dimensional form numerous small boats, medium-size vessels and large ships now sunk or broken up.

Detail of no. 64
**British cargo tramp steamer:**
*Menin Ridge*

# The Thomson Collection
of Ship Models at the
Art Gallery of Ontario

(in course of installation, October 2008)

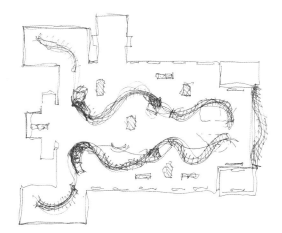
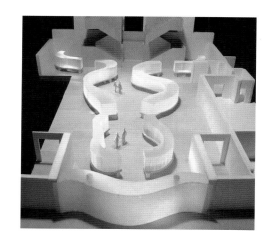

Architect's sketch and model
of the Ship Models gallery
Courtesy Gehry Partners LLP

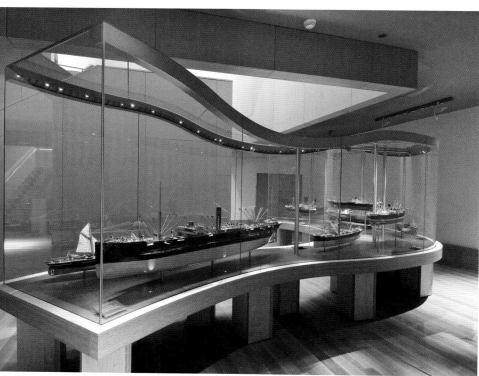

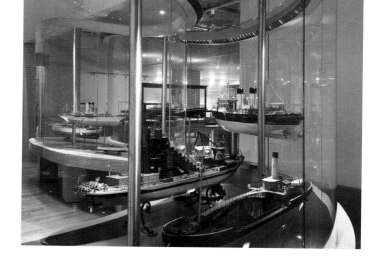

ABOVE
Builder's models – service vessels
and pleasure craft

LEFT
Builder's models – cargo ships

OPPOSITE
Prisoner of War models

LEFT BELOW
*The Hogue*, the largest model in the
Collection, in its original display case

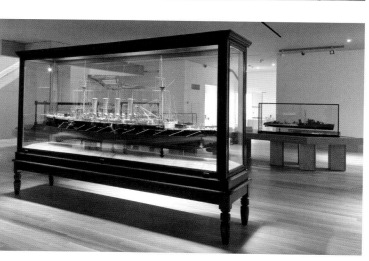

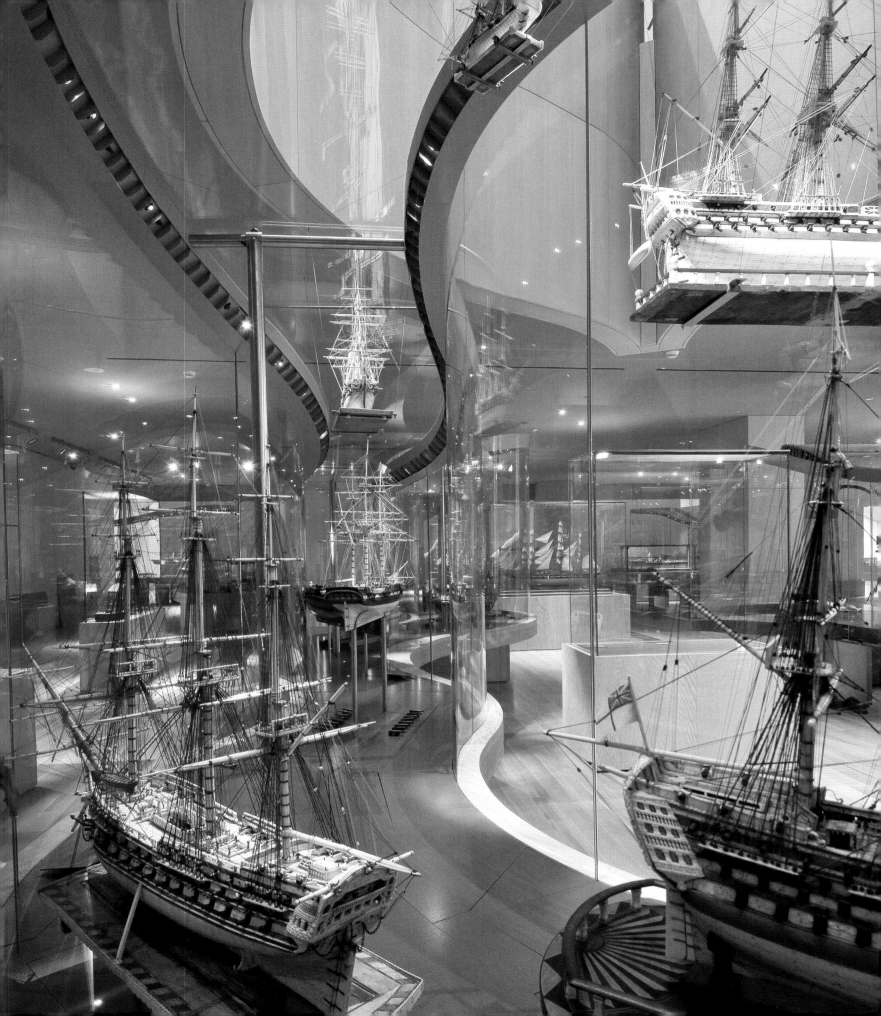

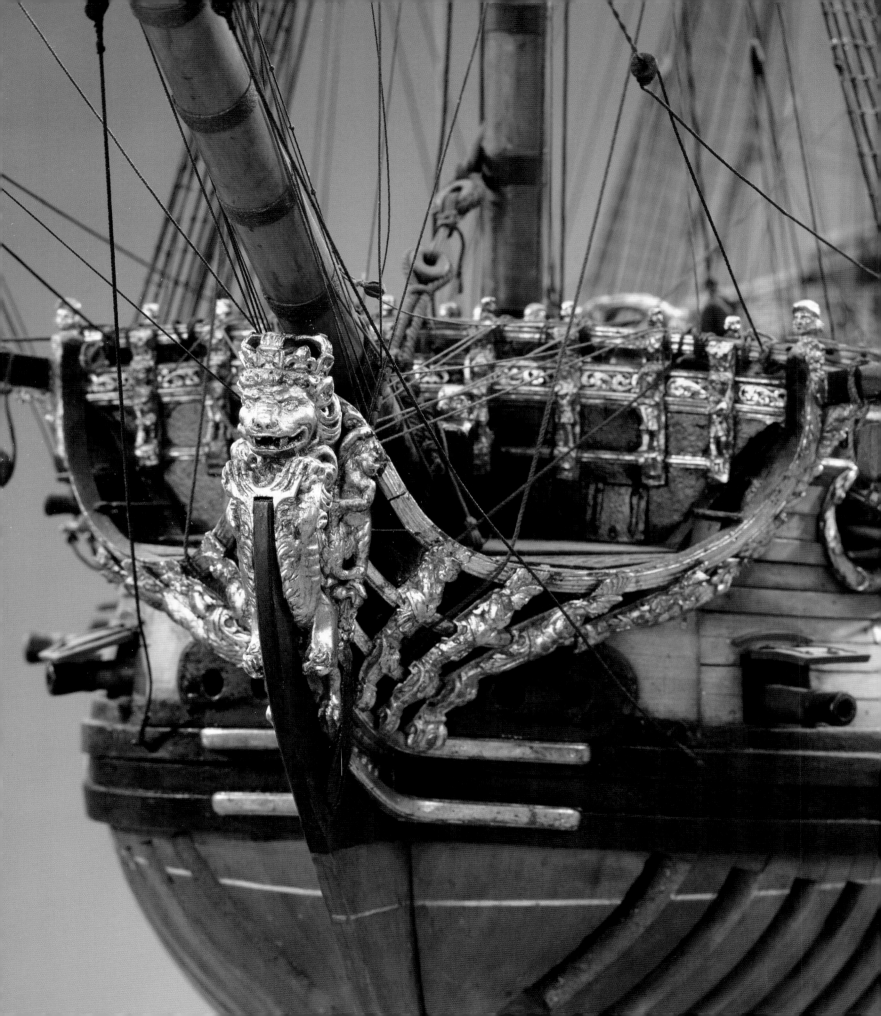

# Seventeenth and eighteenth century

Models of the seventeenth and eighteenth century can be divided into two types, 'Navy Board' and 'Georgian' models. So-called 'Navy Board' models, for whatever purpose they were actually made, use the pattern of light and shade on open frames without the lateral planking to show off the lines of the hull with greater clarity. The generally later 'Georgian' models – a period term, covering most of the eighteenth century and some of the nineteenth – are fully planked and may be very highly detailed and ornately decorated, sometimes surviving with their full rig of sail. Some of these ship models are perhaps still more ornate than the vessels they miniaturize, making greater play with the gilt decoration and using extraneous materials such as bone and oystershell.

The overwhelming majority of models of this period represent warships: these were the emblems as well as the tools of the nascent British Empire. The British Navy 'rated' their warships according to the number of cannon they carried, from a 'first rate' with a hundred guns or more to a 'sixth rate' that might have only twenty. Only the first four rates were considered 'ships of the line', the fighting fleet of the Royal Navy. First-rate ships were rare; most serving ships of the line were third-rate. Sixth-rate ships would be used predominantly for escort and such purposes, rather than to engage with other enemy warships in the great sea battles of the era.

A ship of the line housed its crew and its array of cannon on more than one deck. The highest deck was the poop deck at the stern; forward of this, one level down, came the quarter deck. The middle of the ship, one level down again, was known as the waist, and forward of the waist came the forecastle. The forecastle deck again dropped one level so as not to interfere with the sightlines from the helm at the stern.

Detail of no. 1
**British third-rate two-decker
70-gun warship**

1

## British third-rate two-decker 70-gun warship

Navy Board model, scale 1:48
Great Britain, c. 1692
Boxwood, fruitwood, brass, silk
117 × 135 × 52 cm

This is one of the few seventeenth-century models which has the waterline marked on the hull (the white line just above the open frames).

This 1:48 scale, full-hull model of a British 70-gun third-rate represents one of a large class of warships originally built to the Navy's 1677 'establishment' (specifications) but mostly rebuilt in the 1690s. In the past it has been identified as the *Breda*, launched in 1692, but, like most models of this period, it may equally well represent other ships – notably the *Essex*, launched in 1700, with which its measurements generally correspond. Furthermore, the use of the Royal monogram WR on the stern suggests that the model was made after the launch of the *Breda*: since the monogram is of William alone, it must date to after the death of his consort, Mary, in 1694. Finally, the presence of the coat of arms of the city of Nassau on the stern and quarter galleries suggests the model may represent the *Nassau*, which was launched in 1699.

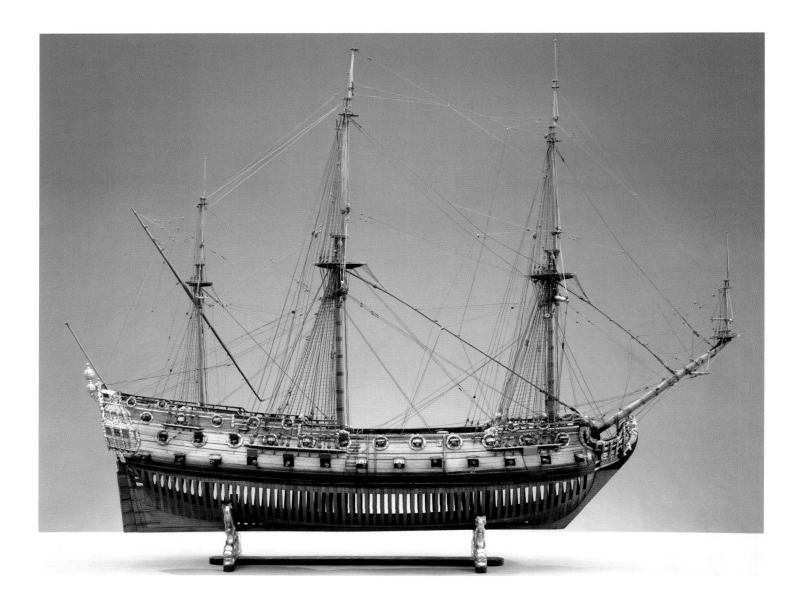

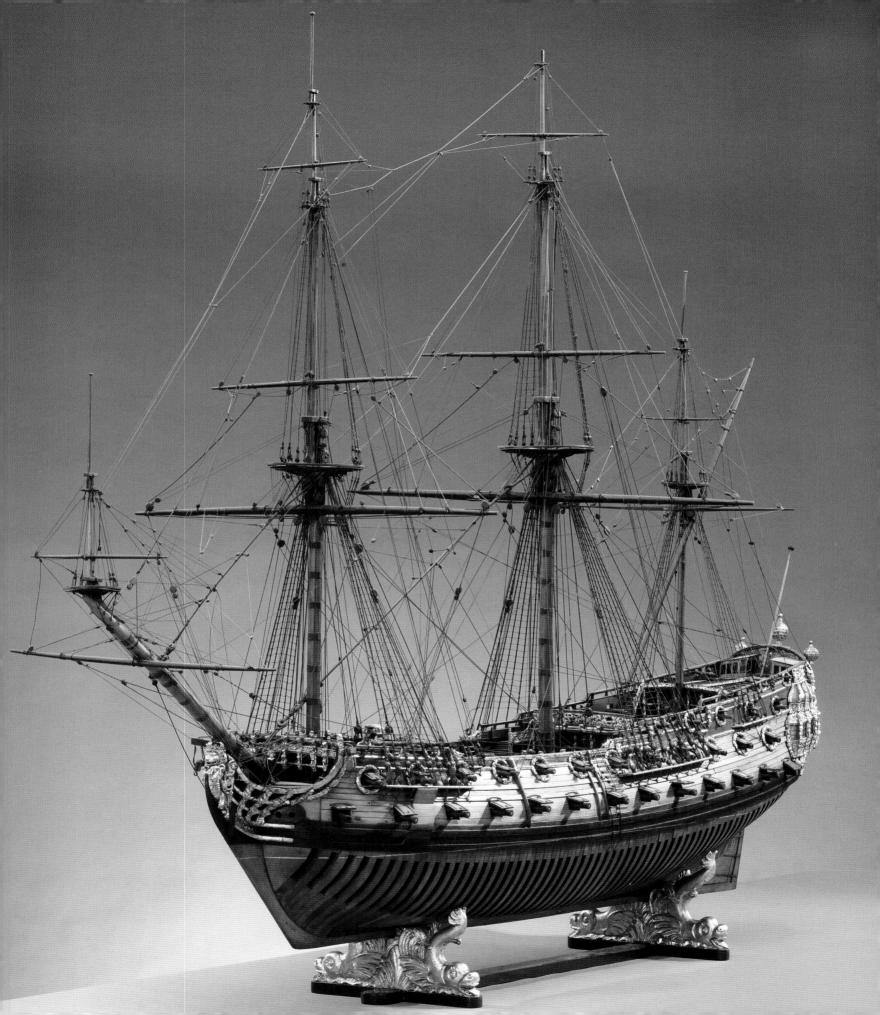

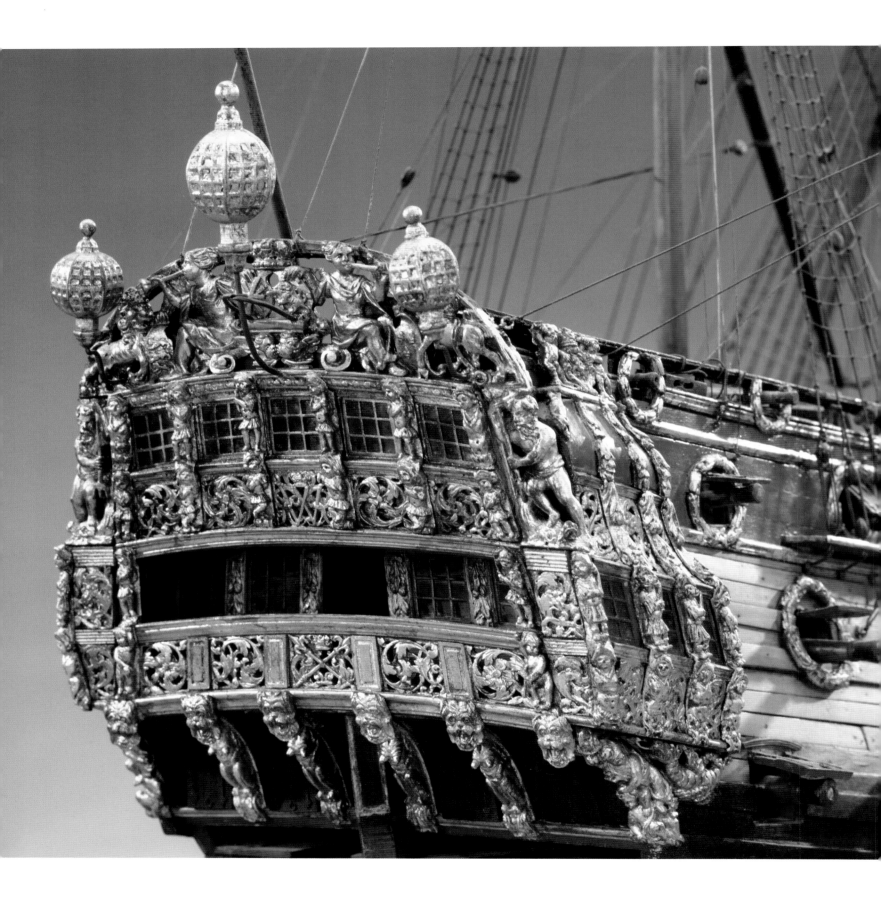

Seventeenth and eighteenth century

The royal monogram appears in the centre above the lower tier of windows of the stern galleries, and the arms of Nassau, held by two putti, are mounted on shields above the roof of the quarter galleries. Spherical stern lanterns are mounted on the carved taffrail that crowns these splendidly ornate galleries. The wreathed gun ports were a common feature of British warships in the seventeenth century – a practice discontinued during the early eighteenth century on grounds of cost and maintenance.

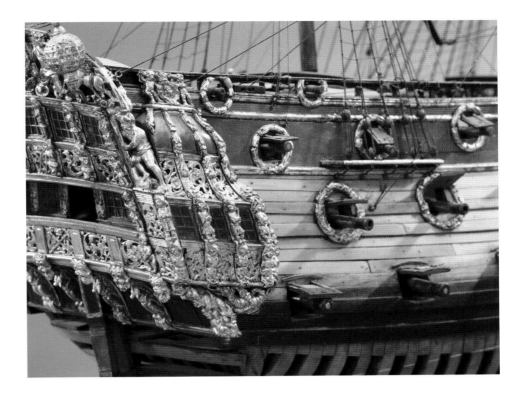

The ship's bell was mounted in the carved belfry on the forecastle. Besides sounding the change of watch the bell was vital in transmitting orders to the crew and communicating with other ships in a fleet.

## 2

## British sixth-rate 20–24 gun warship: *Nightingale*

Navy Board model, scale 1:48
Great Britain, 1702
Boxwood, fruitwood, metal
26 × 71 × 16 cm

The seventeenth-century 'Navy Board' style of modelmaking, in which the hull frames were left un-planked below the waterline, was still in use during the first quarter of the eighteenth century. One theory to explain the use of this 'stylized' system is that the contrast between the light wooden framing and the dark shadows made the shape of the hull more visible and pronounced, especially around the more complicated areas such as the bow and stern. Most models of this period were made from British fruitwoods, such as pear and apple – slow-growing with very little grain and hard enough to work and carve to the detail needed at this scale. For the more intricate decorative carvings, however, boxwood was used, and finished either with a shellac varnish or with gold paint and leaf.

The sixth-rate *Nightingale* was built at Chatham Dockyard in 1702 and carried 24 six-pounder guns, 20 along the main deck and four on the quarter deck. In 1707 she was captured by the French and renamed the *Rossignol*, then later that same year re-captured and re-named *Ludlow Castle* by the British. In 1727 she was rebuilt and re-named *Fox* and in 1737 was broken up.

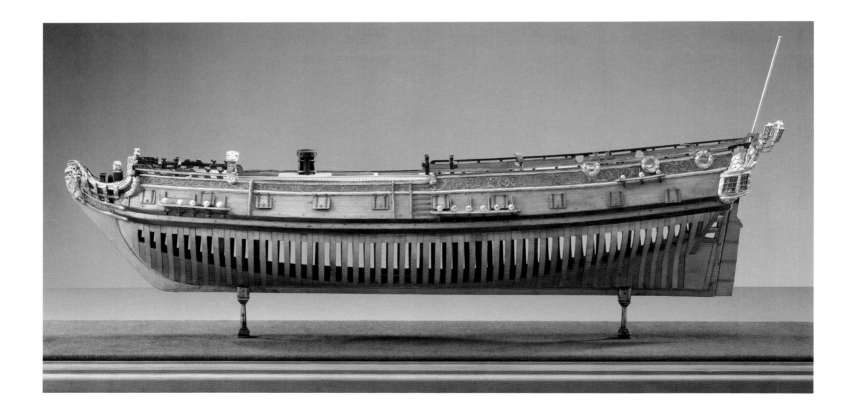

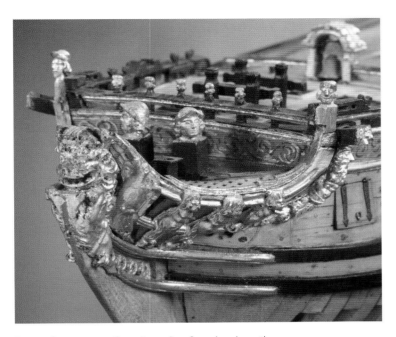

During the seventeenth century a lion figurehead was the norm for British warships mounting up to 70 guns. Larger warships carried individually designed figureheads, which would include human and heraldic figures.

This flush-decked sixth-rate has large gratings between the forecastle and the quarter deck. The gratings provided protection for the crew both against the elements and against small-arms fire during battle.

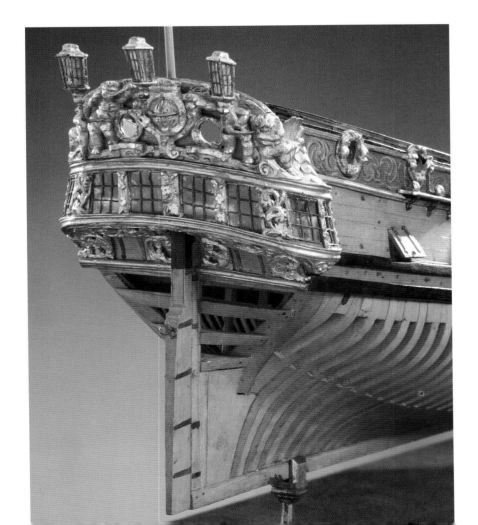

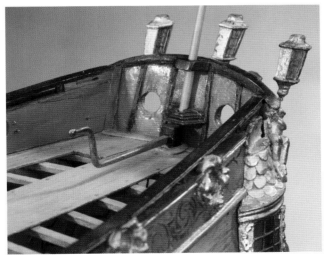

Before the introduction of the ship's wheel in 1703–04 most of the smaller British warships were steered by a tiller.

3

## British fourth-rate two-decker 50–54 gun warship

Navy Board model, scale 1:48
Great Britain, *c.* 1703–10
Boxwood, fruitwood, brass, paper
78 × 104 × 38 cm

This is one of only a handful of ship models of this period with original masts and rigging that have survived in pristine condition. It depicts a typical fourth-rate two-decker of the early eighteenth century, which would usually have fought as part of a fleet, supporting and protecting the larger warships. Since the model is, unusually, fully rigged, it was probably not an official commission but made for a wealthy individual with a connection to the British Navy. One can observe, comparing this to earlier examples, the gradual reduction in carved decoration which was introduced on grounds of cost and difficulty of maintenance.

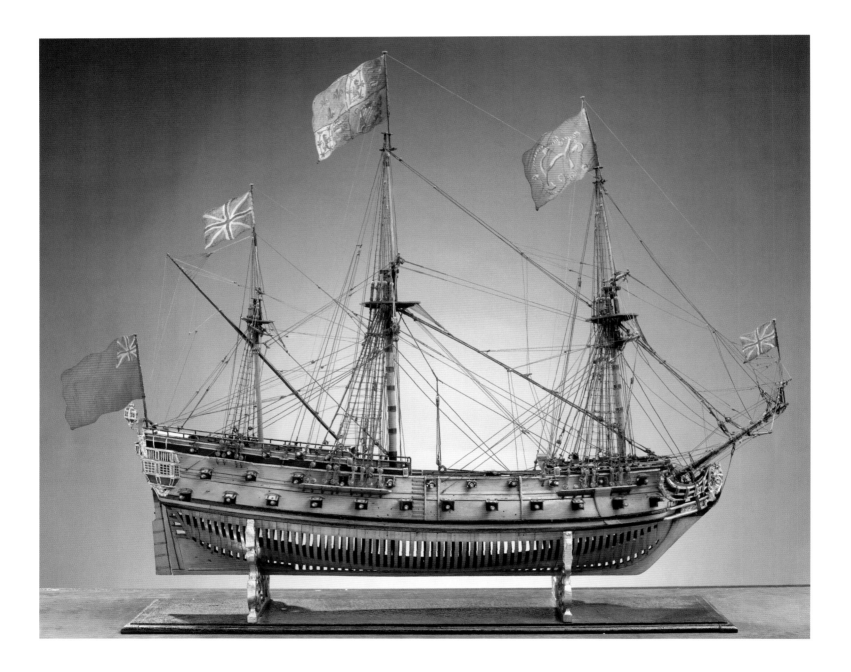

The flags, all of which are contemporary with the model, relate to the vessel when it was commissioned into the Navy. Running from the bow, they are the Union Jack, the Fouled Anchor (denoting the office of Lord High Admiral), the Royal Standard of Queen Anne, the Union Flag and the Red Ensign (denoting that the ship was under the command of the Admiral of the Red, one of three divisions of the Naval fleets, the others being White and Blue).

The sprit topmast (here flying the Union Jack) allowed a square sail to be set at the end of the bowsprit. It was in use during the seventeenth century, but was replaced in the early eighteenth century by an extension of the bowsprit called a jiboom, which enabled additional fore-and-aft head sails to be set. These improved the handling of the ship when changing tack.

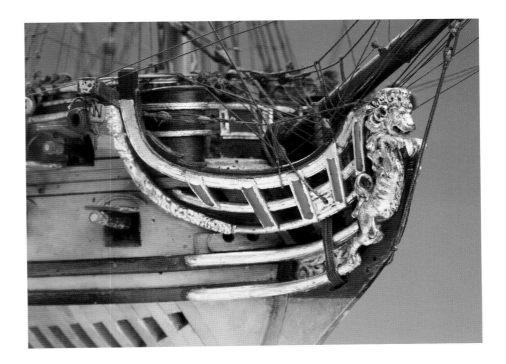

On the beakhead, against the forecastle bulkhead, there are two roundhouses, or privies, for officers' use. This is one of the earliest depictions of this modern and essential convenience; the crew, however, had to sit on flat 'seats of ease' located further forward, just behind the figurehead, and open to the elements. These facilities came to be called, from their location on the ships, 'the heads' – a term that became widely used even outside the Navy.

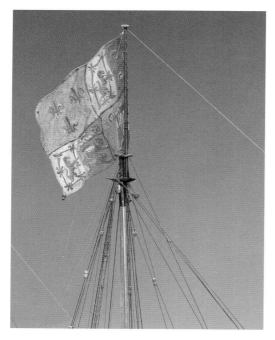

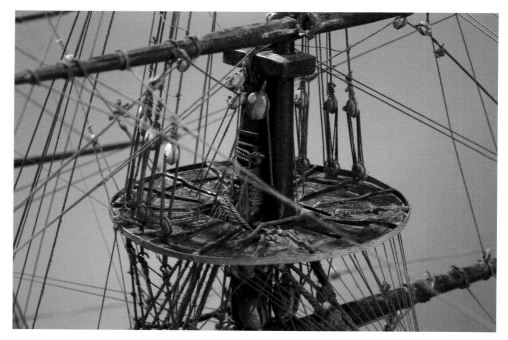

The standard of Queen Anne flies from the head of the mainmast, indicating a monarch on board. The flags are painted and varnished on card.

A small poop deck at the stern provided cover and space for additional accommodation.

The circular fighting-top on the masts, to which the rigging, including the shrouds that supported the masts, was attached, was also used as a lookout and as a point from which to fire on the enemy in close action. During the course of the eighteenth century the shape of these platforms became square, with a slightly rounded front edge.

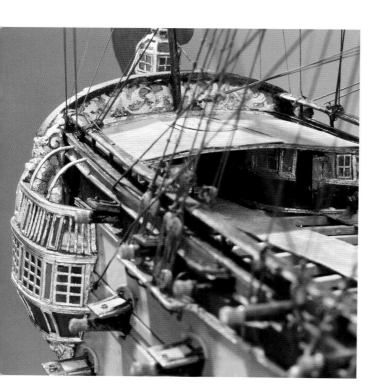

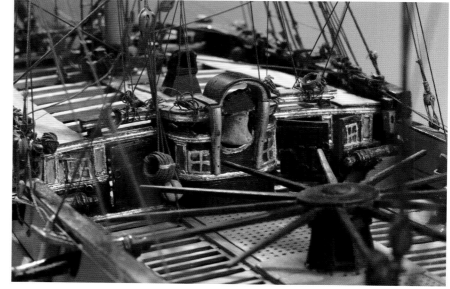

The detail of the forecastle (above) shows the main capstan (with bars rigged) in the foreground, behind it the belfry and behind that the galley-stove chimney.

Quite unusually, this model is complete with its original wooden baseboard and ornately carved crutches.

The monogram of Queen Anne (AR) is located centrally in the carved taffrail decoration below the stern lantern. In addition to the fully open balcony on the lower tier of the stern galleries there is a second small balcony on the upper tier, for the use of the senior officers.

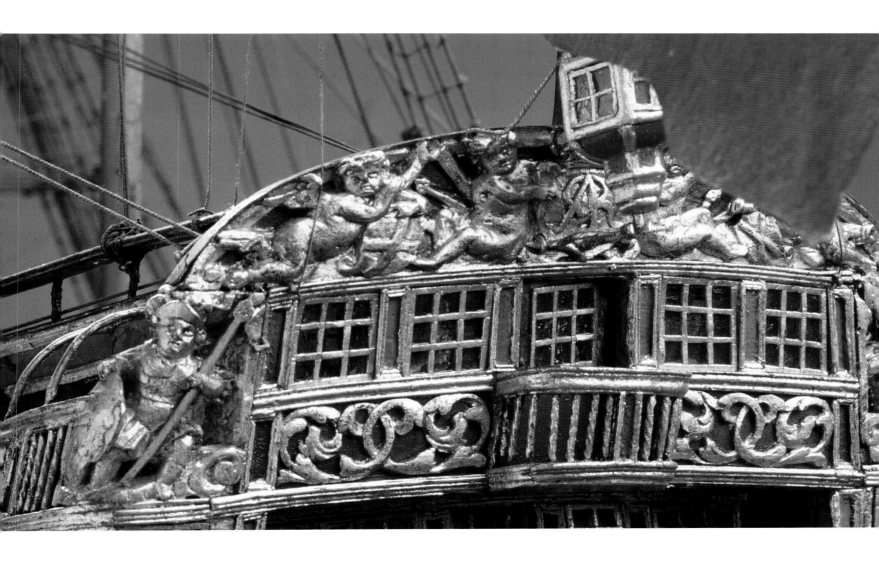

## British third-rate two-decker 70-gun warship: *Edinburgh*

Georgian model, scale: 1:48
Great Britain, 1721
Fruitwood
45 × 106 × 27 cm

This model has some deck-planking removed to show the construction and internal layout of the ship. Notable features include a capstan in the waist (the area between the fore- and mainmast), a belfry on the break of the forecastle and a bench for the officers on the upper gundeck below. Of particular interest are the carved decorations, both the figurehead and the mythological figures, trophies of war and the coat of arms of King George I on the stern galleries.

Built at Chatham Dockyard and launched in 1721, the third-rate *Edinburgh* served in the Baltic in 1726–27 and later became a guard ship at Chatham. From 1733 to 1739 she served in the Mediterranean and was broken up at Chatham in 1742.

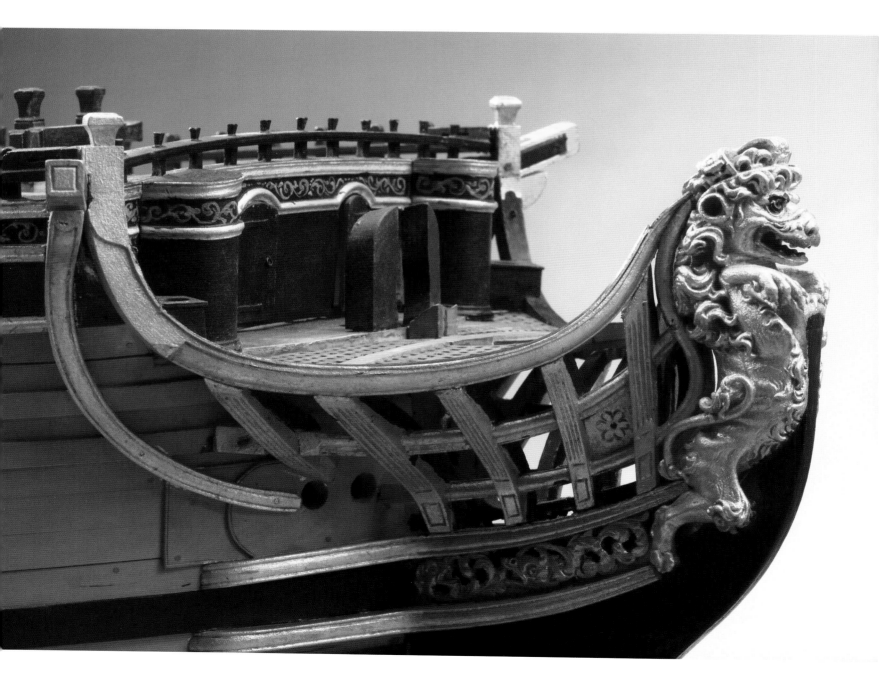

In this case not only the officers' roundhouses but also the seats of ease used by the crew are fitted to the model. For an idea of the scale of the full-size ship, consider that the lions of such standard figureheads are life-size.

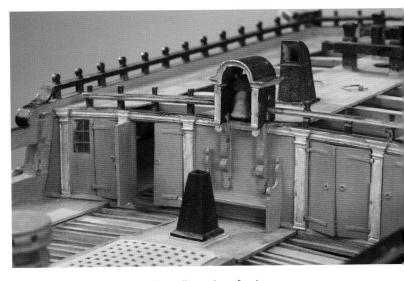

Two chimneys for the stoves in the galleys, where food was prepared for officers and crew respectively, are set one above and one below the belfry, in front of the bench.

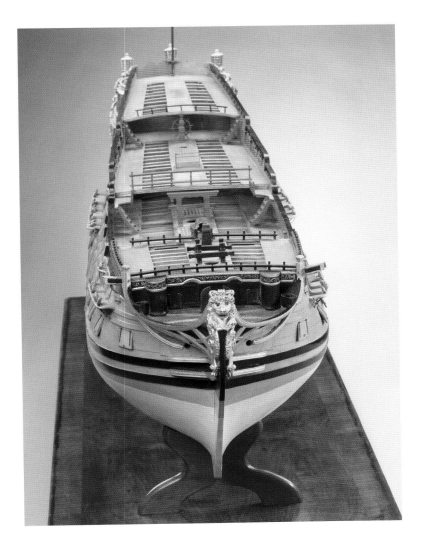

Exposed deck timbers – omitting the planking that would have covered them – are common in models of the seventeenth and eighteenth centuries. It is thought that the intention was to admit light into the model in order to highlight internal fixtures and fittings such as cabins, capstans and bilge-pumps.

The ship's wheel, fitted between the quarterdeck and the poop deck, might be operated by one or more crew, depending on weather conditions.

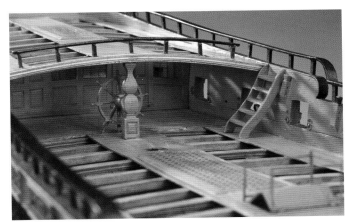

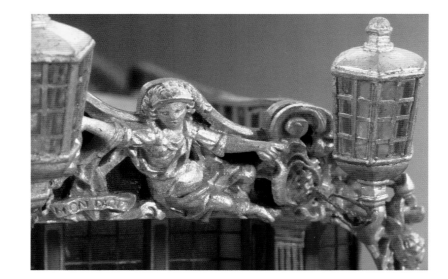

Carved figures recline on the taffrail on either side of the coat of arms between the stern lanterns.

The quarter galleries, mounted forward of the stern galleries on each side, gave additional natural light to the large cabins in the stern.

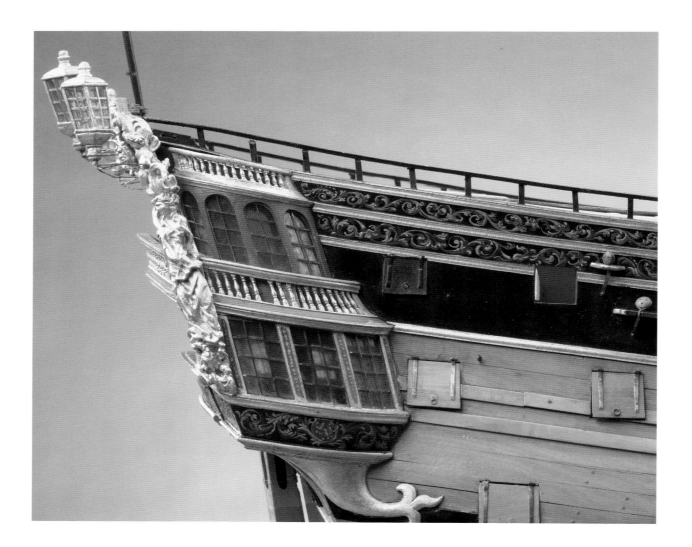

The royal symbols on the lower open gallery – the three lions rampant of England, the white horse on a red ground echoing the flag of George I's Hanover and the feathers of the Prince of Wales – complement the royal coat of arms crowning the taffrail. Notice the shape of the stern lanterns, which are now tall and angular rather than spherical, as earlier.

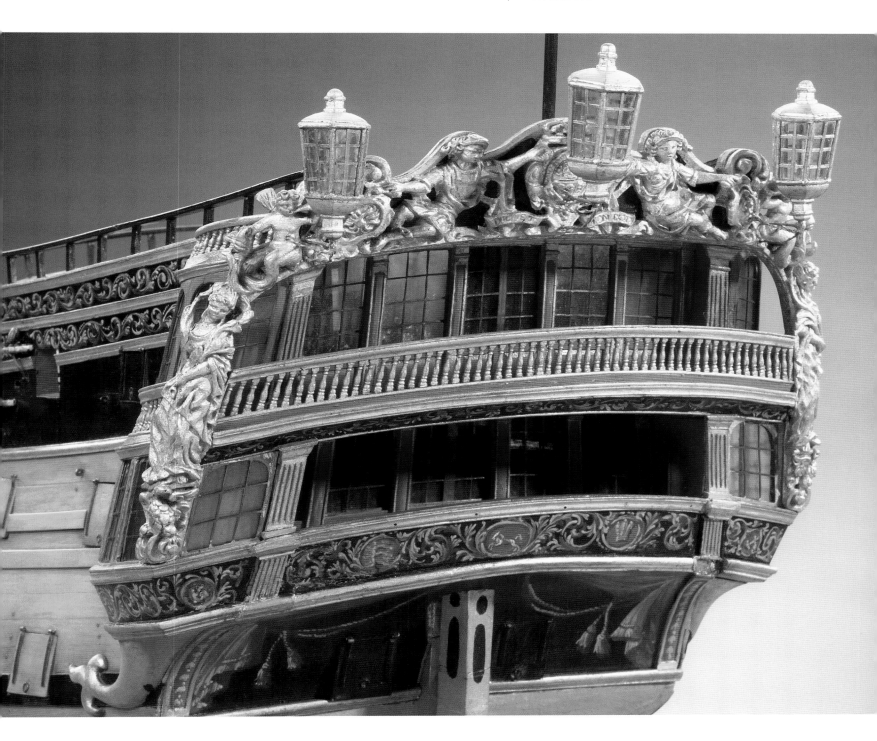

## 5
## Troop-landing craft

Georgian model, scale: 1:24
Great Britain, c. 1755–60
Wood, brass; plaster (?) figures
16 × 42 × 36 cm

These clinker-built troop-landing craft were carried in specially adapted transport ships chartered by the British Navy for operations on enemy shores. They carried a portable wooden ramp in the bows. Many were used in the raids on the coast of France in 1758 and also at the capture of Havana and St Lucia in the Caribbean. Thirty were employed for the spearhead of General Wolfe's attack on the Heights of Abraham in Canada in 1759.

The model illustrates the construction and flat shallow shape of the hull, which was pulled by twenty crew and steered by a coxswain under the directions of an officer. Internally, the thwarts (seating) were removable, so that the craft could be stowed one inside the other for transport in the hold of a ship. A small swivel gun was mounted on the head of the stem to provide cover during landings on beaches or rocky inlets.

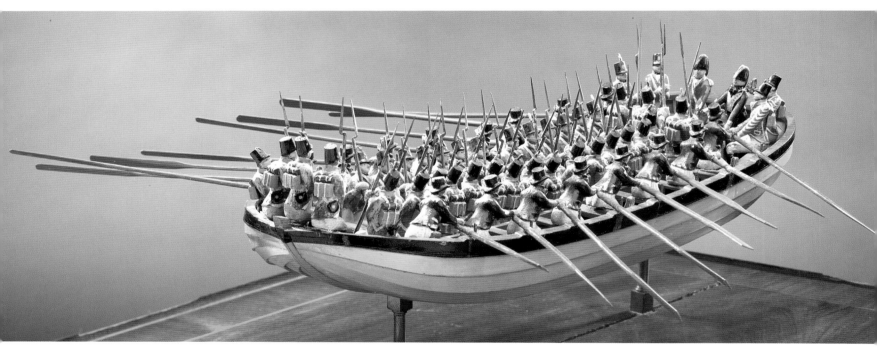

The model is complete with figures, comprising the ship's crew (rowing), the marines (seated on benches along the keel) and, situated in the stern, the officers and coxswain (steering with the rudder). Among the marines are a drummer and a piper, who would set time for the rowers.

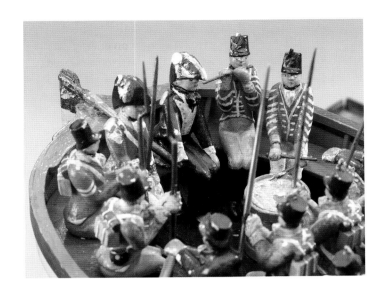
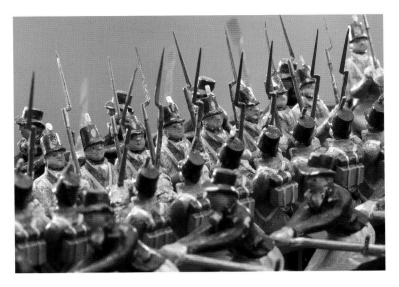

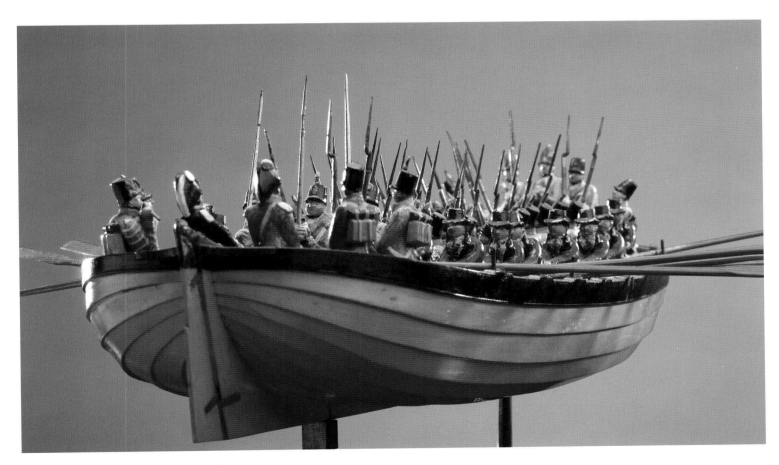

The clinker (overlapping planking) construction
of the hull gave a lightweight build suitable
both for transport on a larger ship and for use
in shallow waters.

## 6

## British fourth-rate two-decker 50-gun warship: *Bristol*

Georgian model , scale 1:48
Great Britain, 1774, signed George Stockwell on
a note recovered from inside the model
Boxwood, fruitwood, bone, ivory, glass
41 × 112 × 27.5 cm

The second half of the eighteenth century was one of the most prolific periods of modelmaking and a high point in quality of craftsmanship and accuracy. The clean and sharp finish of the 'Georgian' style of fully planked hulls together with highly detailed rigging and fittings has never been surpassed. The present model, of the fourth-rate *Bristol*, is one of a very few for which the maker, date and place made are known for certain. When a medical endoscope was used to explore the model internally, a rolled note was found on which was written: *This model was made/ May the 7: 1774 By Geo[rge] Stockwell/ Shipwright at Sheerness Yard*. As a result it was possible for the first time to identify a modelmaker with a particular style, something on which the official naval records of this period throw no light. A second note signed by Stockwell had previously been found in another model, and Stockwell's son, also called George, left a note in a third model.

The *Bristol* herself had a very varied career, seeing action in North America, the West Indies, Gibraltar and the English Channel, eventually becoming a hospital ship and later a prison ship at Chatham, before being broken up in 1810.

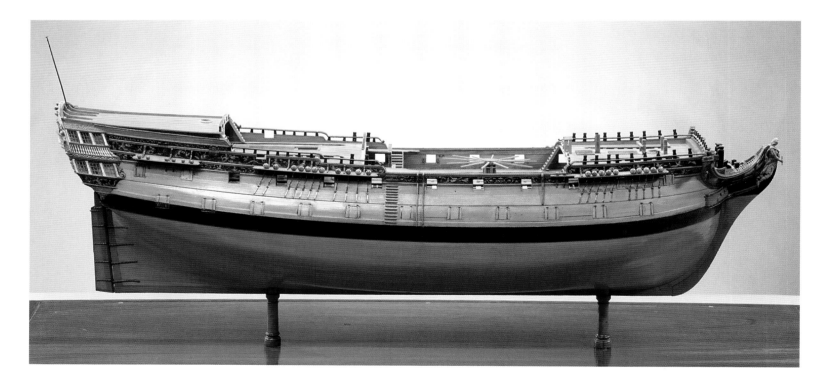

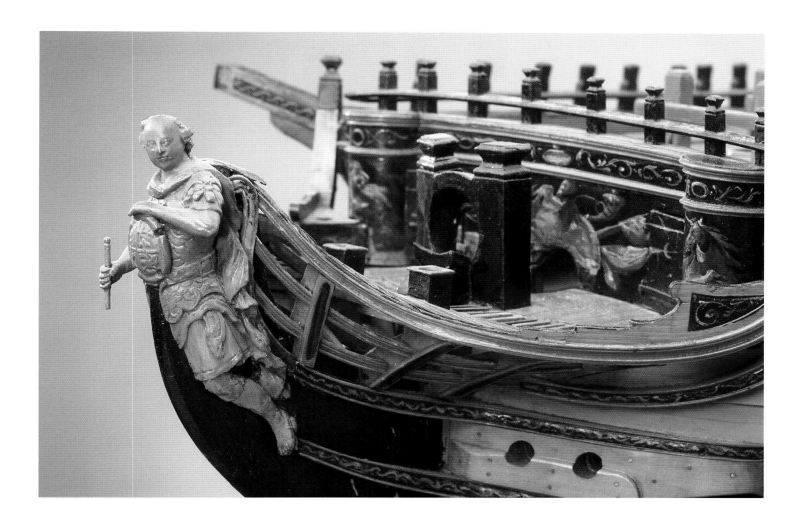

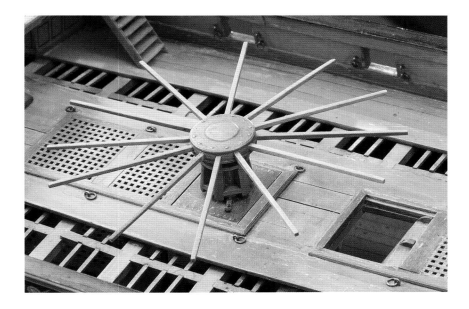

The figurehead depicts the British king George III in classical dress.

The main double capstan is mounted in the waist of the ship, both on the upper deck and on the gundeck below. Its primary purpose was to raise the anchors and cable. The cable was paid out through the two large hawse pipes located just behind the figurehead.

An overall view from the stern illustrates characteristics of the 'Georgian' style of modelmaking: the hull is fully planked and finished in a more realistic fashion than the earlier 'Navy Board' style.

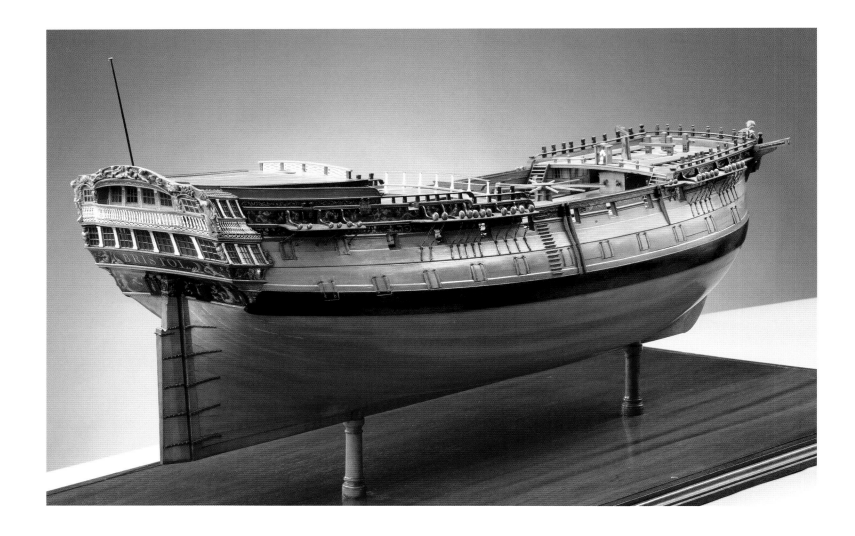

Seventeenth and eighteenth century

Another common feature of the 'Georgian' style of modelmaking was the application of further materials in addition to wood. Bone and ivory were often used where intricate and complicated carving was required – for example on the decoration of the stern and quarter galleries – being perhaps preferred for this over wood, which, because of its grain, was more fragile. These other materials highlighted the decorative features of the model, analogously perhaps to the later nineteenth- and twentieth-century style of modelmaking with gold and silver fittings.

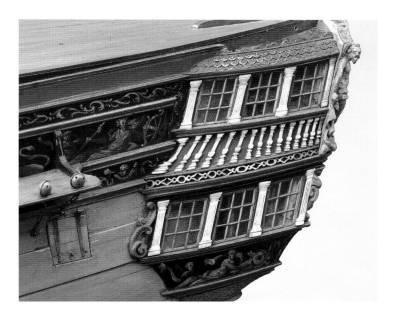

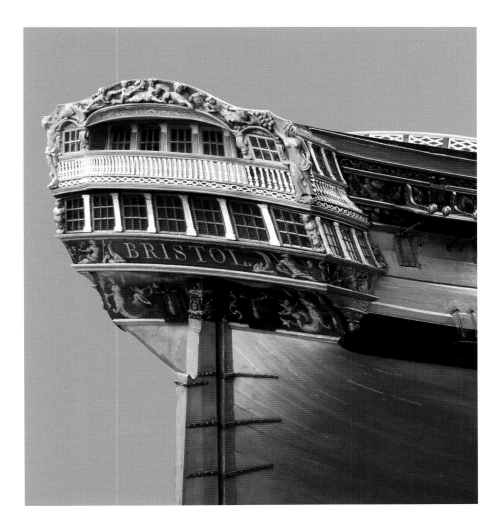

During the 1770s the Navy introduced an order that all ships should have their name painted clearly in large letters on the counter of the stern. This idea was abandoned some years later because identification of the ships might give the enemy an advantage.

## 7
## British revenue lugger: *Alarm*

Georgian model, scale 1:48
Great Britain, *c.* 1782
Boxwood, fruitwood, brass, silk,
paper, glass
37 × 60 × 9 cm

This broadside view from starboard clearly illustrates the large amount of canvas carried by these fast vessels. The model is complete with 'defaced' blue ensigns (Revenue Service emblem and Union Jack) flying from the top of the mizzen mast and from the ensign staff on the stern. The model is mounted in its original case, which has a mirrored bottom to reflect the shape and design of the hull and planking.

During August 1779 the British Admiralty issued instructions for the mobilization of a number of revenue vessels, which were "to be manned and armed to fullest extent." This exquisite model of one of these, the *Alarm*, clearly illustrates the number and type of guns that were to be used against smuggling vessels, which themselves might be heavily armed: her armament consists of 20 three-pounder guns on carriages with a further 20 half-pounder swivel guns mounted on the bulwarks for use in close combat. These 'greyhounds' of the sea carried a large amount of sail: not only does the model carry a full suit of original sails but it is accompanied by the shipwright's plans – both extremely rare survivals. It also includes the ship's cutter, which, stored on chocks on deck, was used for boarding the smugglers' vessels as well as for unloading and transferring contraband goods.

The career of the *Alarm* is only patchily recorded but she generally worked out of ports on the south coast of England and is known to have been involved in several operations, notably the taking of the privateer *Le Jeune Benjamin* in the English Channel in 1793.

It was common practice to draw the plan from which Navy vessels were built at a scale of 1:48 or ¼":1′, as the plans for larger capital warships would measure some six to eight feet in length, which was the upper workable limit of paper plans in a dockyard. As was usual, the plan for the *Alarm* (46.6 x 66.8 cm) shows the hull in three views – cross sections, deck plan and hull profile and plan, complete with waterlines (coloured). The scale rule, under the hull profile, was used to take specific measurements from the plan and convert them to full size for construction.

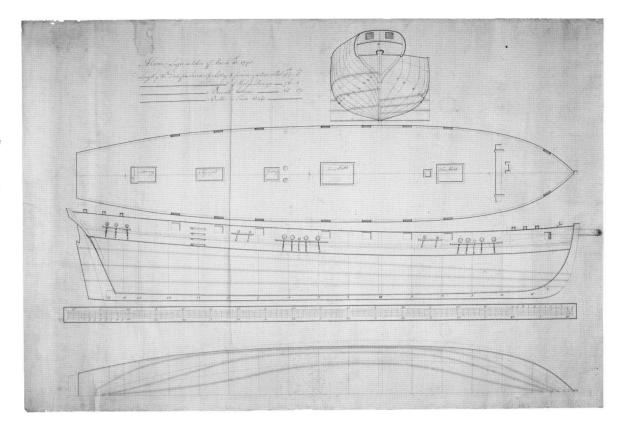

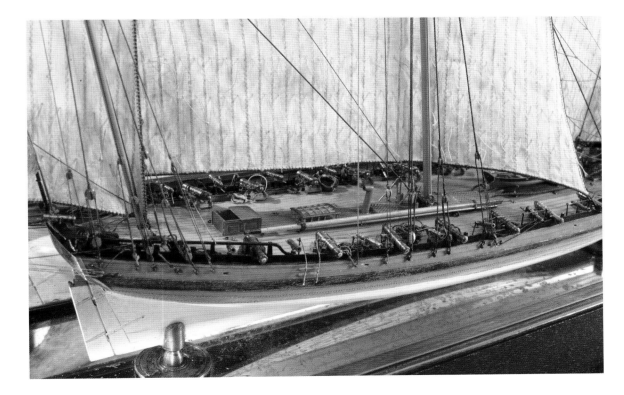

The deck is fairly cramped. Down the centreline from the stern is the companionway to the cabins below, a skylight to illuminate the cabins, the galley stove pipe, and, just beside the mainmast, the bilge-pumps. The long wooden spars lashed together on deck are spare topmasts: the topmasts from which the lighter-canvassed topsails were set might often be carried away should the vessel be caught in a sudden squall.

8

## British 12-gun naval cutter: *Surly*

Georgian model, scale 1:48
Great Britain, 1806
Wood, metal
64 × 82 × 22 cm

Built by Johnson at Dover and launched in 1806, the *Surly* measured 63 feet in length by 23 feet in the beam. She was a typical naval cutter, rigged with a single mast carrying both a fore-and-aft mainsail and a squaresail. She was armed with twelve 12-pounder guns on carriages and manned by a large crew of fifty – needed to work both guns and rig. In 1833 the *Surly* was converted for use as a dockyard lighter at Chatham and was sold out of service in 1837.

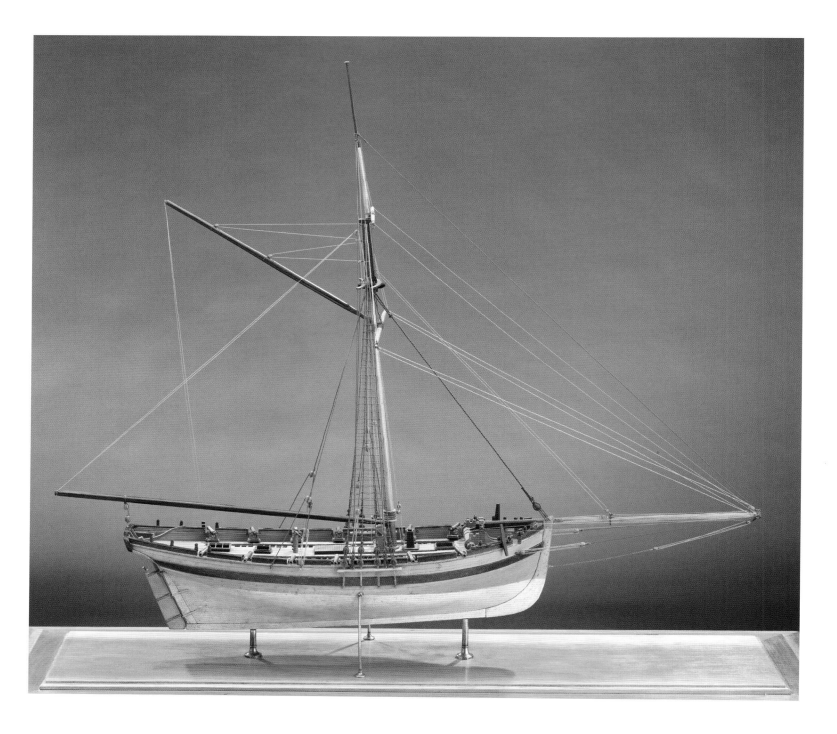

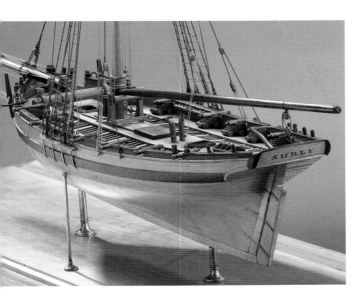

The large sail area and fine lines of the hull made cutters like the *Surly* very fast and handy, and they were used very successfully by the British Revenue Service against smugglers. The mast carried a square topsail, sometimes with a larger square sail below, and a large fore-and-aft sail, gaff-rigged, which overhung the stern. The term 'gaff' refers to the wooden spar supporting the sail along its upper edge, which has open jaws at its forward end, allowing it free movement up and down and around the mast. These vessels were steered both by tiller and by the rig itself. If turned far to one side the rudder would act as a brake, slowing the vessel down. The large wooden windlass in the bow was used for a variety of jobs, including working the anchors and gear, raising and lowering the sails, and drawing in mooring lines when alongside a quay or in dock.

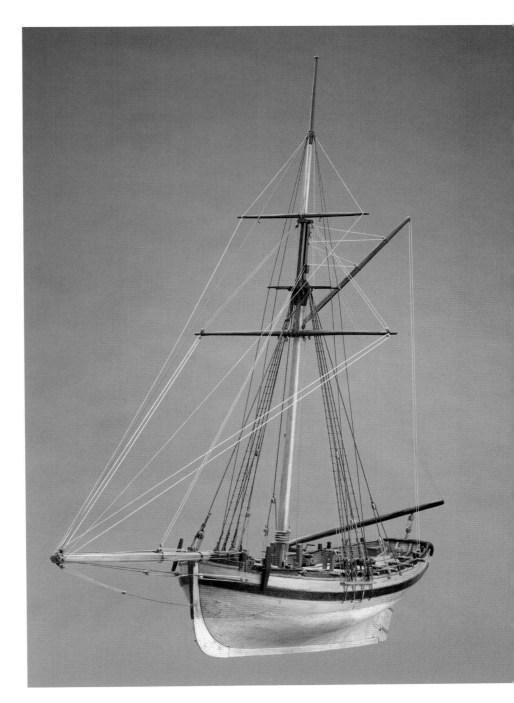

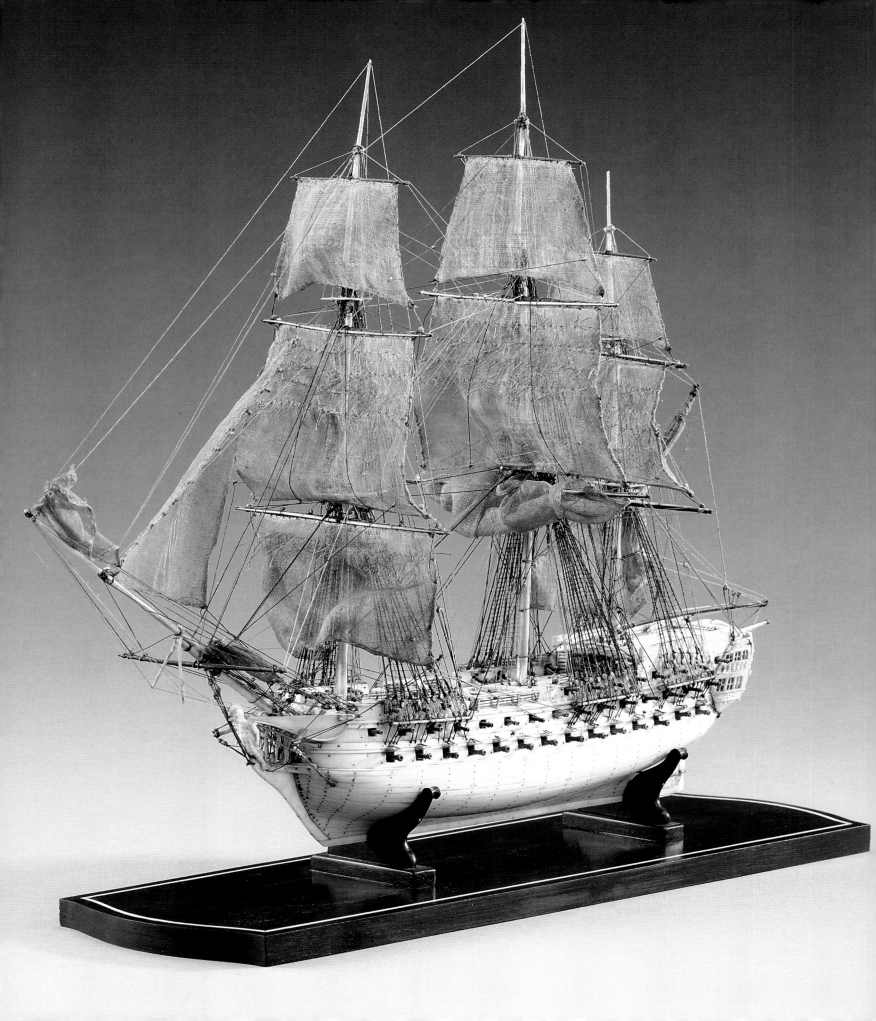

## Prisoner of War models

A large part of the Thomson Collection of ship models consists of models made by French captives imprisoned in Britain during the Napoleonic Wars (1794–1815). The high quality of craftsmanship evident in these objects reflects the fact that many of these sailors had been press-ganged into the Navy and had previously been trained in skilled crafts such as watchmaking, metalwork and woodworking. Incarcerated in Britain, they found that by making models and other objects, for example the double watch stand (no. 14), they could earn money and improve their lot. Bone was available from their weekly ration of beef on the bone and they ingeniously used other materials such as straw, which they coloured, and human hair. The accuracy and quality of these models steadily improved as the prisoners became more organized and were able to source and buy better tools and materials. They probably worked in small groups, each member specializing in one kind of work, for example bone-carving, wood-carving or rigging. Certain features on these models were effectually mass-produced, notably the figureheads: these tended to reproduce a recurrent design of a classical warrior, of which some examples were clearly carved by the same hand. Generally, the smaller, less accurately made examples can be dated earlier than the more accurate and detailed models such as the *Océan* (no. 20).

Detail of no. 11
**French or British warship**

## 9
## French or British warship

Prisoner of War model
Great Britain, probably made by French sailors,
*c.* 1795–1815
Bone, horn, silk, wood and ivory (?)
84 × 108 × 39 cm

The 74-gun two-decker became the standard warship of the line during the late eighteenth century. It was a common feature of these models that the ship's longboats should be rigged from the yard tackles.

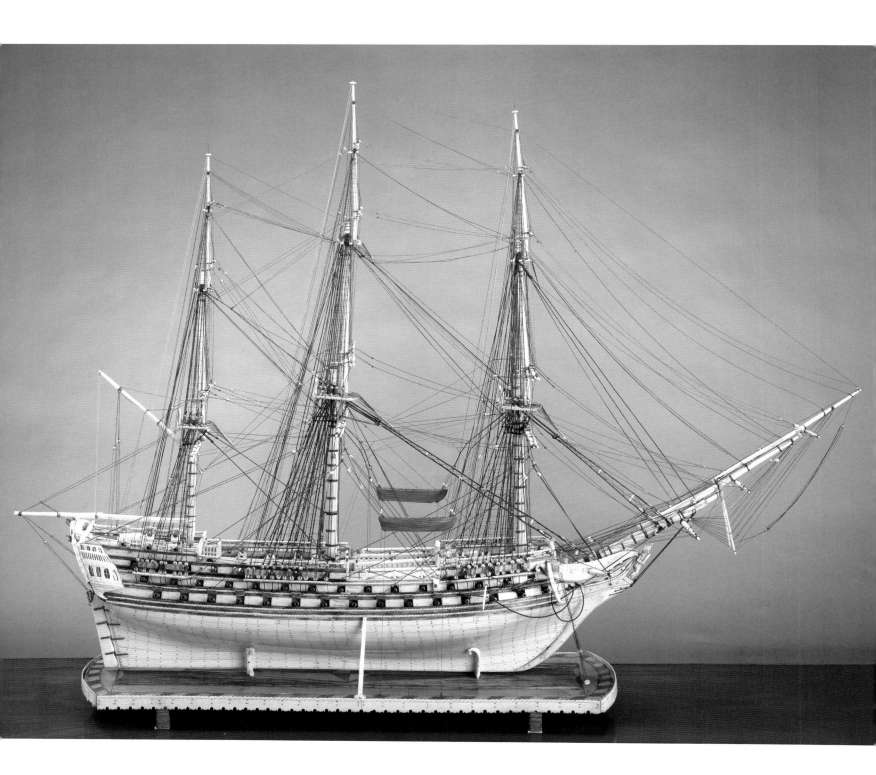

Even though bone was a difficult material to work with, the French prisoners of war were able to produce detailed carved decoration, albeit slightly over-scale.

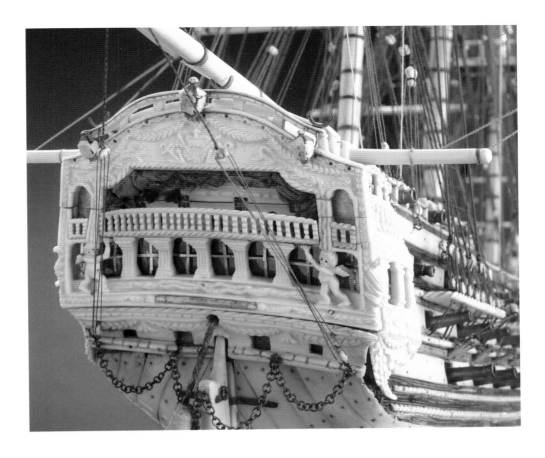

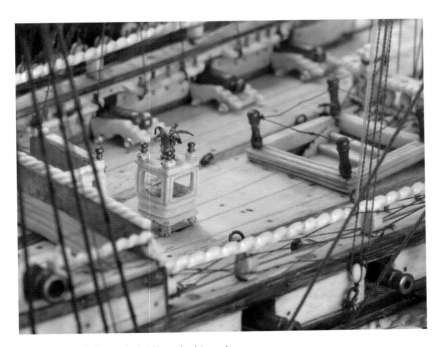

The model includes such details as the binnacle, in which the ship's compass was housed .

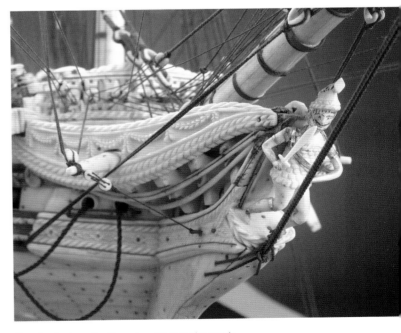

The classical warrior figurehead is complete with body armour, helmet and sword.

## 10

### British or French three-decker 100-gun warship, with admiral's barge alongside

Prisoner of War model
Great Britain, probably made by French sailors,
c. 1795–1815
Bone, horn, paper, silk and brass
27 × 37 × 8.5 cm

It is very unusual to see a Prisoner of War model in a case of such high quality. Clearly designed around this particular model, the case was probably specially commissioned from a cabinetmaker by the owner. It is made from mahogany veneer on a wooden carcass and has a gilt-brass handle, rope-beading and finials at the corners. The hull of the model is set in a sea base, consisting of painted paper glued to a wooden platform with a carved and painted bone skirt. The model must commemorate an event involving the high-ranking officer who stands at the top of the companionway descending to the barge, complete with cabin. In the barge the crew stand with their oars tossed in a form of salute.

OPPOSITE
Visible just forward of the companionway and between the rigging are the nettings where the sailors' rolled hammocks were stowed during the day.

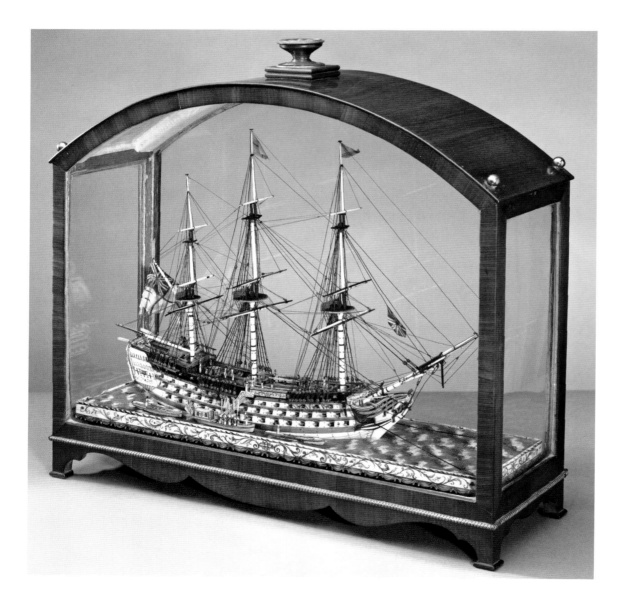

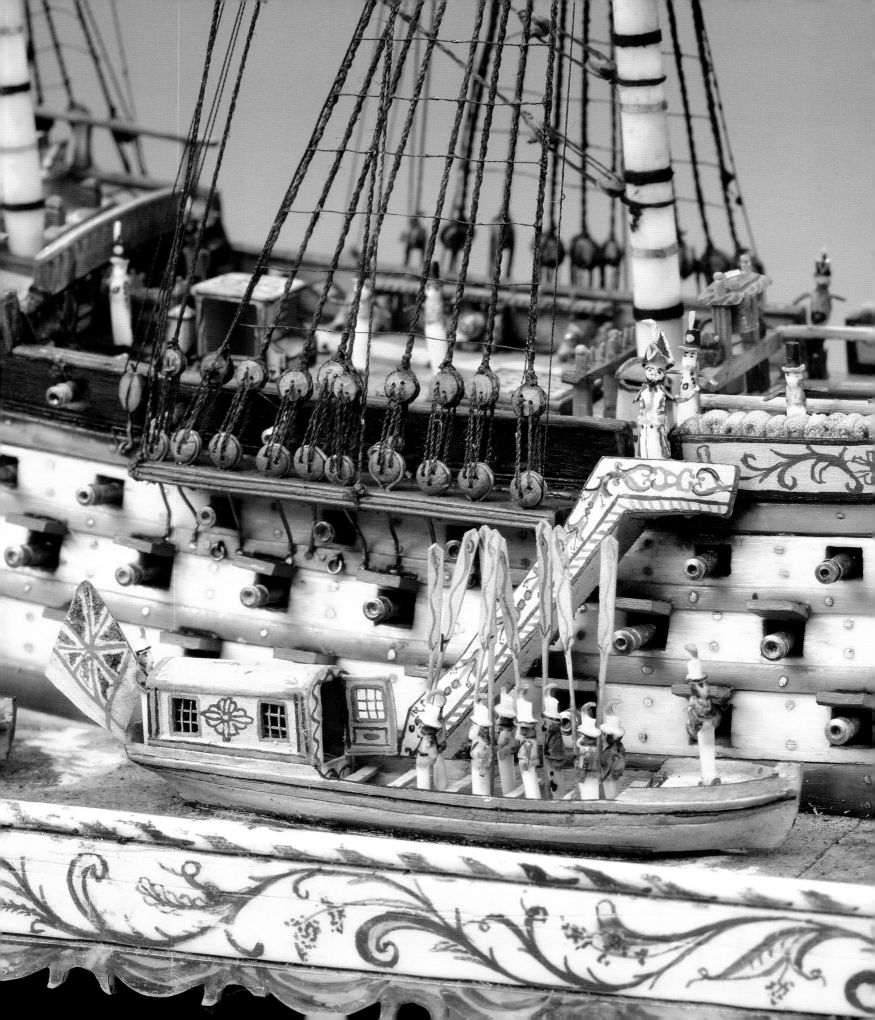

## 11

### French or British warship

Prisoner of War model
Great Britain, probably made by French sailors,
*c.* 1795–1815
Bone, wood, boxwood, brass, ivory, paper, gauze
23.6 × 27.9 × 8.4 cm

This extremely fine small-scale model is rigged with its original sails. It is very rare to find original sails since the material from which they were made would normally suffer from exposure to light and deteriorate over the years. The sails, despite the model's scale, are quite detailed, including the reef points (where the sails could be reefed to reduce their area in windy conditions). The bone planking has been pinned to internal wooden sections.

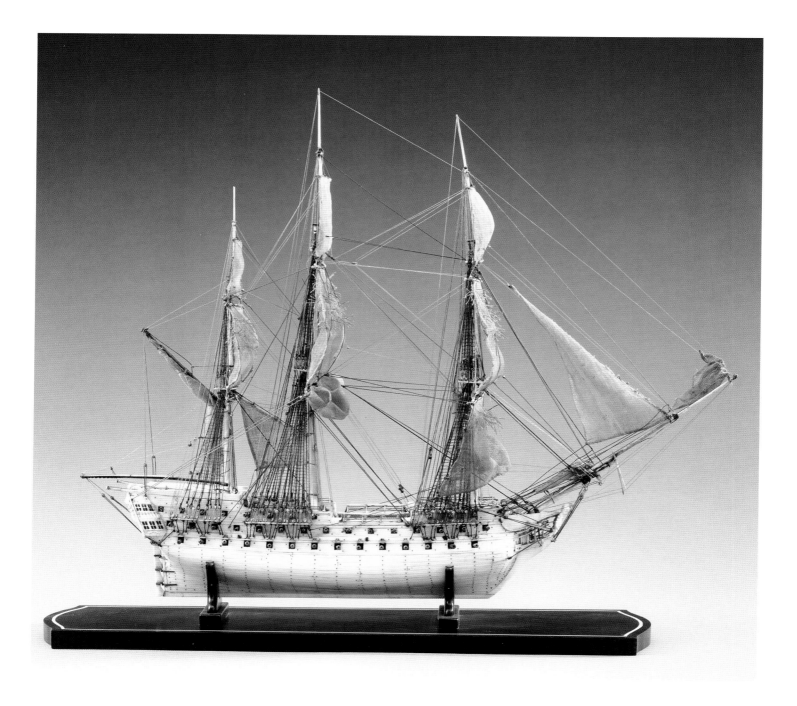

The classical warrior figurehead has been carved from a single piece of bone.

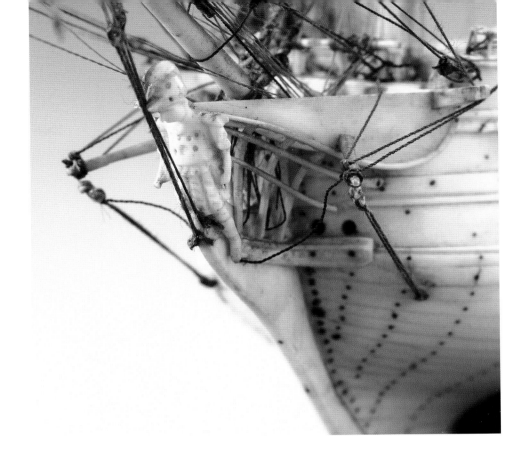

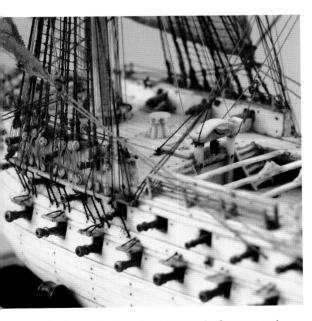

On the waist of the ship, between the foremast and the mainmast, the capstan and belfry are clearly featured. The ship's boats and spare topmasts could be stowed on the wooden beams across the waist.

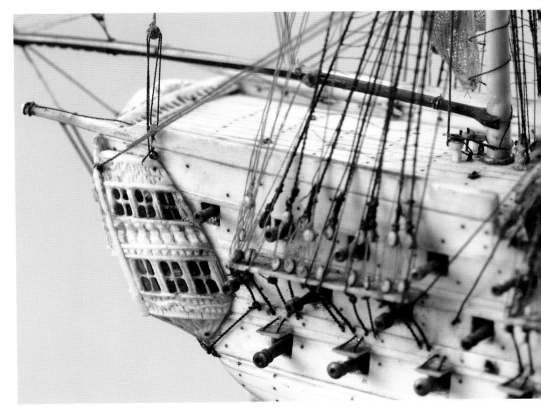

The stern quarter gallery was carved from a single piece of bone. The brass guns were probably turned on a crude lathe.

## 12

## French or British 50-gun warship

Prisoner of War model
Great Britain, probably made by French sailors,
c. 1795–1815
Bone, horn, silk and wood
53 × 72 × 24 cm

This is a typical Prisoner of War model, made from bone and mounted on a decorative wooden baseboard. It depicts a 50-gun frigate of the turn of the nineteenth century. Because the French prisoners of war did not work from scale plans, these models were often inaccurately proportioned, both in their overall shape and, particularly in this case, in the relative height of the masts.

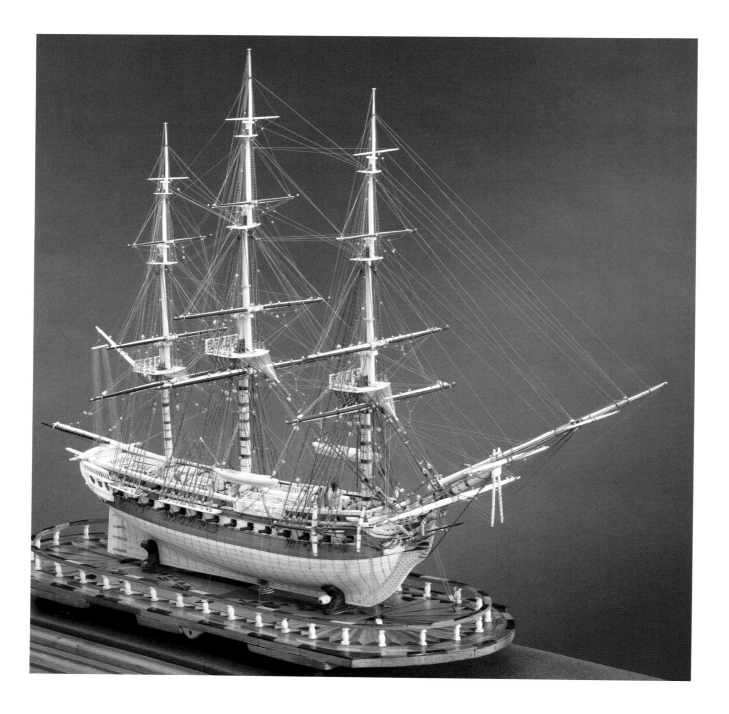

Prisoner of War models

The decoration on the stern and quarter galleries was usually carved from a single piece of bone, normally from the thigh or shoulder-blade of an animal.

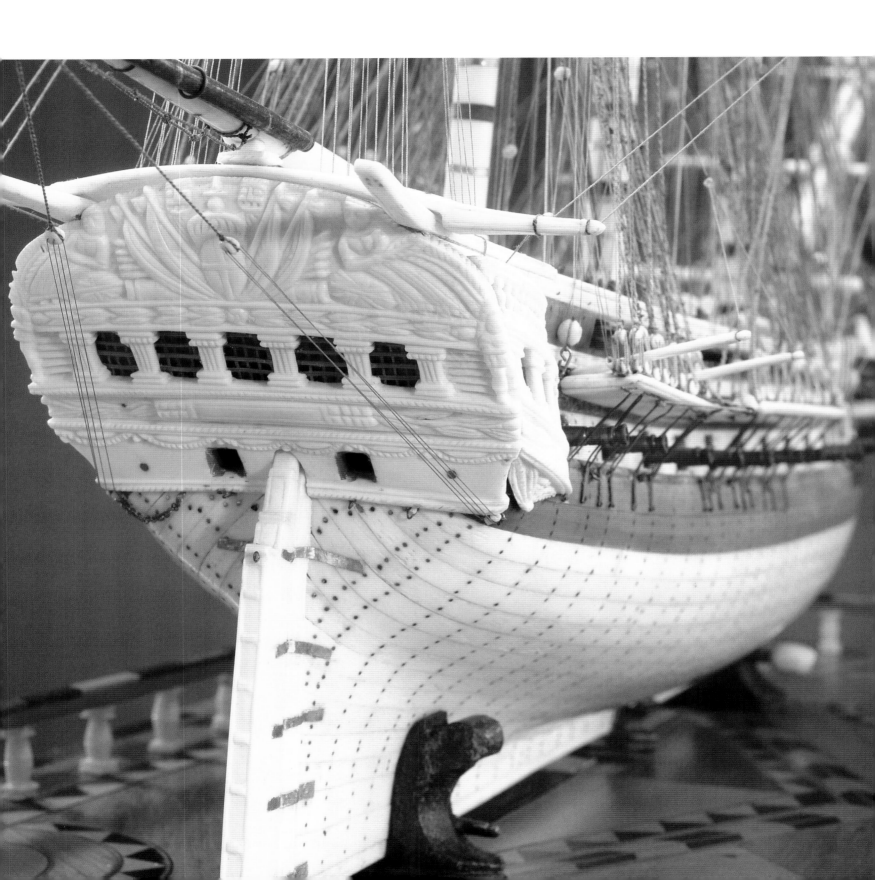

## 13

## French or British 44-gun warship

Prisoner of War model
Great Britain, probably made by French sailors,
c. 1795–1815
Bone, horn, silk, wood and ivory (?)
16 × 21 × 7 cm

This small-scale bone model of a 44-gun frigate is mounted on a wooden baseboard decorated with inlaid straw. The hull planks of bone are pinned to a wooden framework of cross-sections, the intervals of which can be deduced from the pattern of the fastenings. The female figurehead is carved in bone and the cannons are turned in brass.

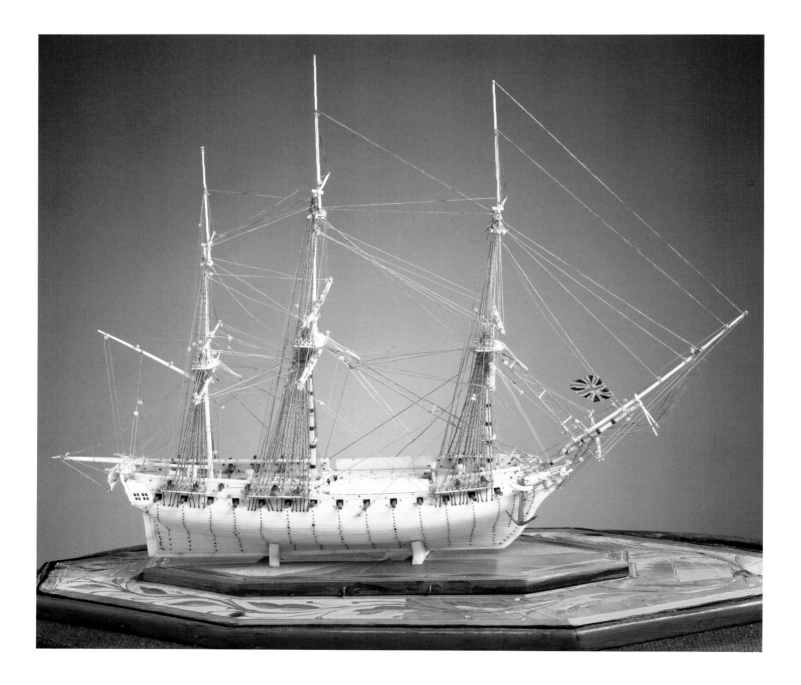

## 14

### Double watch stand with British or French two-decker 74-gun warship

Prisoner of War model
Great Britain, probably made by French sailors,
*c.* 1795–1815
Bone, wood, paper, ink and watercolour,
brass, straw, hand-tinted prints
Stand 53 × 34 × 25 cm
Model 17 × 22 × 7 cm

Two fob watches, when not being carried, were set in the circular apertures above the cased model below and would serve as stationary clocks. The piece's main feature is the small-scale model of a two-decker warship mounted on a waterline base. To better 'illuminate' the model with natural light and allow study of the port side of the ship, a mirror has been set at the back of the case.

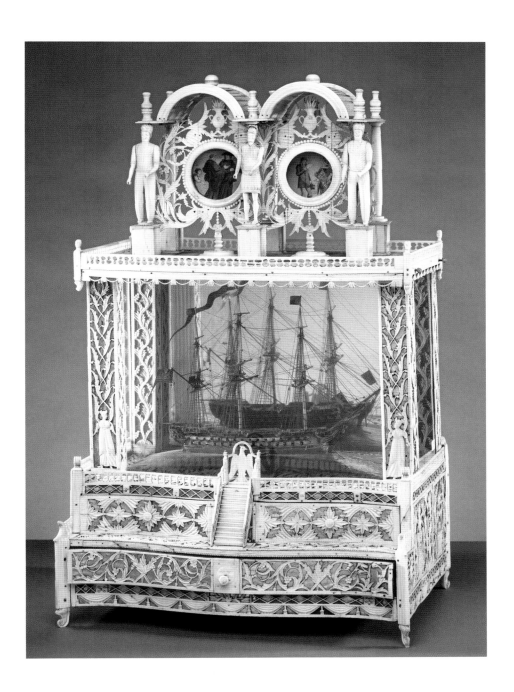

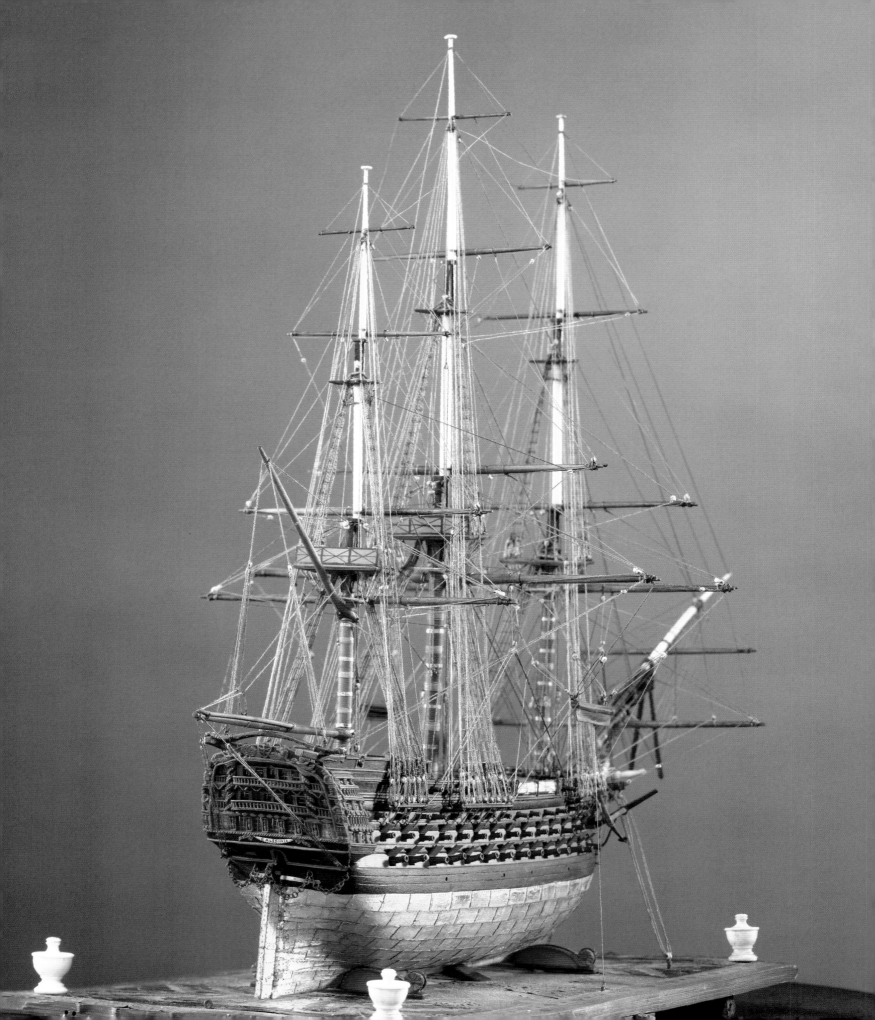

## 15

## French or British warship

Prisoner of War model
Great Britain, probably made by French sailors,
*c.* 1795–1815
Bone, wood, brass, horn, silk
27 × 36 × 14 cm

An unusual feature of this model is the use of both bone and wood for the mast and spars. The name *Caledonia* has been painted on the counter of the stern after the British 120-gun ship of that name launched in 1808, although the model typically includes both French and British features: evidently the name was borrowed to make the model more saleable.

OPPOSITE
The model shows the underwater area of the hull as sheathed in copper, intended to prevent both weed growth, which would slow the vessel down, and damage to the timbers by the marine mollusc *Toredo navalis.*

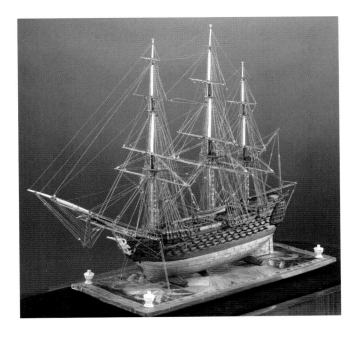

16

## British or French three-decker 100-gun warship

Prisoner of War model
Great Britain, probably made by French sailors,
c. 1795–1815
Wood, paper, brass
13 × 18 × 6.5 cm

It was a common style of the Prisoner of War models to mount an almost full-depth model on a water-lined baseboard. This gave the impression of the vessel afloat while also presenting the underwater body of the hull.

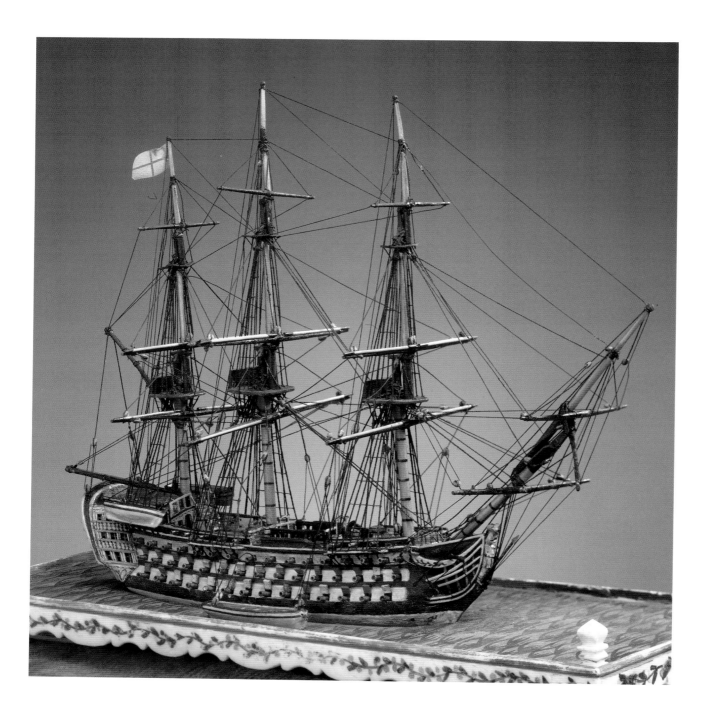

# French or British two-decker 74-gun warship

Prisoner of War model
Great Britain, probably made by French sailors,
c. 1795–1815
Varnished and unvarnished wood, paper, mesh net,
copper alloy
Model 11 × 12 × 4 cm

This model, finely carved in boxwood and including the rigging together with sails made from paper, is mounted on an oval base surmounted with a canopy, which suggests that it was made as a memorial to a ship lost in action.

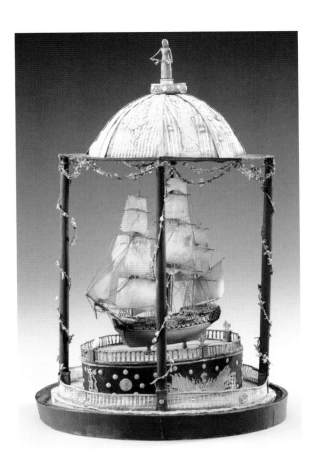

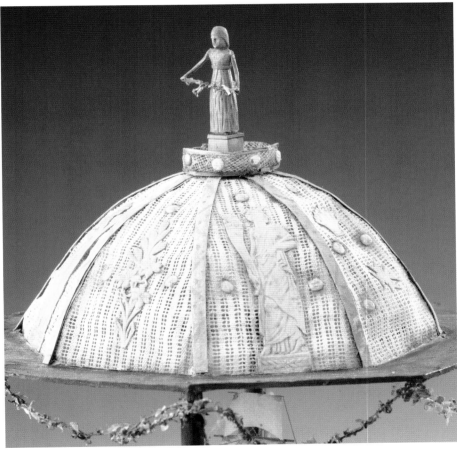

The canopy is made from a starched fabric embellished with embossed paper and is crowned with a female figure in carved wood.

Looking from astern in a raised view one can see clearly that the craftsman did not have access to scaled plans and that the rig is overheight. The hull has been carved from a single piece of boxwood, on to which the decks, bow and stern decoration have been added.

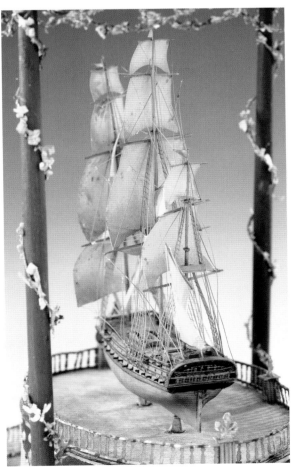

18

## British three-decker 100-gun warship: *Victory* (funerary catafalque for Lord Nelson)

Prisoner of War model
Great Britain, probably made by French sailors,
*c.* 1806
Fruitwood, boxwood, ebony, paper, copper, brass
29 × 42 × 11 cm

The hull, though relatively embellished, is modelled on that of *HMS Victory*, Vice-Admiral Lord Nelson's flagship. On its deck is the coffin of Britain's hero, surmounted by victory trophies, beneath a canopy supported by palm trees bound with vines. The black ostrich feathers on the roof and the silk hangings were signs of mourning taken from contemporary funerary ritual. The inscription around the top of the canopy reads PALMAM QUI MERUIT FERAT – Nelson's personal motto – which translates as 'let him who has deserved it bear the palm'. The body of Lord Nelson was conveyed by river to St Paul's Cathedral for burial in January 1806. Nelson's death provoked the production of a wave of commemorative objects.

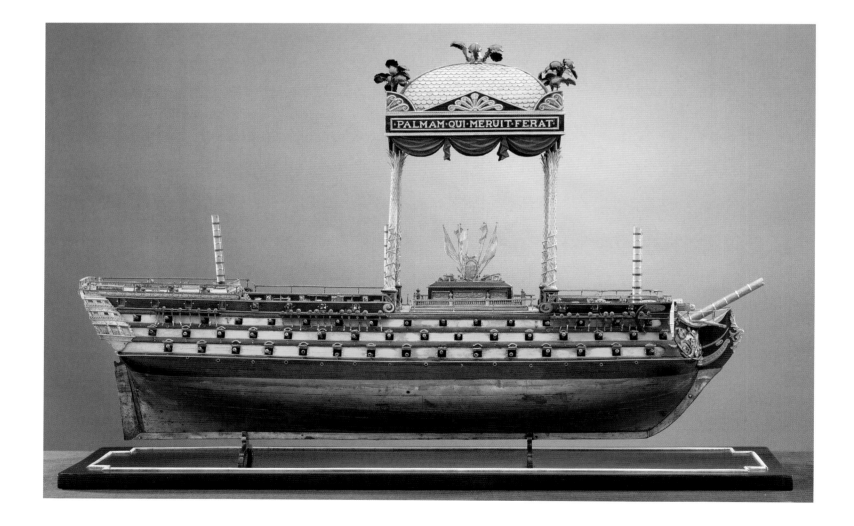

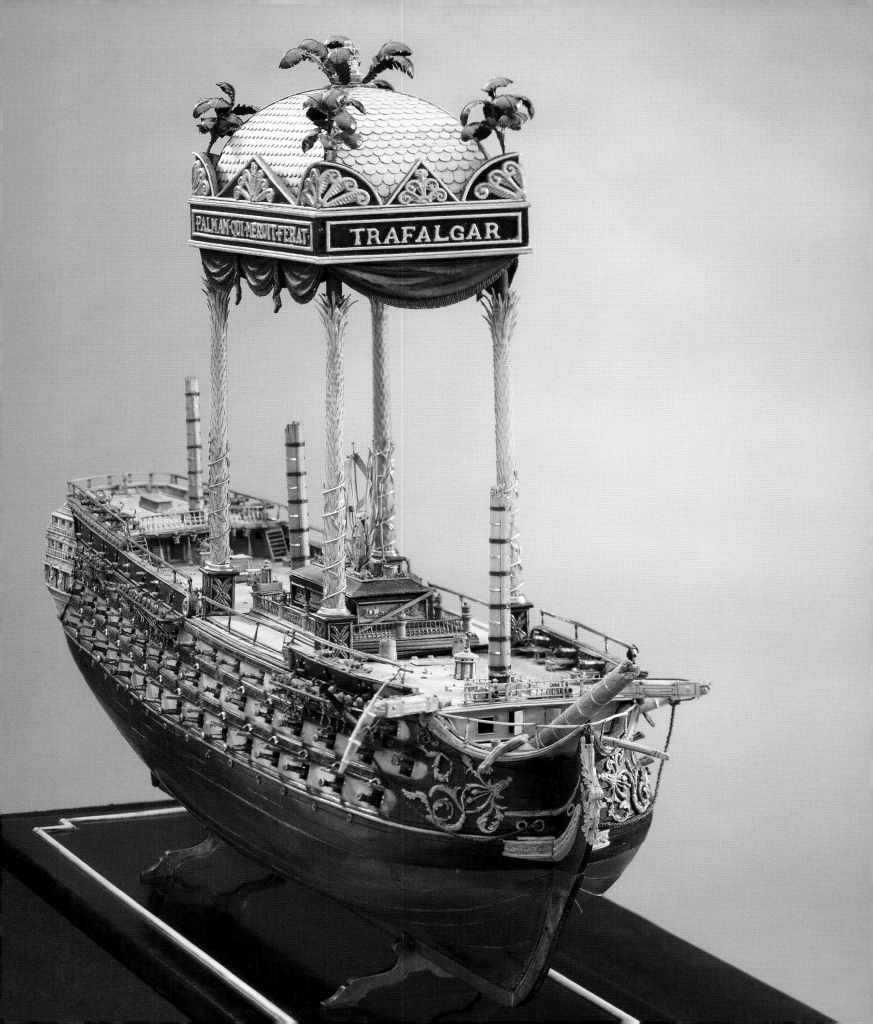

19

## British third-rate two-decker 80-gun warship: *Canopus*

Prisoner of War model?
Great Britain or France, *c*. 1795–1815
Fruitwood, boxwood, brass, horn
24 × 80 × 18 cm (with brackets)

This ship was originally built and launched at Toulon in 1797 as *Le Franklin*, then was captured by the British at the Battle of the Nile and renamed the *Canopus*. It was considered to have excellent sailing qualities and its design was followed in a number of ships built after 1815. The third-rate *Canopus* had a very active career, seeing action at Lisbon and in the Mediterranean and joining Admiral Lord Nelson's fleet off Toulon in 1803. After a series of repairs, she was finally laid up in ordinary (taken out of commission) and hulked as a receiving ship (housing trainees), eventually being sold off in 1887.

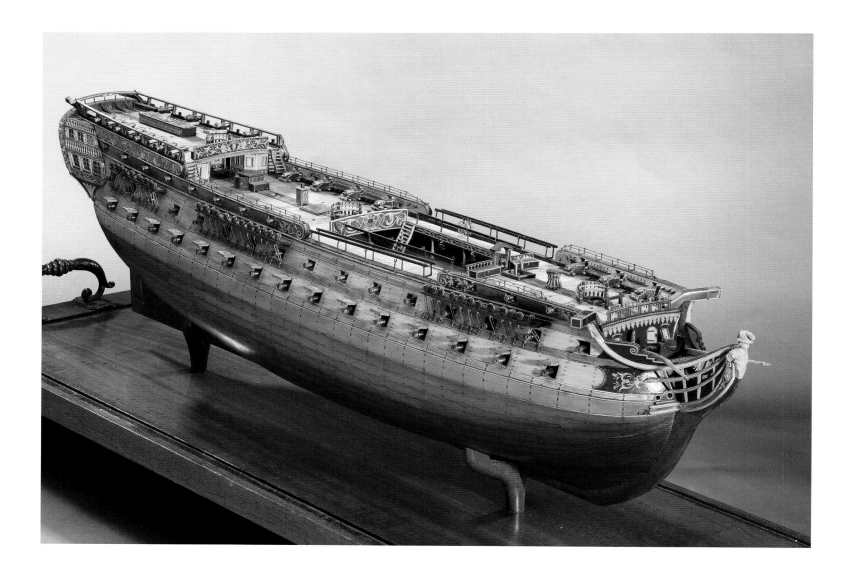

Prisoner of War models

The forecastle deck is complete with a belfry whilst just behind are chimneys from the galley stove below decks. A capstan is mounted centrally for working the anchors and their gear and a series of pinrails, both on the bulwarks and around the base of the mast, were used to secure the running rigging.

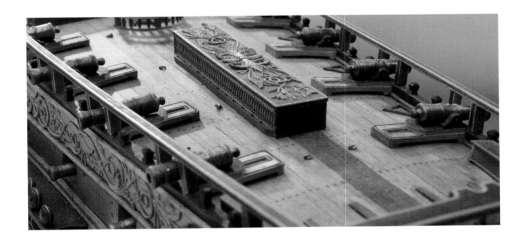

The quarter deck is fitted with a highly decorated skylight set over the cabins below. There are also a variety of cannon mounted on sliding carriages, which are complete with triangular shot garlands alongside.

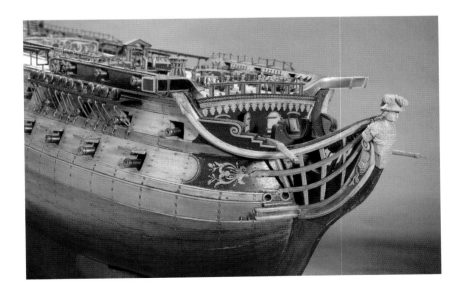

The figurehead is a modern replacement, copied from the original, which is now in the collections of the National Maritime Museum, Greenwich, London.

The typically rounded French stern galleries are decorated with carved boxwood against a darker ground. The two davits over the taffrail were an innovation of the early nineteenth century: they would have supported a cutter which could be launched quickly in the event of an emergency such as a man overboard.

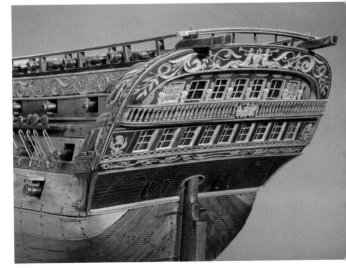

## 20

## French three-decker 120-gun warship: *L'Océan*

Prisoner of War model
Great Britain, probably made by French sailors,
*c.* 1815–20
Boxwood, ebony, brass, bone, glass
30 × 41.3 × 15.9 cm

This is a particularly fine example of Prisoner of War modelmaking and was probably made after 1815, when a number of prisoners are known to have stayed on in Great Britain, despite the end of the war, and carried on making objects for sale. Judging by the accuracy, detail and good proportions of the hull and rigging, the maker would have had access to scale drawings or was able to obtain the measurements of the ship itself.

The 120-gun warship *L'Océan*, originally named *Etats de Bourgogne*, was built to the designs of Jacques Noël Sane and launched at Brest in 1790. After further modification and several changes of name, she was eventually broken up in 1855.

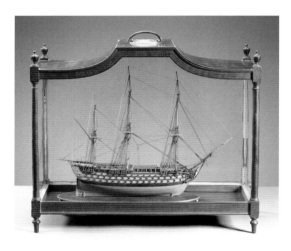

The model is displayed in an original and beautifully proportioned mahogany case, complete with a gilt-brass carrying handle and turned finials on top. Thanks to its case the fine but fragile rigging of the model has survived virtually intact.

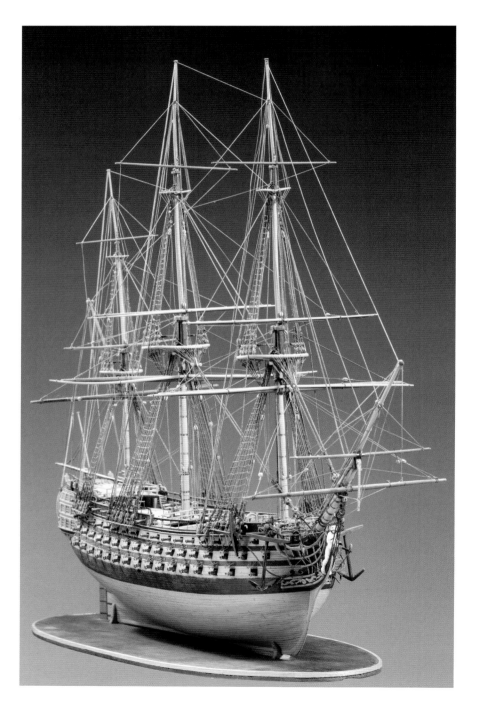

The ship's double wheel is positioned just forward of the mizzen mast and beneath the poop deck. The poop, the highest deck, is fitted with carronades on slides, while the quarterdeck and the three gundecks carry cannon on carriages. The carronade, named after the Carron Iron Founding and Shipping Company, was a short, lightweight gun that could fire a heavy shot over a short range using only a small propellant charge. The gun made a name for itself in the close ship-to-ship combat during the Napoleonic Wars, becoming known in the British Navy as 'the smasher'.

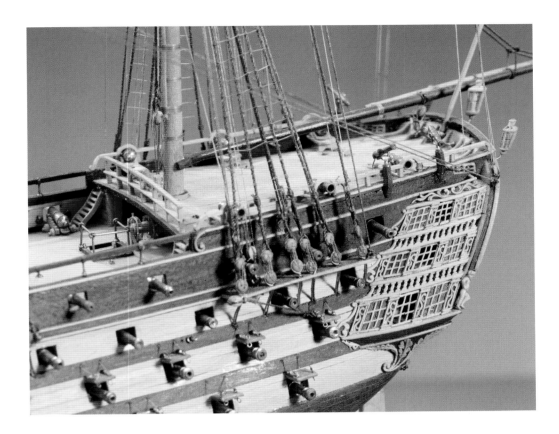

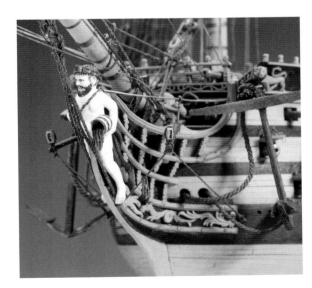

The figurehead is carved in bone and depicts a man pouring water from a bucket, personifying the Ocean. The dark planking between the rows of guns is known as the wales. They were additional timbers providing longitudinal strength.

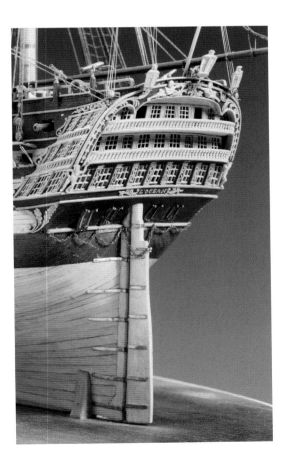

The name, *L'Océan*, on the lower counter must date from after 1806, when the *Etats de Bourgogne* was renamed. However, other features, including areas of the rig, date from an earlier part of this ship's career. Such a mixture is not uncommon in Prisoner of War models.

## 21

### French 18-gun corvette

Prisoner of War model
Great Britain, probably made by French sailors,
c. 1795–1815
Wood, brass, straw, textile, bone
31 × 40.5 × 15.5 cm

This is a small, delicate model of a corvette, as operated by the French Navy. As so often in Prisoner of War models, the proportions of the rig are exaggerated, especially the height of the masts. The planking is a mixture of boxwood and ebony, pinned to a series of wooden frames.

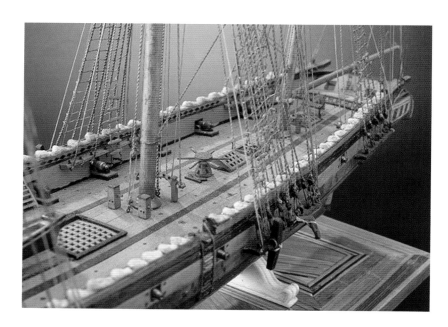

The ship's guns are carronades on wooden slides. She has a single capstan, between the masts. Cream-coloured hammocks are stowed along the top of the bulwarks in nettings.

The anchor is rigged with a black conical 'float' tied to the shrouds. The float served both to mark the position of the anchor on the seabed and as a means of 'tripping' the flukes of the anchor if it became snagged during retrieval. The model is mounted on bone crutches secured to a wooden baseboard decorated with coloured straw.

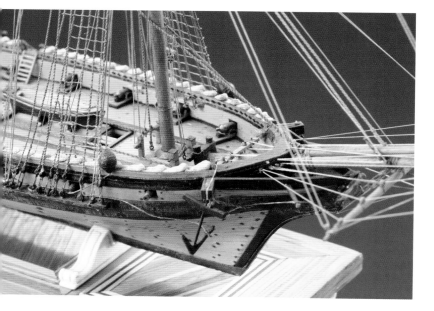

The figurehead is a typical classical soldier, carved from a single piece of wood and varnished.

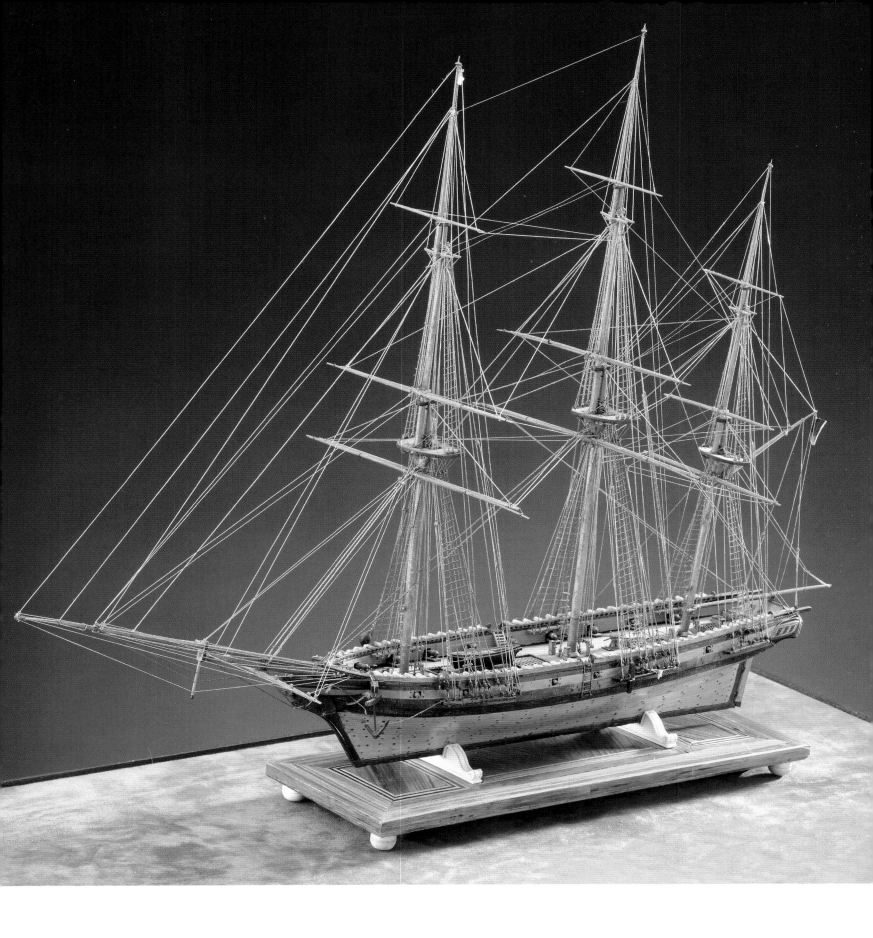

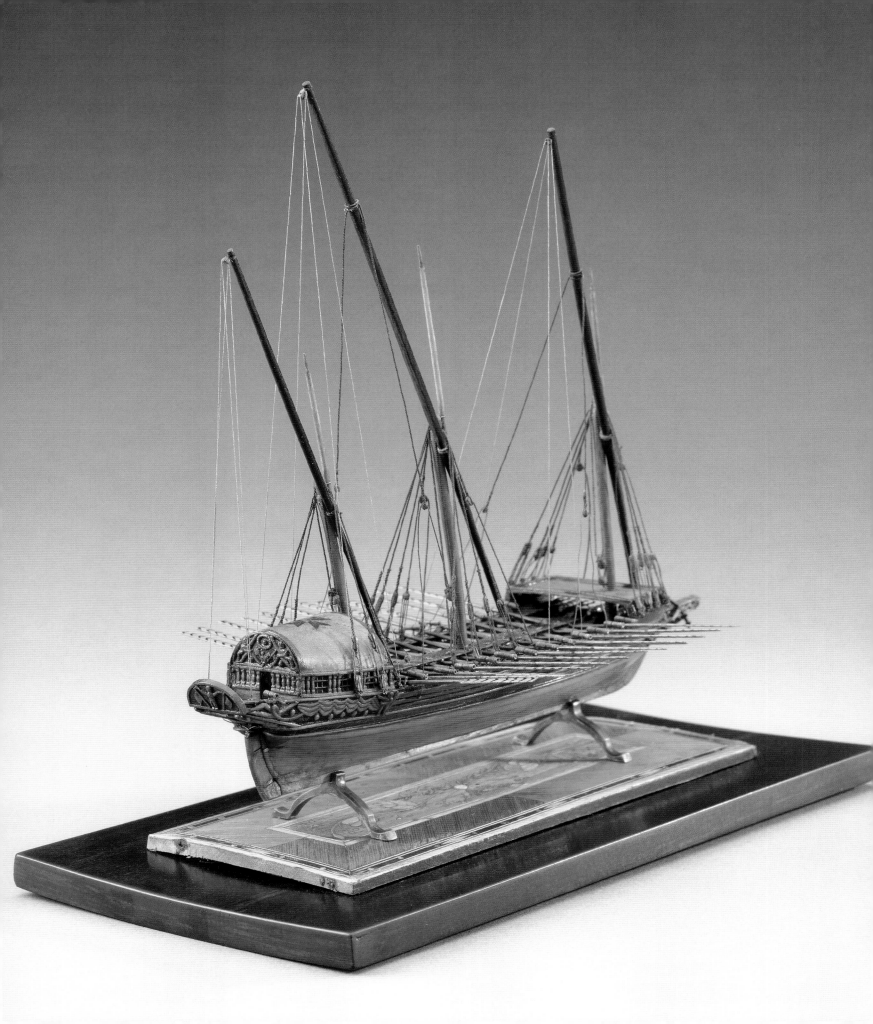

# Maltese fighting galley

Prisoner of War model
Great Britain, probably made by French sailors,
*c.* 1795–1815
Wood, boxwood, brass, straw
20 × 20 × 11 cm

The single tier of oars, located below the gundeck for practical reasons of space and operation, was manned by slaves and prisoners. The crew manned the guns and managed the rigging. The combination of sail and oar gave these vessels an advantage against larger sailing warships during very light airs or flat calm conditions.

These vessels were very fast both under sail and rowed by oar. Their three-masted lateen rig was commonly used in the Mediterranean and could be handled by a smaller crew than was required for the more complex square rig.

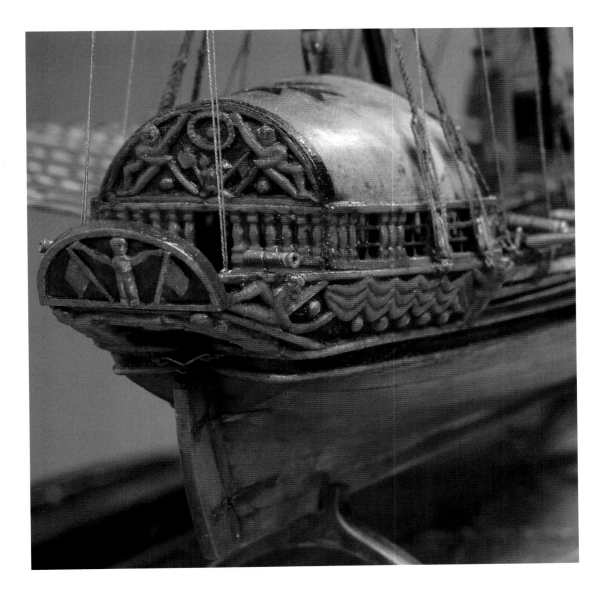

The long protruding bow was sometimes used for ramming enemy ships as well as constituting an important part of the long and shallow hull. The wooden hulls of these galleys were of carvel construction, that is, edge-to-edge planking on sawn wooden frames, which was easier than clinker to build, maintain and repair in a ship of this size. The forecastle is armed with several large guns trained forward while slightly smaller guns are mounted along the hull on either side.

The stern cabin was normally built in wood with large iron hoops supporting the canvas roof. This model has a Maltese cross painted on the canopy as well as a large amount of carved decoration on the transom and cabin bulwarks.

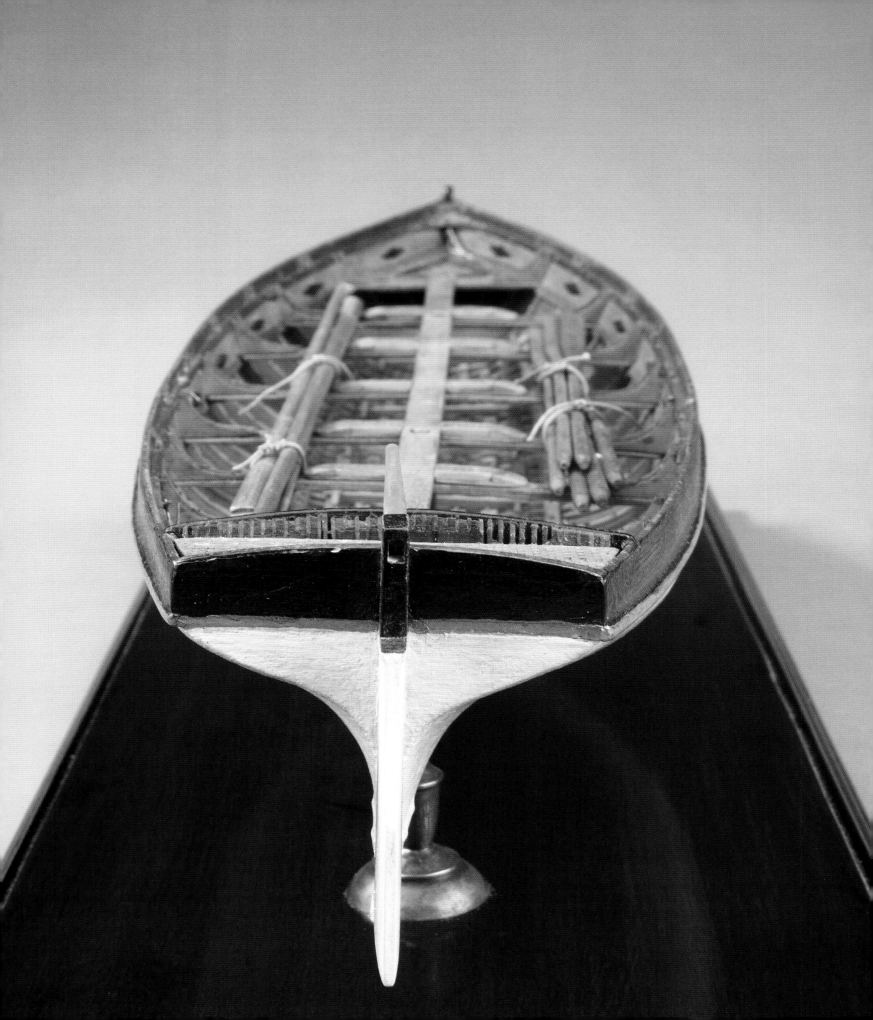

# Small craft and life boats

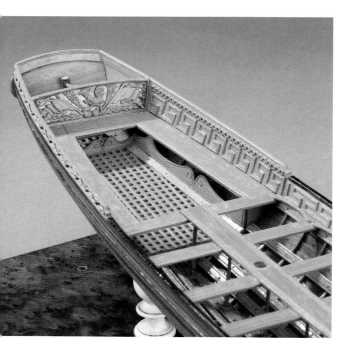

## 23

## French 32-foot open boat:
## *La Patience*

Georgian or Prisoner of War model, scale 1:32
Great Britain or France, *c.* 1800
Wood, brass, bone
5 × 31 × 7.1 cm

As far as we know a vessel of this name never existed, and it is anyway very unusual to find the name displayed on the transom of a craft of this kind. It was perhaps a whim of the modelmaker, wanting to declare one of the virtues essential to the craft of modelmaking. In its general layout and decoration the model is similar to the large rowing and sailing barges that were in use during the Napoleonic period (1795–1815). It depicts a hull 32 feet in length, of clinker build – which was both light and strong, though not so easy to repair as the heavier, edge-to-edge planking of carvel construction. Such craft were used either for general duties carrying men and stores or for the private use of high-ranking officers or civilians; the ornate carved decoration suggests the latter in this case.

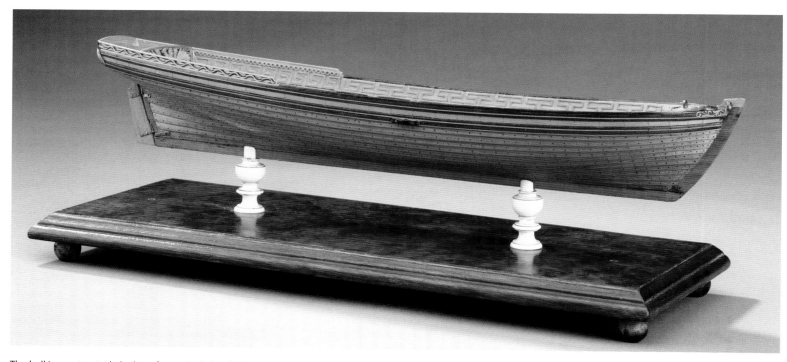

The hull is constructed plank on frame in clinker fashion with the wale, transom, inwale and gunwale made from a darker wood such as ebony. Just below the black line of the wale is a small wooden clamp, which would probably hold wooden shores or legs to keep the hull upright at low tide.

This vessel was rigged with two masts carrying lugsails and with a bowsprit held in place by brass ring-clamps on deck and on the port side of the stem. Running along the centre of the hull and above the rowing thwarts is the gangplank, which provided a walkway for the passengers to the stern area from the bow. The benches in the stern are surrounded by carved decoration on the inwales as well as the backboard, which is complete with a French cockerel and war trophies on a red background. The coxswain operated the tiller from just behind the backboard, either standing or sitting on a raised seat to obtain a clear view ahead. Notice the nicely finished kickboards under the seating, which stopped the movement of water in rough conditions and protected the frames and planking from damage by foot.

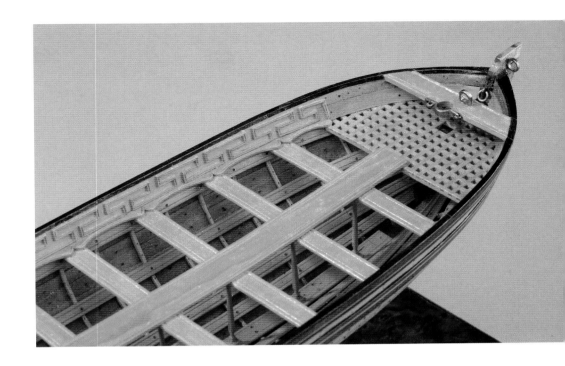

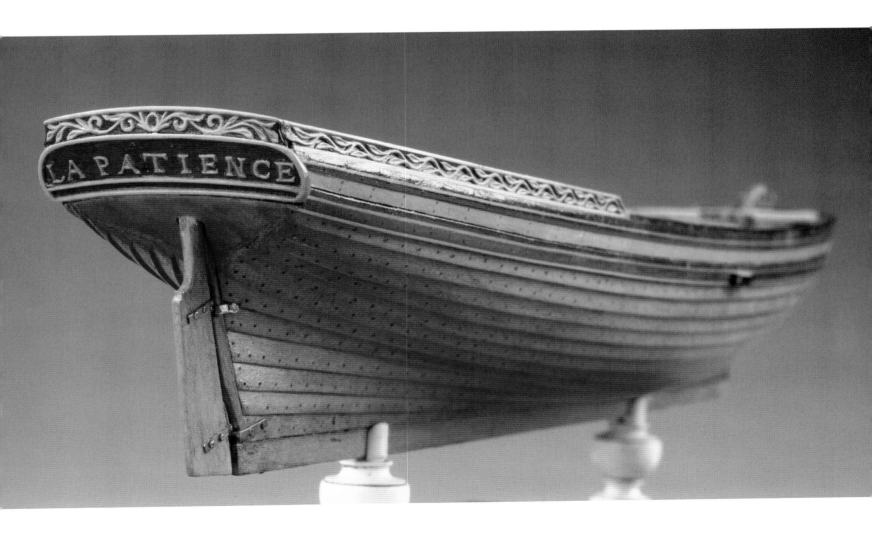

## 24

# British rowing and sailing
# 38-foot gunboat

Georgian model, scale 1:24
Great Britain, *c.* 1790–1800
Wood, brass, ebony
9 × 46.7 × 11.4 cm

The large carronade is mounted on a heavy wooden base which
can be moved across the hull and turn in either direction, giving a
180° arc of fire. There are also six swivel guns mounted on hexagonal
trunks; these could be operated by the crew when under attack
from the shore. They are removable, and when the vessel was
under sail would be stowed on the floor of the hull along the keel,
providing extra ballast. The hull is complete with a small foredeck
and hinged seating in the stern, under which would be stowed the
ammunition for the guns and small arms. Also included are the
metal mast-clamps on the two thwarts amidships and in the bow,
as well as the large eye fixed to the stem head to rig a bowsprit.
The upper strake is built for eighteen rowing positions, with
removable 'poppets' for use under oars.

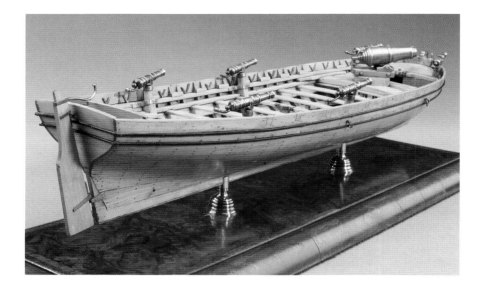

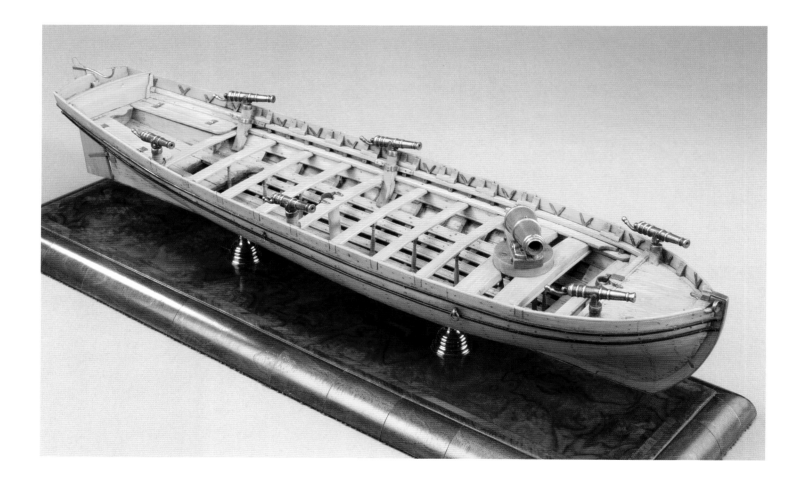

Small craft and life boats

The use of rowing and sailing gunboats by the British Navy became more common with the growing need for amphibious landings by troops in both Europe and North America. They were also employed to protect and patrol the bays and harbours of the British coastline, and were armed either with a single carronade and small swivel guns, as shown in this model, or with a larger cannon on a sliding carriage. It is thought that they were adapted from the troop-landing rowing boats (see no. 5) and the large sailing cutters and launches of the eighteenth century, all of which were broad in the beam and had a flat shallow hull.

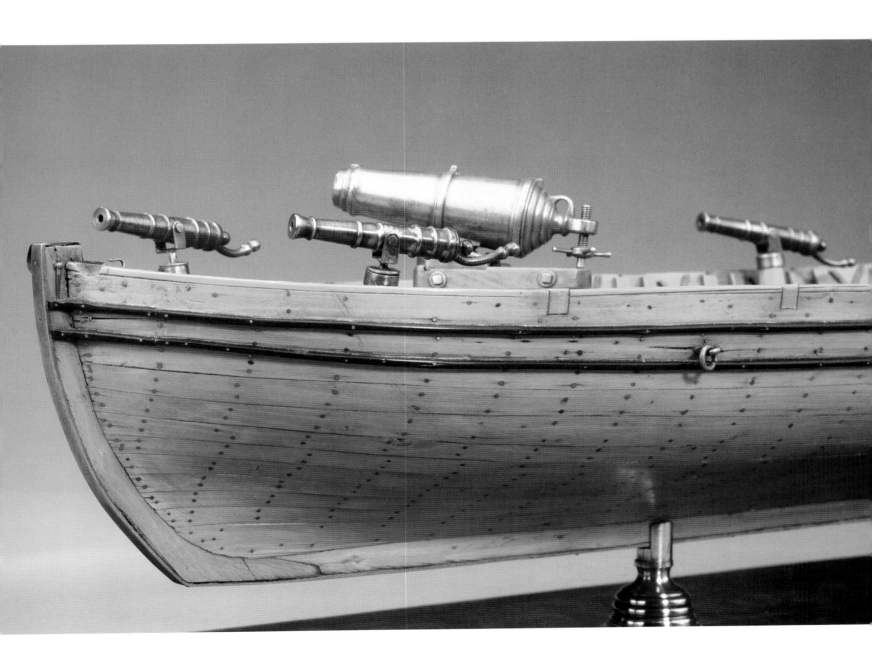

## 25
## British Navy 30-foot gig

Builder's model, scale 1:24
Great Britain, c. 1850–80
Wood, brass
4.2 × 39 × 7.4 cm

Gigs came into use in the British Navy in the 1760s, for carrying aboard the Revenue Service cutters stationed around the coast to suppress the smuggling trade. These fast and light boats were rigged with two masts, carrying a lug foresail and a mizzen. During the Napoleonic Wars captains found these boats more convenient, with their greater speed and superior handling, than the heavier and clumsier barges otherwise used. By the nineteenth century the gig was a standard part of the complement of boats carried on larger warships. In some cases the gig was the private property of the ship's captain and used for his own transport to and from the ship.

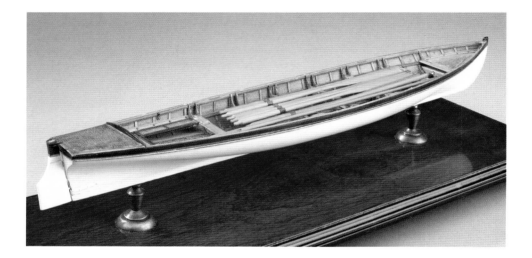

The wooden gratings in the bow and along the floor of the hull prevented the build-up of surface water and reduced the risk for the crew and officers of slipping while stepping on and off the craft during bad weather.

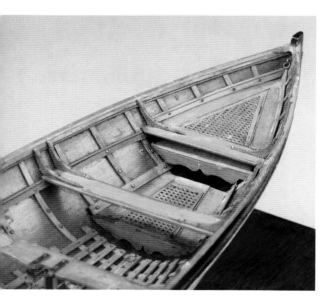

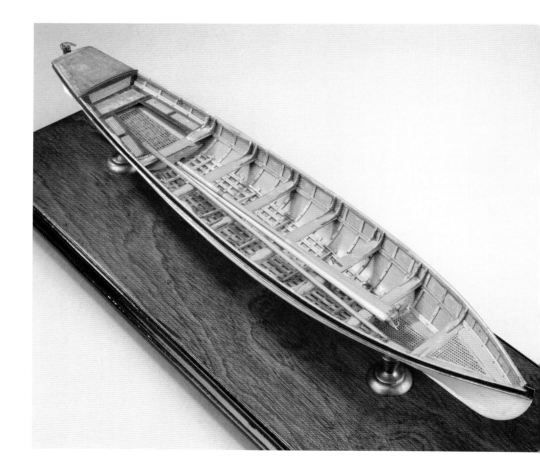

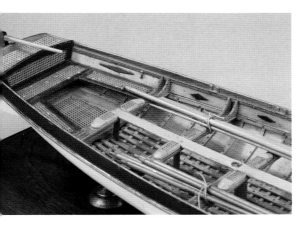

## 26

## British Navy 34-foot launch

Builder's model, scale 1:24
Great Britain, c. 1850–80
Wood, brass
6.5 × 46 × 11.4 cm

The launch was originally designed for use in the royal dockyards. Carvel-built, very beamy and fairly flat in section, it was mainly used for carrying large, heavy equipment such as hawsers, small guns, water casks and stores, as well as personnel. By the nineteenth century these large, heavy boats were also part of the complement of warships, the largest ships sometimes carrying as many as ten. The model shows two mast positions, which would have been rigged with large, dipping lug sails. Along the centre line of the hull are fitted 'gangboards', which facilitated access from the bow to the stern and surrounding thwarts. The small wooden grating pads on each side of each thwart raised the oarsman a little higher and gave him a drier seat.

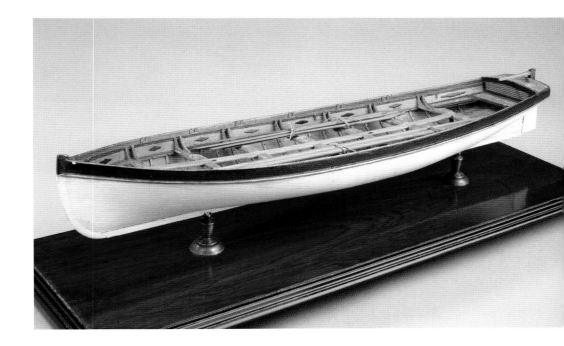

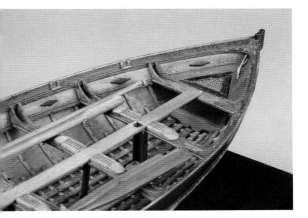

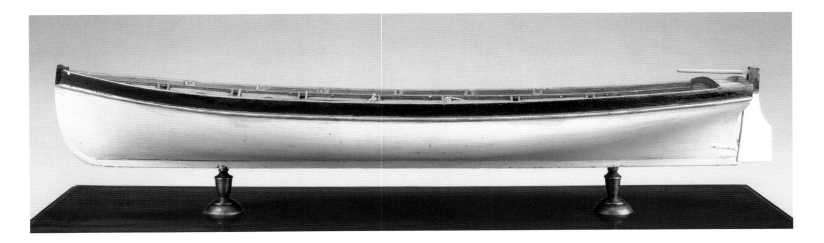

## British self-righting pulling and sailing lifeboat: *Christopher Brown*

Presentation model, scale 1:16
Great Britain, 1868
Wood, cork, brass, silk, silver
15.5 × 63 × 14 cm

The British Royal National Lifeboat Institution was founded in 1824. Funded by voluntary contributions from the public, it established a fleet of lifeboats around the country. In 1851 an international competition was held to find the best design for a lifeboat, and was won by James Beeching of Great Yarmouth with a double-ended, self-righting vessel. Following several improvements and modifications by other designers, the new boat was adopted by the Institution. This is the boat illustrated in the present model. The boats could be launched down a slipway from a lifeboat house, or carriage-launched on a beach into the surf, or float at anchor in a harbour. Such was the success of this design that over 450 were built over a period of about fifty years. The *Christopher Brown* represented in the model was stationed at Penmon in Anglesey (Wales) from 1868 to 1880; during its career it went to the aid of many vessels and saved twenty-four lives. The model is a presentation model, given by the Institution in appreciation of a generous donation.

The rudder was normally raised or 'triced up' before launching so as to prevent damage to the blade. Once in deeper water it was lowered and steered by the coxswain using the rope lanyards attached to the yoke.

The engraved silver plaque with a rope surround was presented in thanks together with the model to the donor Christopher Brown, Esq., after whom the boat itself was also named.

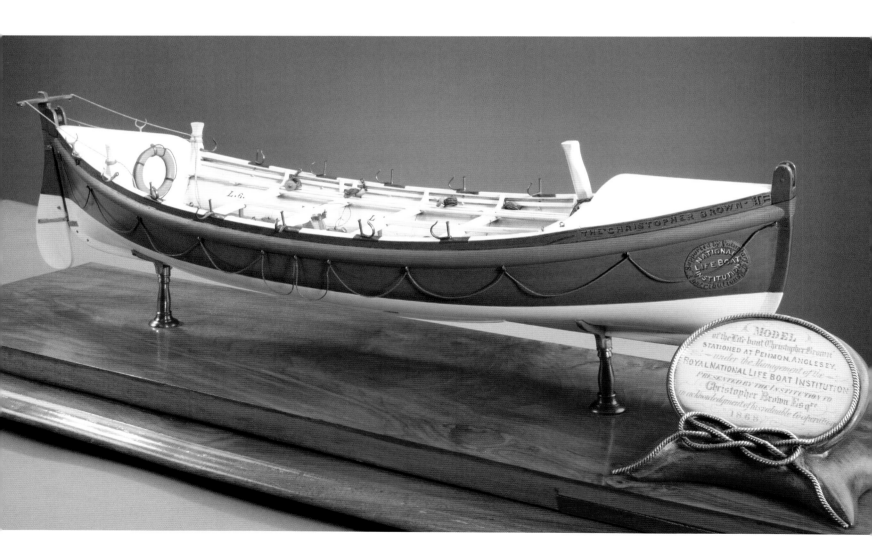

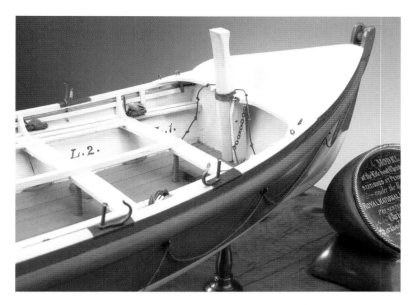

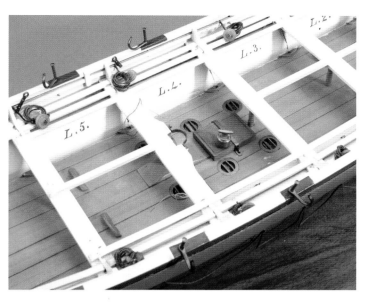

At both the bow and stern the boat had sealed air cases, which, if the boat were overturned, would raise the hull, rendering it unstable, so that eventually it would right itself. A removable towing bollard could be set up in the forward mast tabernacle when the boat was under oars, either in order to seat a drogue (sea anchor) to keep the boat's position or to tow casualties to a safe place.

For additional buoyancy, besides the two large sealed air cases at bow and stern there were a number of smaller air cases (numbered L.5. – L.2.) fixed under the side benches and rowing thwarts.

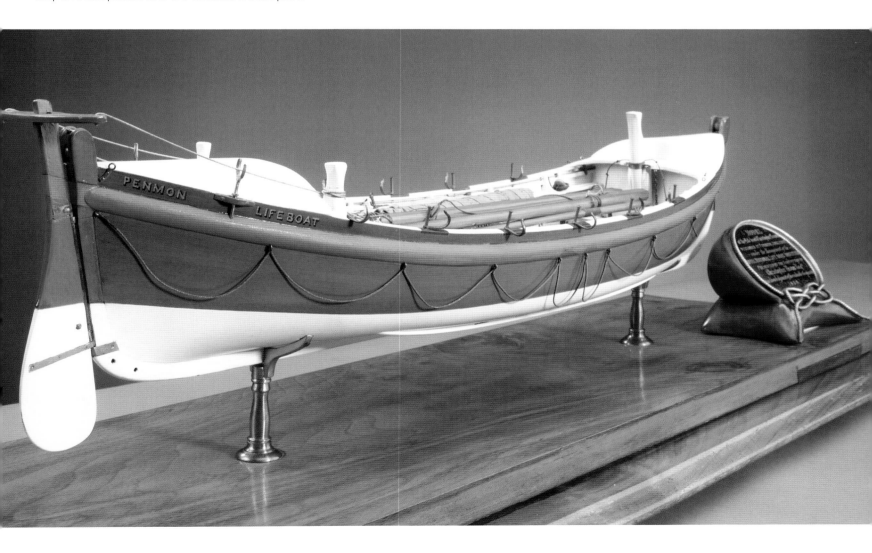

## 28

## British non self-righting pulling and sailing lifeboat

Builder's model, scale 1:12
Great Britain, c. 1890
Wood, cork, metal, silver, silk, cotton, paper
67.2 × 91.5 × 28 cm

Because of the sheer, or curve, of the hull towards the bow and stern, wooden pads were added to the rowing thwarts to enable the crew to operate the oars effectively.

A set of eight circular relieving tubes with one-way valves were fitted amidships to drain the deck of water if the boat should be swamped by a large wave. The coiled ropes are fitted with circular cork floats and were used as lifelines for the oarsmen.

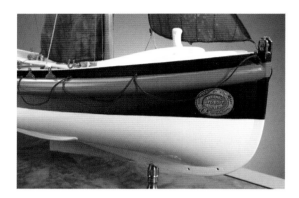

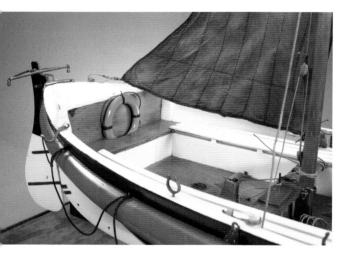

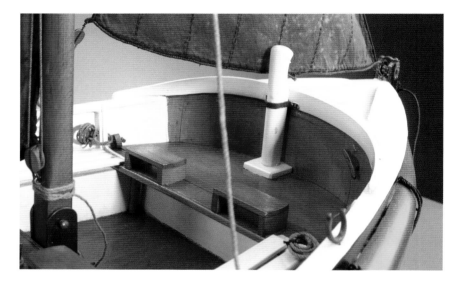

The badge of the British (later Royal) National Lifeboat Institution on the bow states that the Institution is entirely funded by voluntary contributions, as indeed it still is today.

The hull is fitted with a large half-round fender, painted red, which, made of cork and wood, provided extra buoyancy in rough conditions. The grablines hanging over the fender were for survivors in the water to hang onto while the crew tried to manhandle them aboard.

Small craft and life boats

The Liverpool Class of lifeboats, re-designed by Watson, were very versatile, and could either be moored afloat or launched from a carriage on a beach, depending upon the local terrain. The sail plan was that of a two-masted standing lug rig with a foresail. To counteract leeway, or the pressure of the wind blowing the hull sideways, a pair of steel drop-keels could be lowered through the centre of the boat once it had been launched.

The British Royal National Lifeboat Institution had for many years adopted a standard self-righting pulling and sailing lifeboat for their fleet (see no. 27). In 1887, appointing the yacht designer George Lennox Watson as its first consultant naval architect, the RNLI looked again at the design and use of these self–righters. Watson favoured better sailing qualities over self-righting capabilities and re-designed the hull lines of the old Liverpool class of lifeboat (designed by Thomas Costain in 1828), also increasing the sail area and adding twin drop-keels. All these improvements provided a longer service afloat under sail. The present model, representing Watson's new design, was built on a larger than usual scale of 1:12 and was probably made to illustrate the design to the Board of the RNLI. Thus it differs from the more common presentation models given by the Institution to individuals in recognition of their donations (such as no. 27).

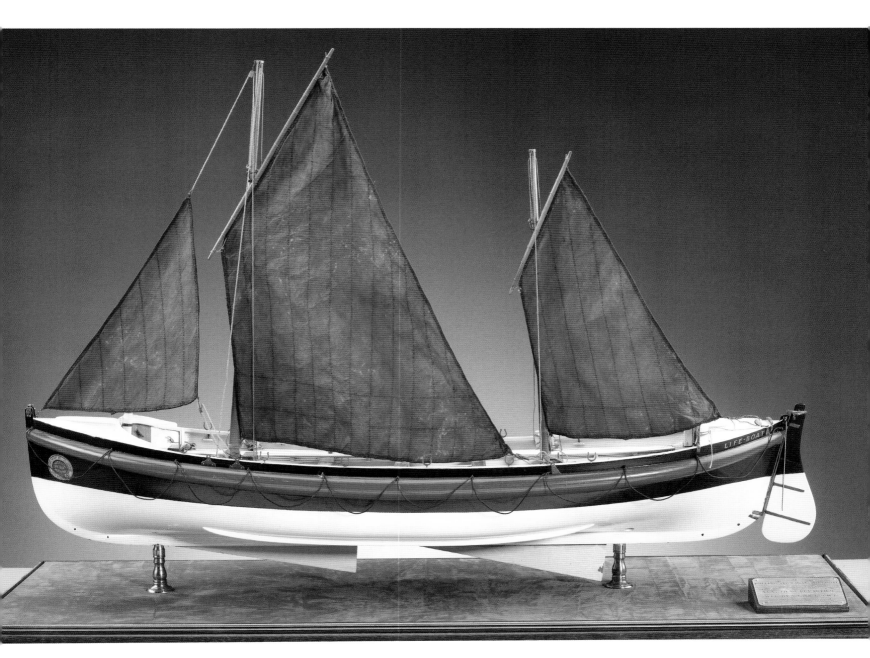

## Sail and steam

The first half of the nineteenth century was an important time for the technical development of the ship. The emergence of iron and later steel allowed both changes in the shape and increases in the size of the hull and the advance of the steam engine. It was the steam engine, together with the invention of the screw propeller, that was to make the greatest impact. Improved boilers were able to work at higher pressures, which would turn more efficient triple-expansion engines at greater speeds. Speed made possible, and economical, a greater range of operation.

Detail of no. 31
**British iron ship:** *Melpomene*

By the 1880s steam-powered ships were leading the global trade, especially in cargoes which required a fast route to market or special conditions such as refrigeration, but sailing vessels were not yet superseded. Their owners focused instead on bulk cargoes, for example nitrate and wool, for which market freshness was not paramount but which were equally profitable. Trade under sail would continue well into the early twentieth century, and for a long time steam ships continued to carry sail as a secondary means of propulsion. However, the emergence of twin- and triple-screw ships and the ever greater reliability of engines eventually made masts and sails superfluous.

Detail of no. 32
**British sail and steam
passenger liner: *Golconda***

29

# British steam and sail corvette

Builder's model, scale 1:48
Great Britain, c. 1862
Wood, metal, gold-plated fittings
23 × 117 × 26 cm

Amidships there are five cannons on wheeled carriages on either side, and at the stern (and bow) a large pivot gun that could be moved from one side of the ship to the other on a system of raised metal rails.

Corvettes were single-decked, three-masted ships (the rig is omitted but the mast positions are indicated by stumps), with a hull shape that resembles that of a fast clipper. Because of their speed they were used for duties such as scouting, despatch and repeating a signal from ship to ship. They were able to operate as independent warships, crewed by up to 170 men, and were fitted with a variety of armaments. Both the dimensions and the ordnance depicted by this model tend to agree with the *Archer*, originally launched as a sloop in 1849 and re-classed as a corvette in 1862.

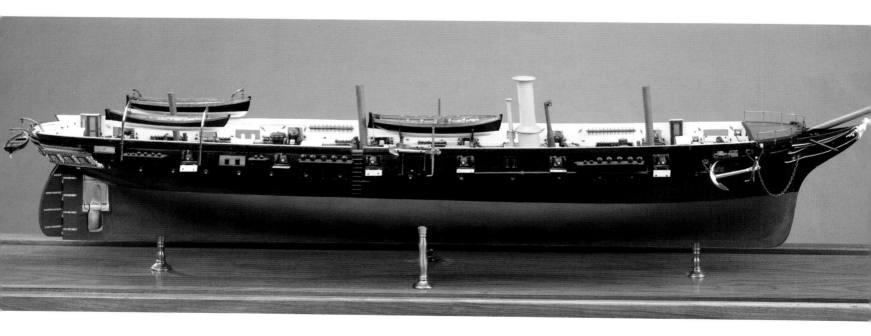

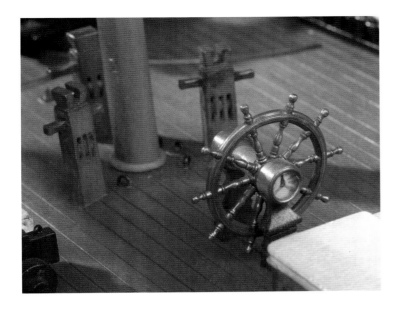

The centre of the steering wheel is fitted with a helm indicator, showing the angle of the rudder when the ship is underway.

The single screw is mounted in a frame which can be lifted into the hull so that, when the ship is under sail, it will not create drag. A small dinghy, rigged to a pair of davits over the stern, could be launched quickly in case of emergency, such as a man overboard.

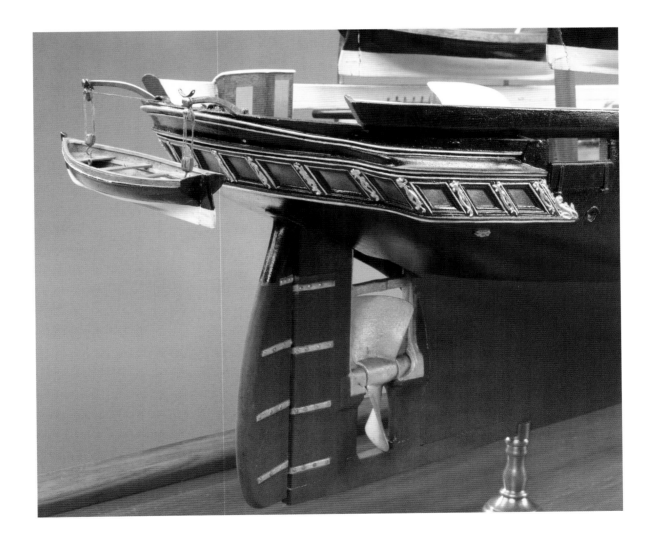

30

**American Confederate raider:**
*Florida*

Builder's model, scale 1:48
Great Britain, 1861
Wood, metal
25 × 129 × 20 cm

Made in secret by Bulloch & William Cowley Miller, Merseyside, in 1861, *Florida* was the first warship built under contract for the American Confederate Navy. The design was based upon a British naval gunboat. She was commissioned into the Confederate Navy in August 1862, and between March 1863 and June 1864 the *Florida* captured or destroyed thirty-seven Union vessels and cargoes valued at over $3.5 million. *Florida*'s most lucrative capture was the *Jacob Bell*, which she intercepted off the Bahamas in 1863 carrying a cargo of tea (valued at over $1.5 million at the time) as well as 10,000 boxes of Chinese firecrackers destined to be sold before the July 4 celebrations that year.

 *Florida*'s career ended when a Union warship, *USS Wachusett*, rammed and captured her, illegally, in Bahia harbour, Brazil, in 1864. She was towed back as a prize to Hampton Roads, Virginia, and later that year sunk mysteriously on her moorings.

The propeller frame is fitted with chains for raising the propeller, preventing drag when under sail.

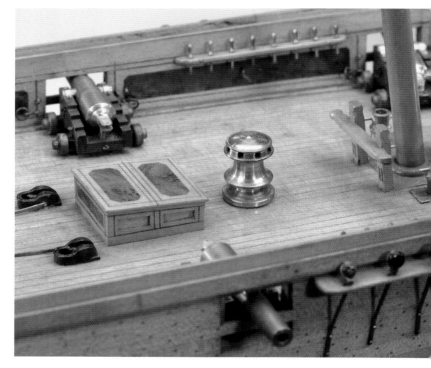

The Florida was fitted with cannons on wheeled carriages as well as with two large muzzle-loading guns on sliding carriages.

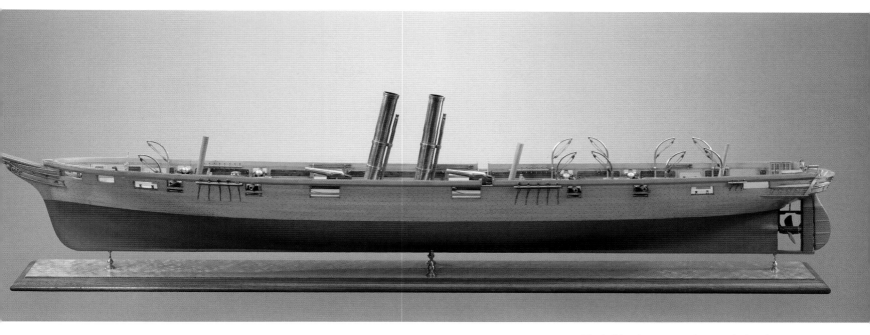

The hull has been painted copper below the water line to indicate the original copper sheathing. The two funnels are of riveted construction

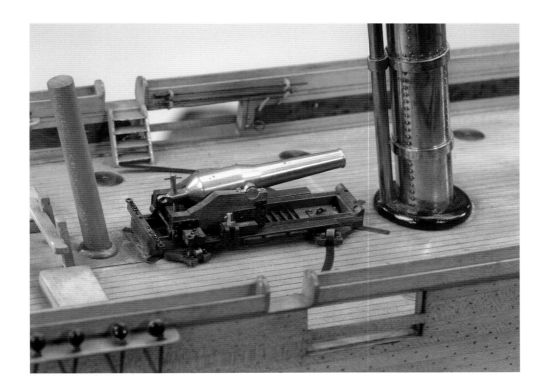

The carriage of the large muzzle-loading gun is manoeuvred by wheels on raised rails set into the wooden deck. Notice the wider gunports, which allowed a greater arc of fire, forward as well as broadside.

31

# **British iron ship:** *Melpomene*

Builder's model, scale 1:48
Great Britain, 1876
Wood, metal, bone, fabric
106 × 182 × 43 cm

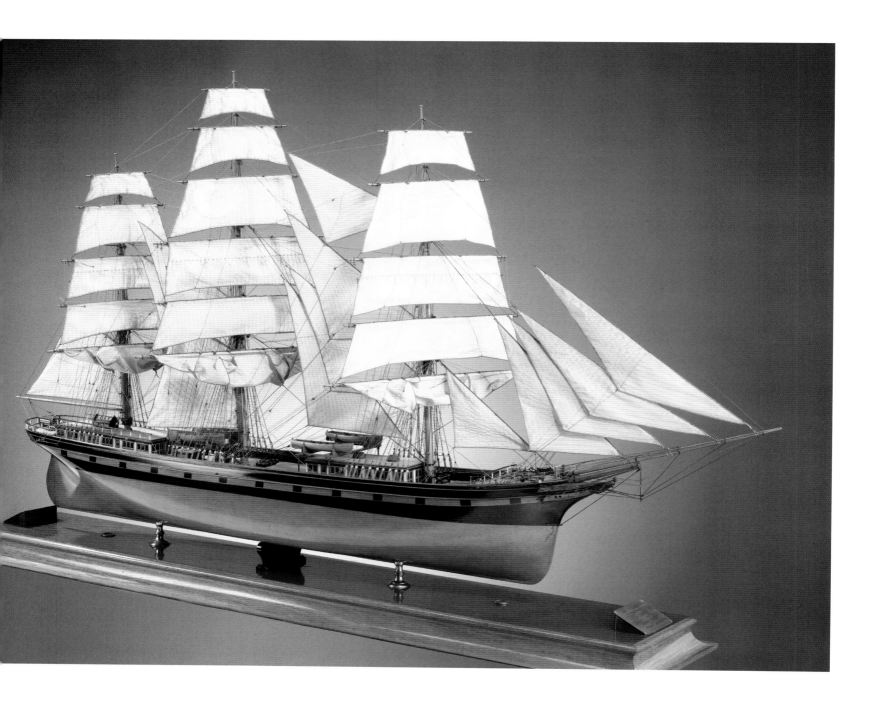

The *Melpomene* was originally built as a three-masted square-rigged ship in Sunderland by Osbourne, Graham & Co. for T. Scott & Co. in 1876. In 1889 she was re-rigged as a barque, the square sails on the mizzen or after-mast being replaced by two triangular sails. She was sold in 1890 to H.N.A. Meyer of Blankenese (Hamburg), Germany, and in 1894 she was lost by fire.

The model is rigged with a full suit of sails, including staysails between the masts. It has passenger accommodation above and below the main deck, and clinker-built lifeboats stowed on cradles above deck. Fake gunports have been painted along the hull.

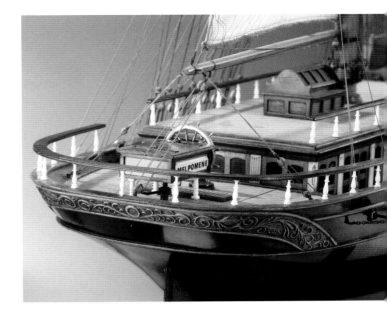

The carved figurehead represents the Muse of Tragedy, Melpomene.

The ship's name is painted on the steering-gear box cover.

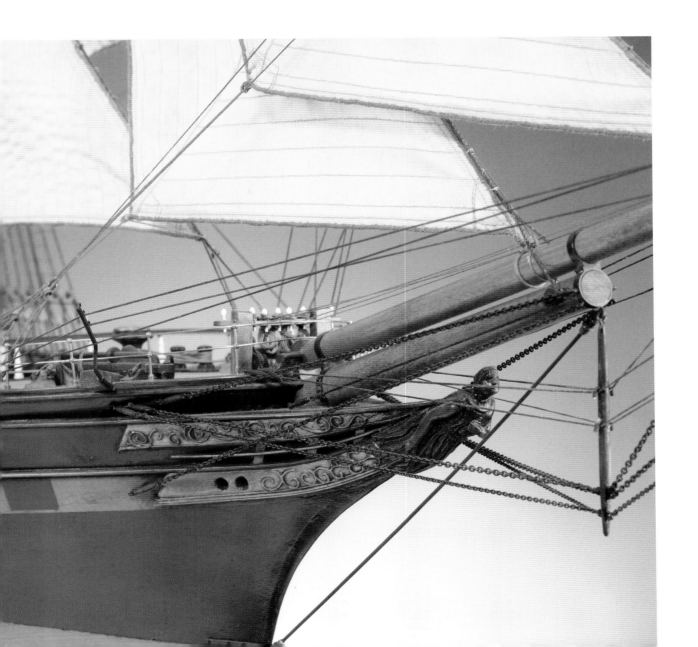

## 32

## British sail and steam passenger
## liner: *Golconda*

Builder's model, scale 1:48
Great Britain, 1887
Wood, metal, gold-plated fittings
92 × 276 × 47 cm

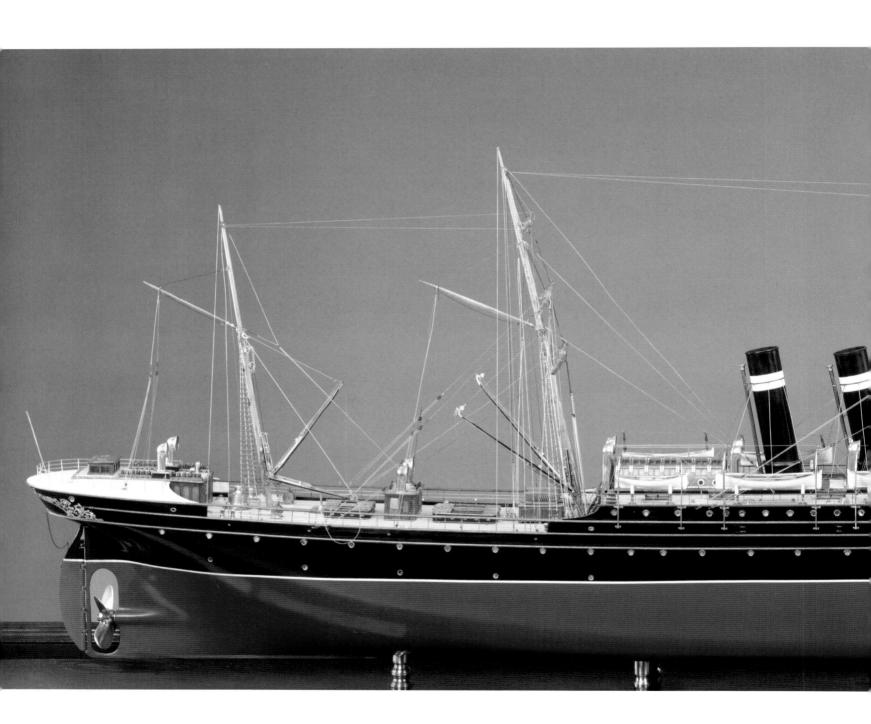

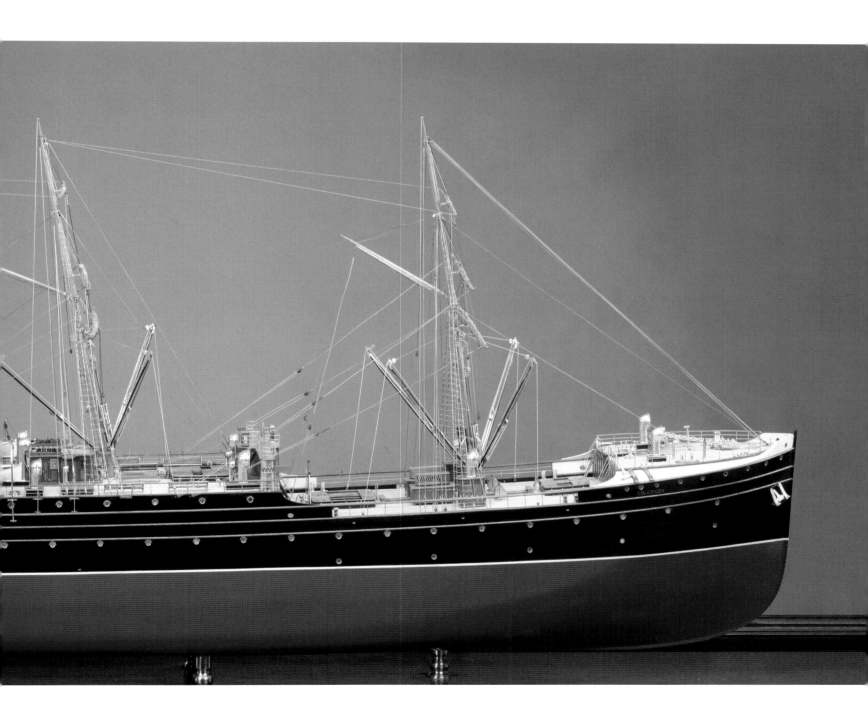

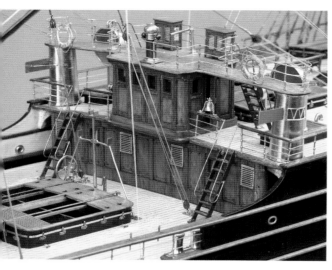

Bells were fitted on the forecastle and bridge for communication between bridge and bow.

This vessel was built by W. Doxford & Sons, Sunderland, in 1887, as the *Transpacific* for the Canadian Pacific Railway Co., intended for Vancouver–Hong Kong service. She was instead sold to the British India Steam Navigation Co. Ltd., London, for the London–Calcutta service and re-named *Golconda*. Considerable alterations were made to adapt her for this service, including the whaleback deck around the accommodation at the stern. *Golconda* was the largest ship in the British India fleet for fifteen years: she could accommodate 80 first-class and 28 second-class passengers, and her vast cargo capacity earned her the nickname 'the Calcutta thief.'

*Golconda* is credited with the first stockless anchor (one with no crossbar) and the first hydraulic winches. In 1900, during the Boer War, she served as a transport, and in 1915 was purchased by the Indian Government to carry six hundred German and Austrian prisoners of war to England. In June 1916 she was sunk by a mine laid by the German submarine *U-C3* in the North Sea, with the loss of nineteen lives.

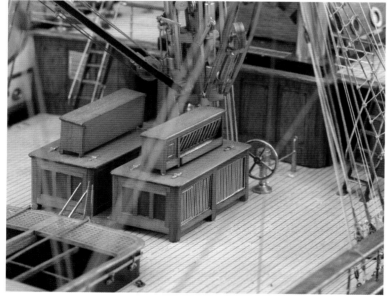

The cargo hatches are shown with their covers removed. On the fore and aft decks there are also chicken coops and livestock pens.

Each mast was fitted with derricks for hoisting the cargo.

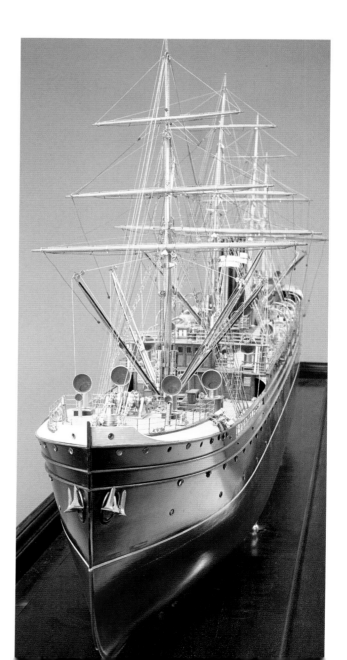

A large skylight aft of the funnels provides light and ventilation to the engine room below. At its four corners are ventilation cowlings. The lifeboats are hung on davits and stowed in the inboard position. The system of launching lifeboats from davits was introduced by the British Navy from the 1860s onwards.

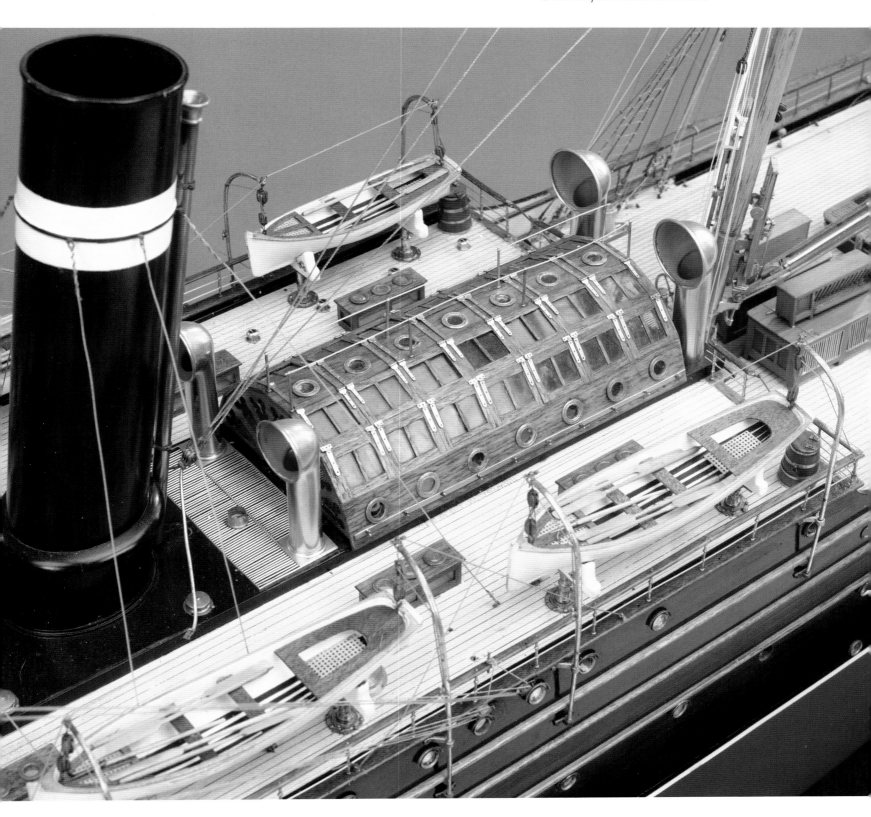

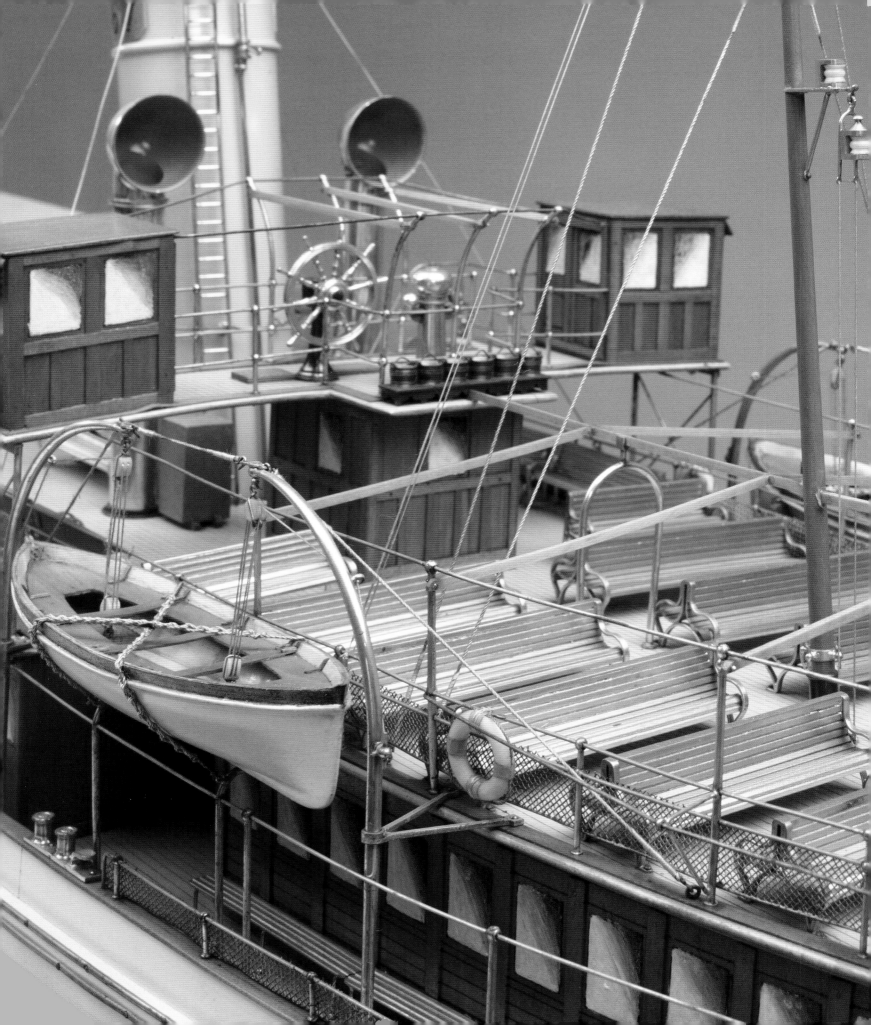

# Ferries

Detail of no. 35
**Turkish ferry steamers:**
*Bosphorus Nos. 67 and 68*

33

**British horse and cart ferry**

Builder's model, scale 1:48
Great Britain, c. 1880
Wood, gold-plated metal
21 × 66.5 × 29.2 cm

The horse and cart ferry was built by Smith's Dock Co. Ltd. in 1880 for the North and South Shields Ferry Co. It was one of more than twenty-six ferries on the River Tyne, connecting Newcastle, Tyneside and North and South Shields. The shallow broad-beam hull has paddles on both sides for greater manoeuvrability on a busy river.

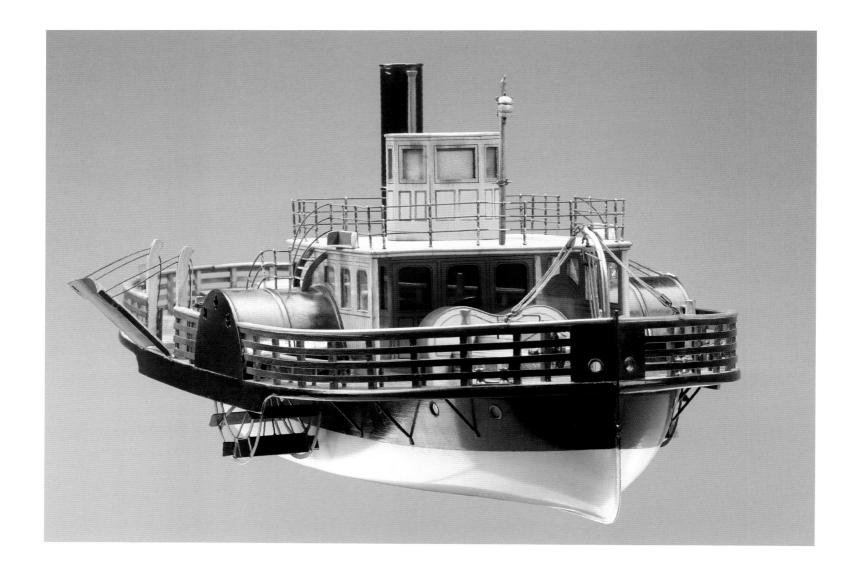

A detail of the foredeck (right) shows a large skylight and what may be a covered companion-way with a rounded roof – suggesting that the passengers had access to a saloon below decks. Alternatively the rounded forms may be a protective casing over the steam engine below.

The ramps are ribbed and convex-curving, preventing the accumulation of mud and water and so permitting less slippery access for hoofed animals such as horses and cattle from the landing stages.

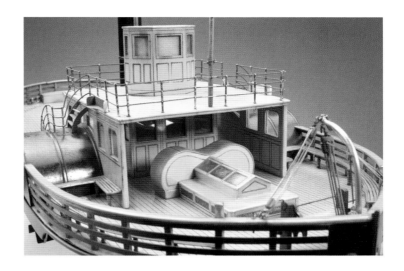

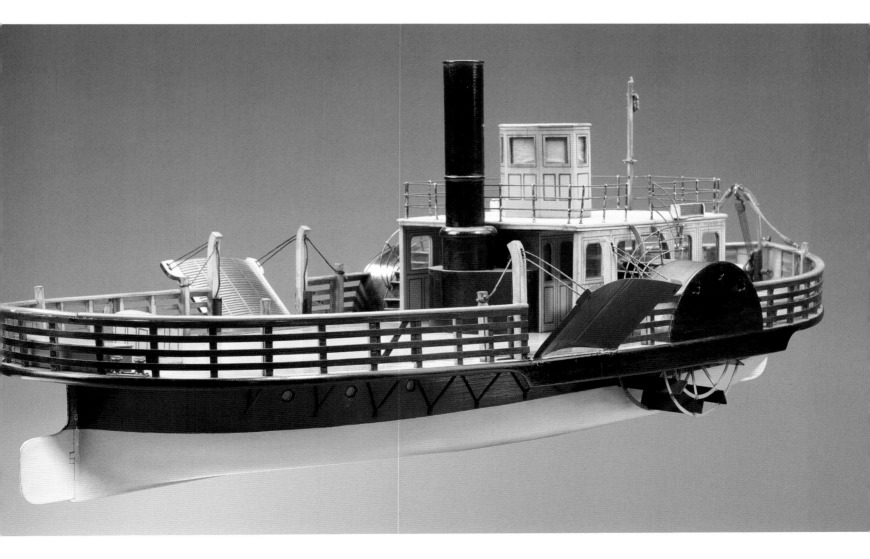

## 34
### Colonial river stern-wheeler

Builder's model, scale 1:48
Great Britain, *c.* 1890
Wood, metal, gold- and silver-plated fittings
30 × 78 × 25 cm

Two nearby pistons drive the stern paddles but the boiler with its funnel was located towards the bow, counterbalancing the weight of the machinery at the stern.

Shallow-draughted stern-wheelers were built in large numbers during the late nineteenth and early twentieth centuries and operated on most of the world's major river systems, including the Yangtze, Congo, Nile, Niger, Amazon, Zambesi and Ganges, and on lakes such as Titicaca, Tanganyika and Nyassa (Malawi). A company specializing in this type of vessel was Yarrow & Co. of London, who would supply them finished or ship them in kit form for construction at the final destination. This model bears a close resemblance to the *Tiddim*, one of several ferries built by Yarrow & Co. for the Irrawaddy Flotilla Company in the period 1905–08. Measuring 132 feet in length, it carried three classes of passengers as well as mixed cargo.

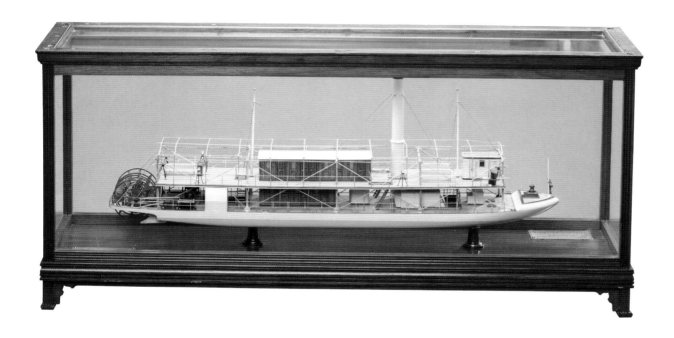

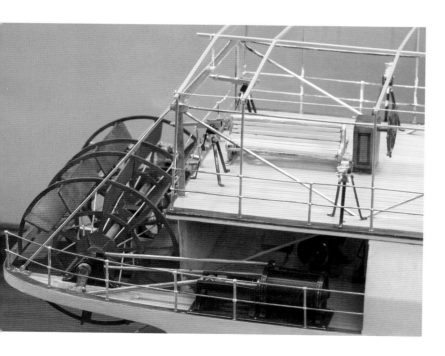

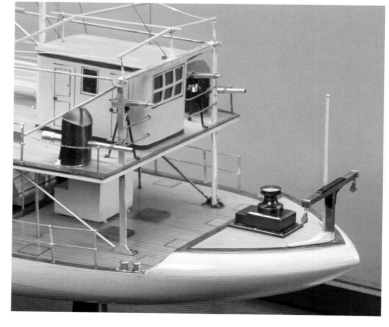

## 35

**Turkish ferry steamers:**
*Bosphorus Nos. 67 and 68*

Builder's model, scale 1:48
Great Britain, 1911
Wood, metal, gold- and silver-plated fittings
39 × 100 × 35 cm

This is the model for two vessels ordered in 1911 from R.& W. Hawthorn Leslie & Co. Ltd. by the Chirket-Hairie Co. of Constantinople. Designed for passenger service on the Bosphorus and the Sea of Marmora, the ferries had saloons for first- and second-class passengers arranged on two decks – the upper saloon shelter being removed in the summer months. There were also saloons exclusively for ladies.

*Bosphorus No. 67* was later re-named *Kalender*. She was hulked in 1981 and broken up at Tuzla in 1989. *Bosphorus No. 68* was later re-named *Guzelhisar*; she was hulked in December 1986 and left derelict at Tuzla from 1994.

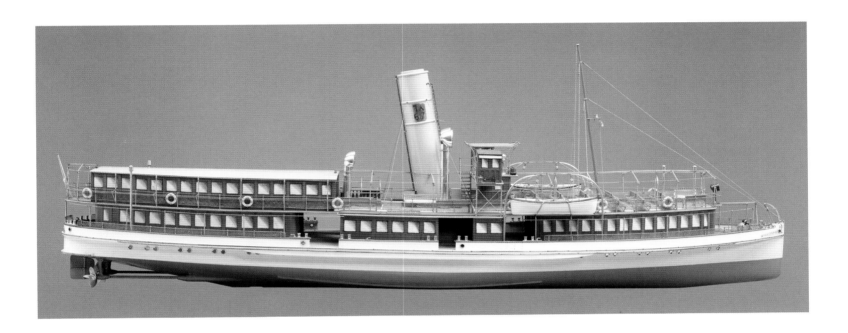

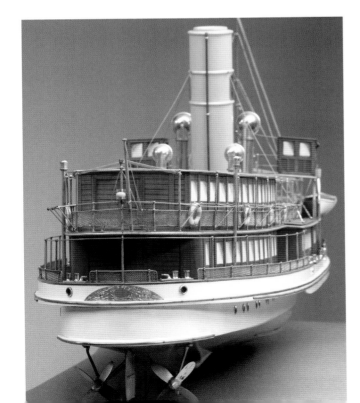

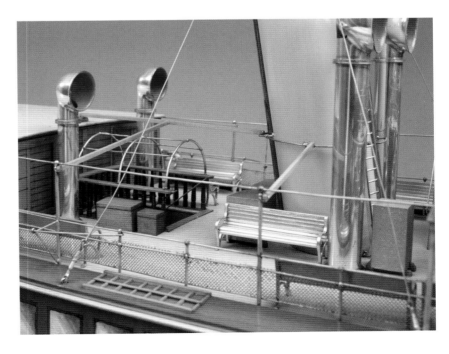

## 36
## Woolwich paddle-steamer ferries: *Squires* and *Gordon*

Builder's model, scale 1:48
Great Britain, 1922–23
Wood, silver-plated metal, copper, brass
29.3 × 110 × 38.2 cm

Although there had been a ferry service operating across the Thames at Woolwich in south-east London for many years, the Woolwich Free Ferry Service was officially opened on March 23, 1889 by Lord Rosebery, Chairman of the London County Council. Built by J.S. White & Co. Ltd. of Cowes in 1922–23, these vessels were named after two famous natives of Woolwich, General Gordon of Khartoum and William James Squires, mayor and local businessman. They had a crew of fourteen and operated between floating pontoons on the busy tidal river, carrying cars and lorries on the upper deck between the funnels and passengers on both decks. The two large paddles amidships were independently operated and provided excellent manoeuvrability, although the wooden blades were prone to damage from floating debris in the river. Having carried more than fifty-five million vehicles during their respective careers, the two ferries were replaced in 1963 by larger diesel-powered vessels.

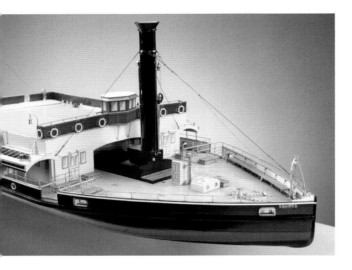

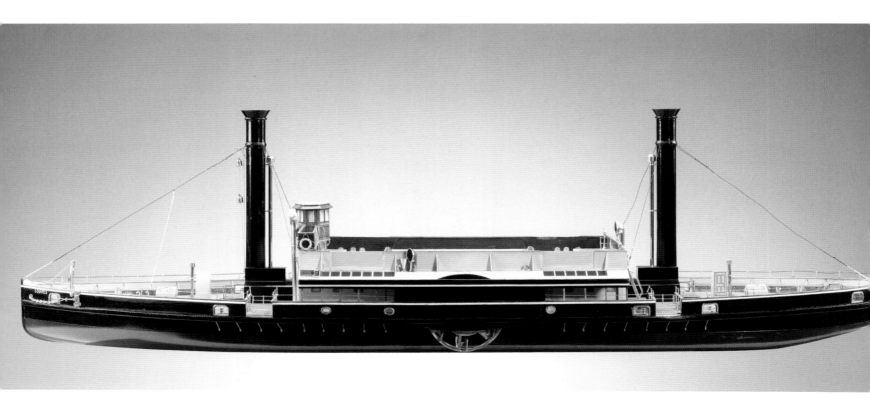

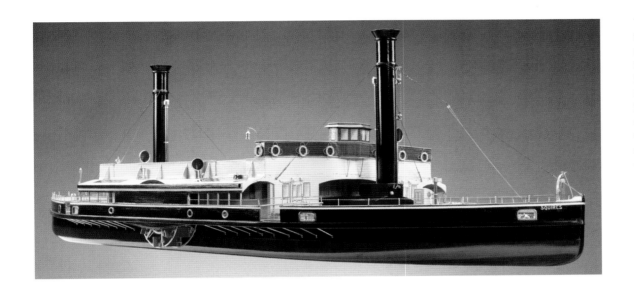

The shallow and wide hull allowed the vessel to be operated at most states of the tide as well as maximizing space for both passengers and vehicles. The high funnels provided the required updraft for the boilers as well as carrying the smoke and soot away from the decks. Notice also the large numbers of lifebelts stationed around the bridge and deck, a legal requirement for the carrying of passengers.

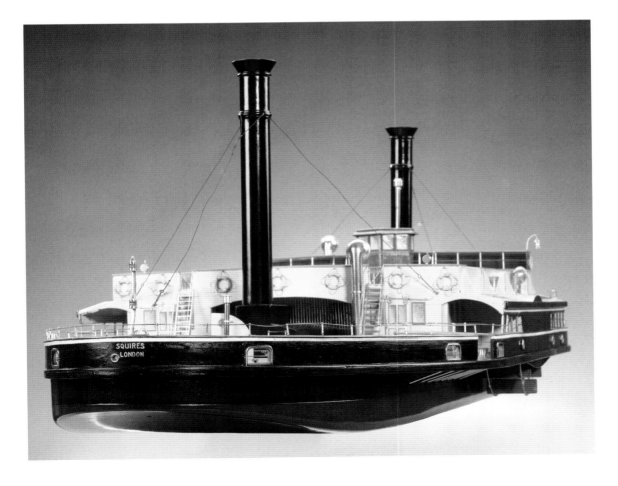

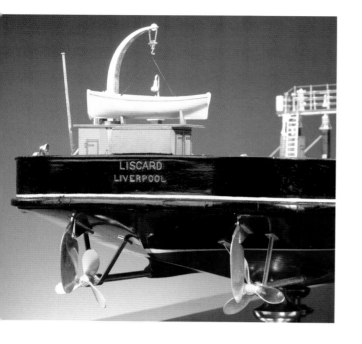

37

## British car ferry: *Liscard*

Builder's model, scale 1:48
Great Britain, 1921
Wood, metal, silver-plated fittings
32.5 × 96.5 × 38.5 cm

With the growing use of the motor vehicles between the World Wars, it became necessary to design and construct ferries that could cope with the traffic on busy crossings, for example on the River Mersey with its large complex of commercial docks. Built by J.I. Thorneycroft & Co. Ltd., the *Liscard* was one of five boats operating between Seacombe and Wallasey. She was able to carry about twenty-five vehicles together with foot passengers. Although not renowned for her passenger comforts, she also ran additional special cruise services when the demand for passenger traffic was high, especially during weekends. During the Second World War *Liscard* was taken over by the British Admiralty and fitted with large deck-cranes for the unloading of aircraft and heavy cargo being brought into the Mersey on the decks of merchant shipping. In 1946 she was sold and found work in Holland and Denmark, mainly as a crane ship.

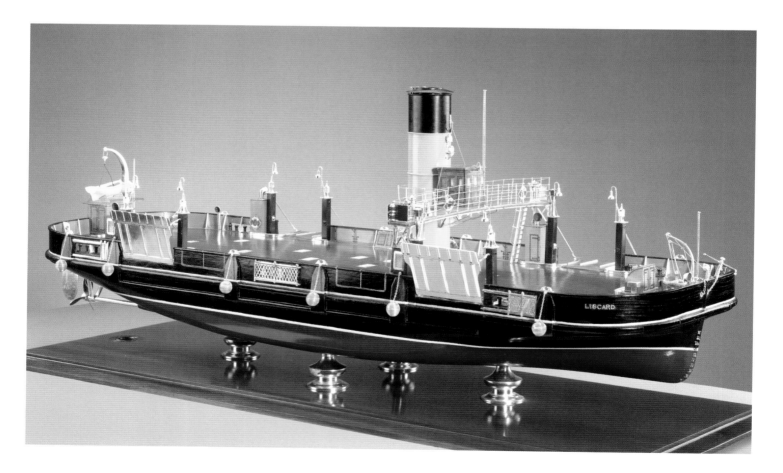

The model illustrates the shallow, flat hull needed to accommodate maximum deck cargo. The loading ramps are rigged up on the starboard side, facing the river and not in use, whilst on the port side they are lowered, one for disembarkation, the other for embarkation. Large round rope fenders, rigged on chains, prevented damage to the hull when coming alongside the pier or jetty.

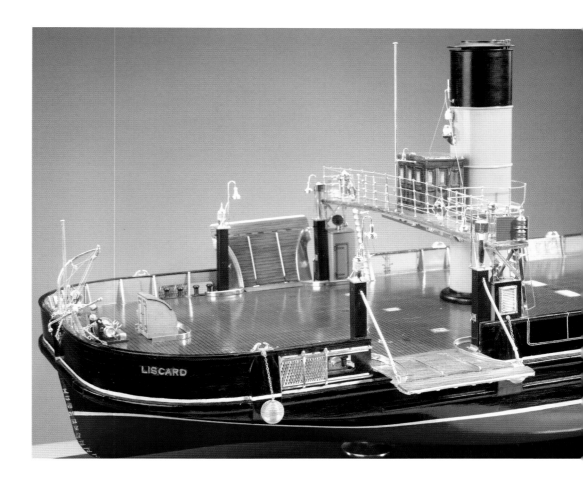

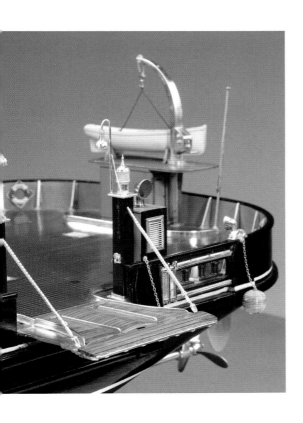

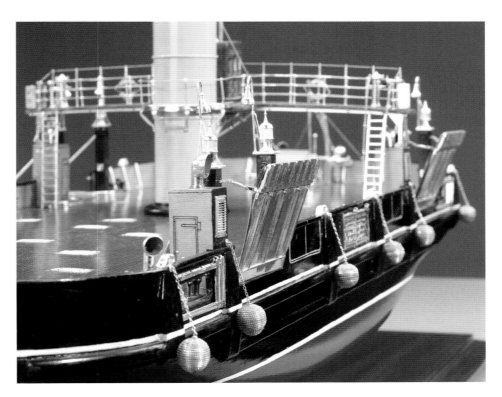

38

## Argentine double-ended car ferry

Builder's model, scale 1:48
Great Britain, 1928
Wood, metal, silver- and gold-plated fittings
33.3 × 97.8 × 25 cm

Designed for transporting passengers and motor cars on the River Parana in Argentina, this steel double-ended ferry was constructed by Yarrow & Co. Ltd., Glasgow, for the Argentine Government. It was one of the earliest ships to have diesel-electric propulsion and was of a specially light but robust construction. The upper deck could accommodate 250 passengers and the lower deck could hold up to twenty motor vehicles. The machinery had threefold control, from either of the two pilot houses on the bridge deck or, if required, from the engine room itself.

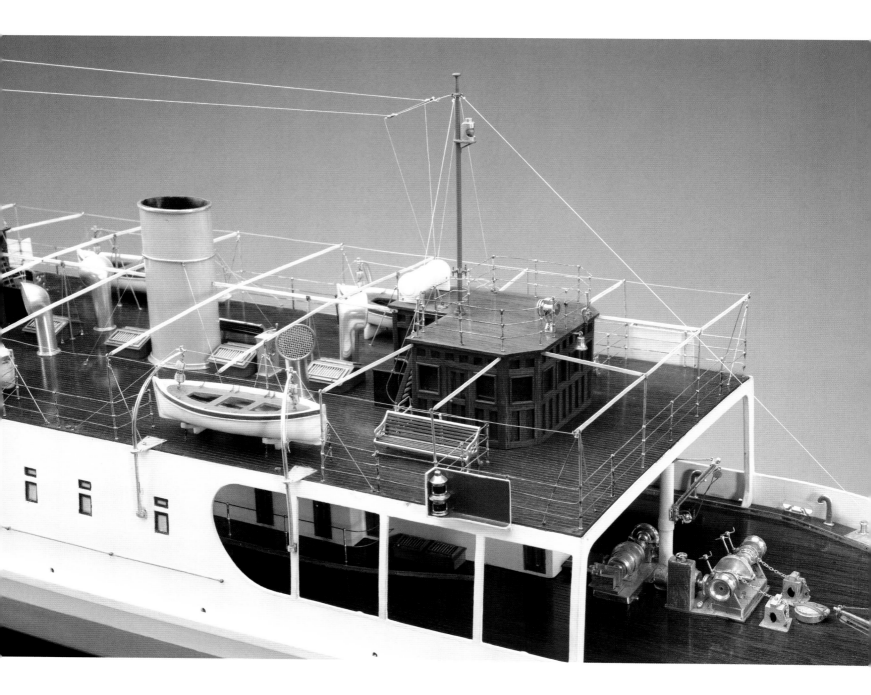

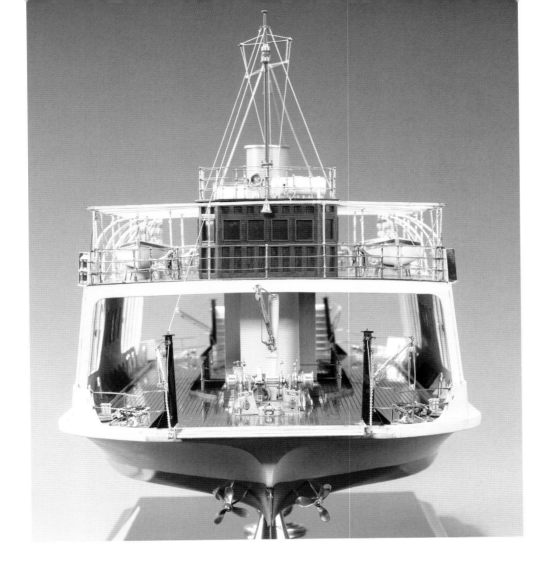

On the upper deck are the two pilot houses, lifeboats, and seating for the passengers. The wooden framework on a level with the pilot houses supported large canvas awnings that provided shelter from the sun.

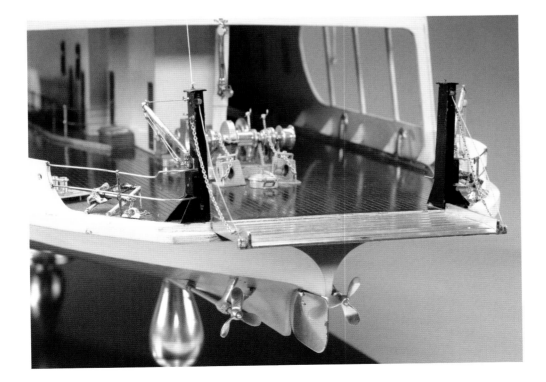

There were four shafts driving two pairs of propellers at each end of the hull. Each shaft was driven by an electric motor, running off electricity generated by the two diesel engines; combined, they could reach a maximum of 10.5 mph, but could also be controlled individually, enabling the ferry to turn almost on its axis.

OVERLEAF
The ship was fitted with both port (red) and starboard (green) navigation lights on both sides, and could achieve 'roll-on, roll-off' operation without having to turn round.

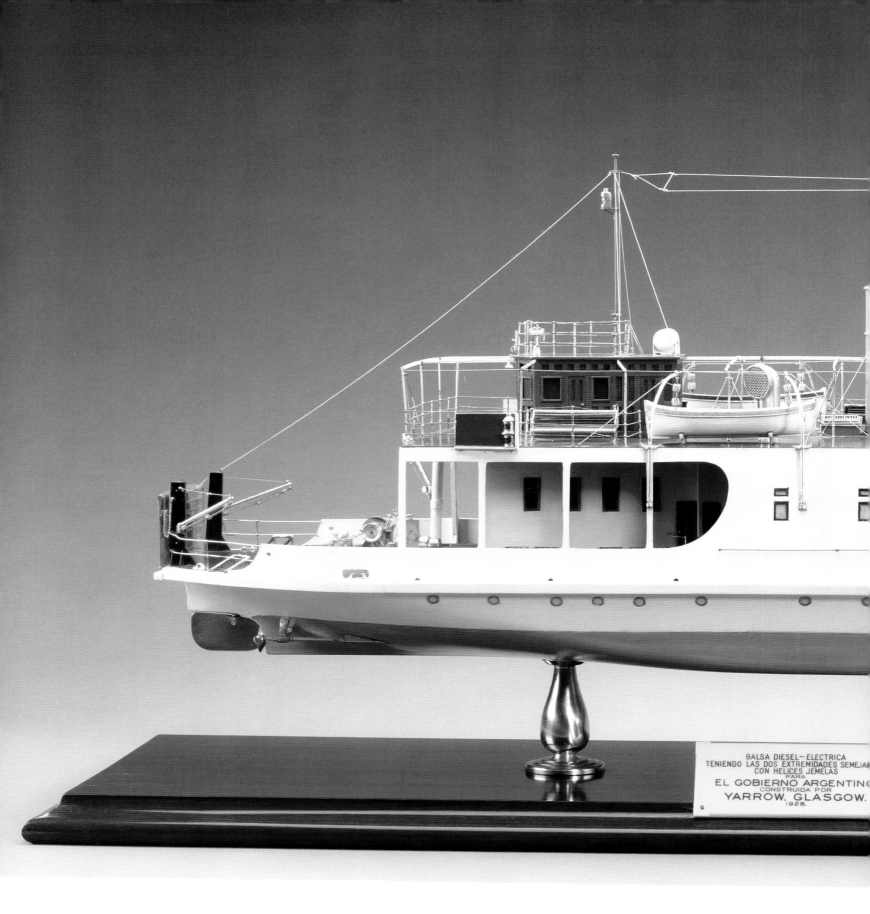

BALSA DIESEL-ELECTRICA
TENIENDO LAS DOS EXTREMIDADES SEMEJA
CON HELICES JEMELAS
PARA
EL GOBIERNO ARGENTINO
CONSTRUIDA POR
YARROW, GLASGOW.
1928.

Ferries

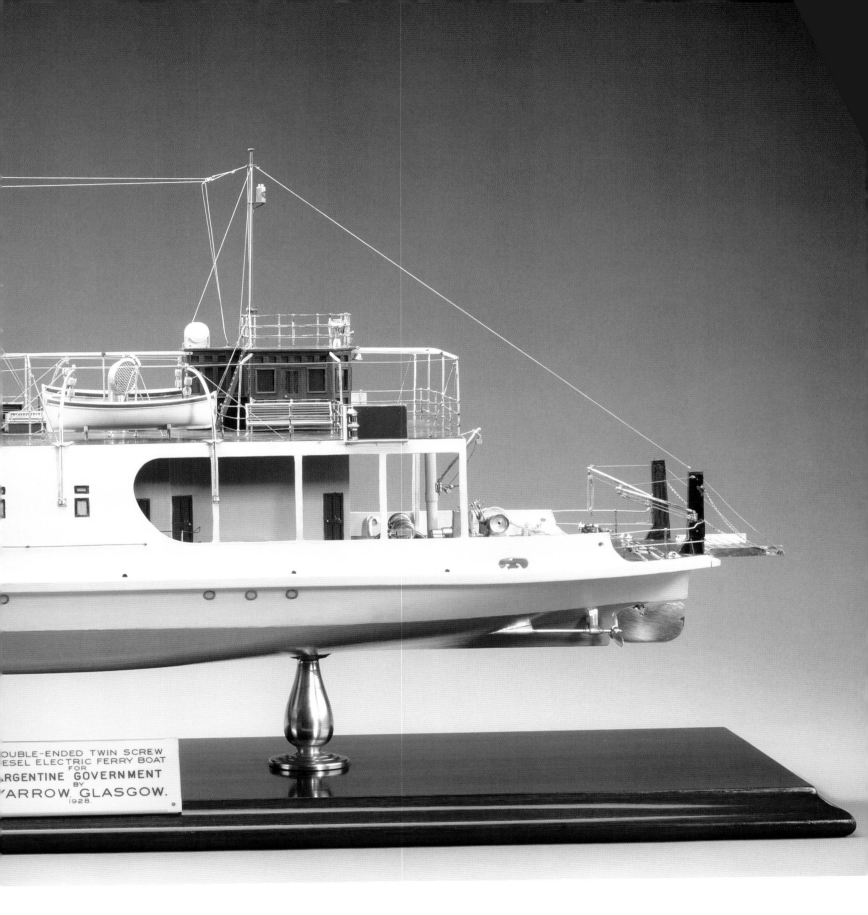

DOUBLE-ENDED TWIN SCREW
DIESEL ELECTRIC FERRY BOAT
FOR
ARGENTINE GOVERNMENT
BY
YARROW. GLASGOW.
1928.

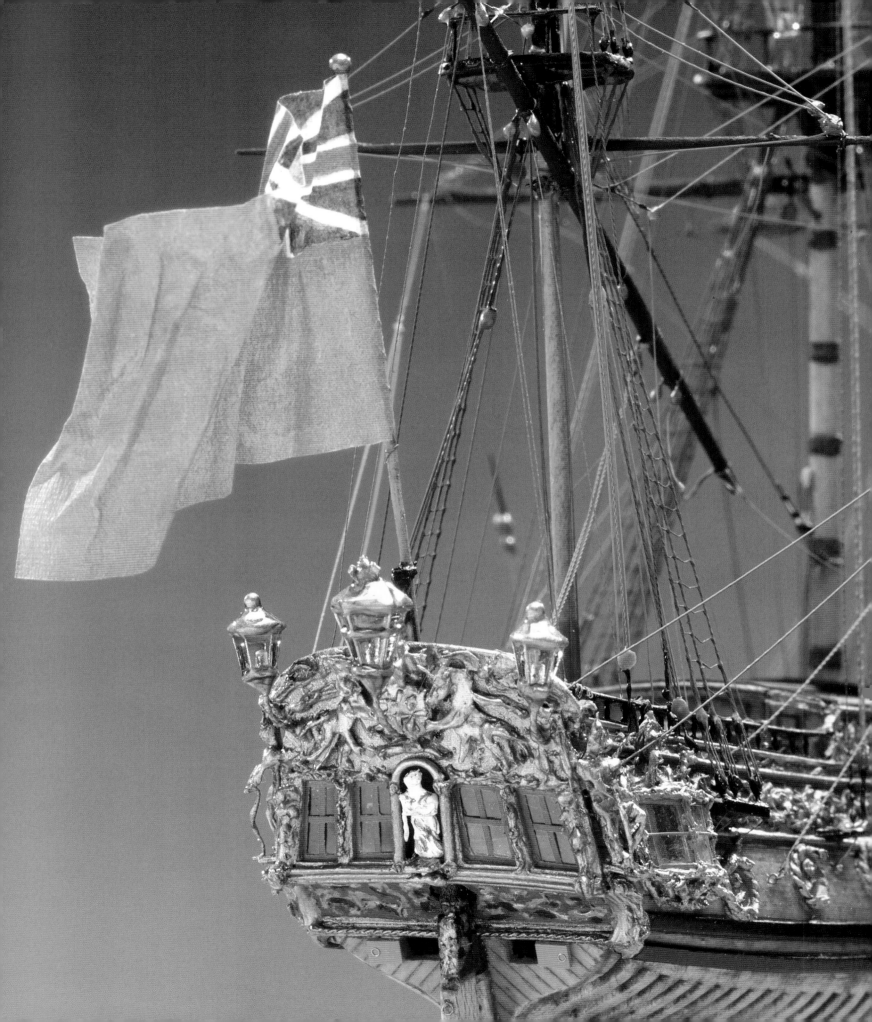

# Donald McNarry

Born in 1921, Donald McNarry has been building models for most of his life. During the period 1935–55 his models regularly won 'best of class' in British National Model Engineer exhibitions. From 1955 he has been a full-time professional modelmaker, undertaking commissions both for public institutions and for private collectors, working in extreme miniature scales, ranging from 1 inch: 16 feet to 1 inch: 100 feet. The subjects of his models have ranged from historic ships dating as early as 700 BC all the way to steamers of the 1960s, and through a variety of styles, from full-hull open-frame 'Navy Board' to waterline and scenic models showing the vessels underway. He has always maintained that his models are miniature ships rather than models of ships and that it is possible to include all the many fittings one would expect to see on a full-scale ship both in a static full-hull and in a waterline scenic miniature. Most of his models are finished in his trademark fitted display cases, made from various hardwoods, a favourite being English walnut.

Detail of no. 42
**British royal yacht:**
*Carolina*, **1716**

## 39

### British state barge, *c.* 1700

Scale: 1:96
Donald McNarry, 1990
Wood, paper, metal, acrylic
6 × 13 × 3.5 cm

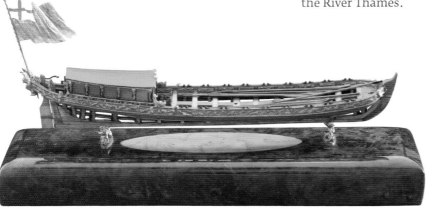

This model represents the type of barge that would have been used by high-ranking members of state and citizens of London around 1700. It is based upon the lines of a shallop, a ship's boat in the complement of large warships of the mid to late seventeenth century. It was rowed by as many as eighteen oarsmen, double-banked, and steered by a helmsman on the raised deck behind the cabin. Such boats were used for ceremonial and official duties on the river, carrying individuals and their guests along the River Thames.

## 40

### Barge of the Stationers' Company (Publishers' Guild), London, 1826

Scale 1:96
Donald McNarry, 1991
Wood, metal, paper
9.4 × 29 × 4.5 cm

This model shows the last barge of a total of six owned by the London Stationers' Company, built in 1826. It was used purely for ceremonial occasions on the Thames, in particular for the Lord Mayor's Day procession, and was large enough to accommodate numerous passengers as well as musicians, who were positioned on the cabin roof. The hull is a larger version of a Thames wherry, a small clinker-built boat used as a water taxi along and across the river.

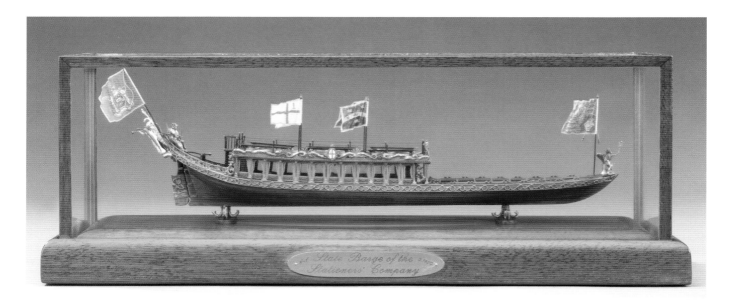

Donald McNarry

## 41

## British royal yacht: *Charlotte*, 1747

Scale 1:192
Donald McNarry, 1988
Boxwood, pearwood, sycamore, beech, applewood, hollywood, metal
7 × 16.5 × 4.5 cm

Built in the 'Navy Board' style, this model shows the two-masted ketch-rigged *Charlotte* after she was lengthened in 1747. She had originally been built in 1710, but it was common practice during this period to rebuild or alter vessels to extend their working lives.

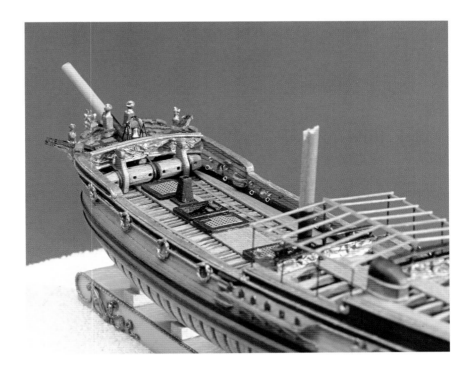

The foredeck is represented complete with gratings, galley stove pipe and a large windlass for working the anchor gear and rigging. Just aft of the mainmast and forward of the state cabins is a wooden frame for supporting a canvas awning, which would provide protection against the elements on deck.

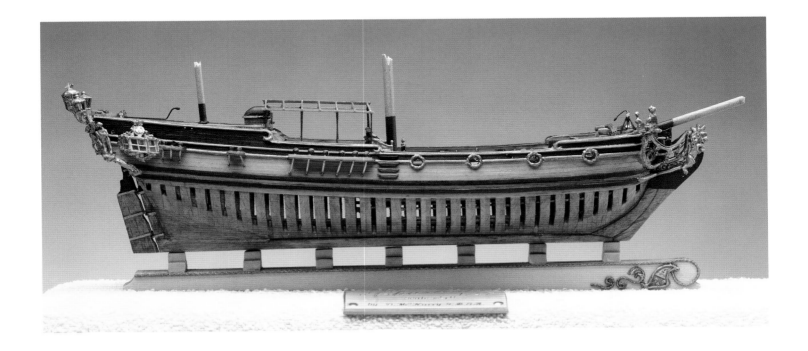

## 42
## British royal yacht: *Carolina*, 1716

Scale 1:192
Donald McNarry, 1988
Boxwood, pearwood, sycamore, beech,
applewood, hollywood, copper, paper
20 × 22.5 × 7.5 cm

Originally designed by Peregrine, Lord Danby as a sixth-rate and named the *Peregrine Galley*, she was built at Sheerness and launched in 1700.
She was refitted as a royal yacht in 1716 and re-named *Carolina*, after the Princess of Wales, later Queen to George II. During George I's reign, this was his principal yacht and in it he made six crossings to Hanover. The *Carolina* was lost with all hands in the Bay of Biscay in 1762.

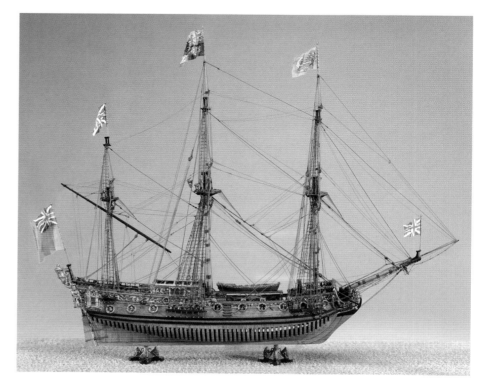

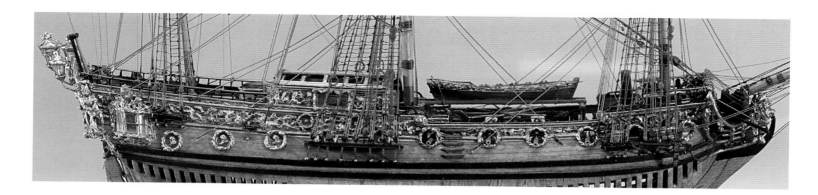

**43**

**British royal yacht:**
*Britannia*, **1893**

Scale 1:192
Donald McNarry, 1996
Wood, paper, metal
25 × 34.5 × 15 cm

Commissioned in 1892 by Edward, Prince of Wales, later King Edward VII, *Britannia* was designed by the famous Scottish naval architect George Lennox Watson (see nos. 28 and 46) and built by D. & W. Henderson's yard on the Clyde. She was a 23-metre class cutter with a mast 164 feet tall, rigged with 10,327 square feet of sail. The arrival of *Britannia* sparked new life into the sport of yachting and during her career she won 360 prizes (231 firsts) in 635 starts. After the death of King George V, in 1936, her spars and equipment were sold by auction at Cowes for the benefit of King George's Fund for Sailors. The hull was towed out to Saint Catherine's Deep, off the Isle of Wight, where she was sunk by *HMS Winchester*.

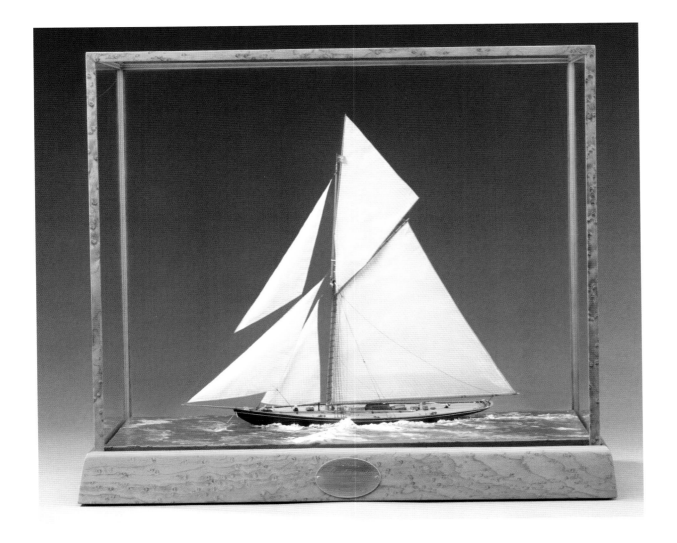

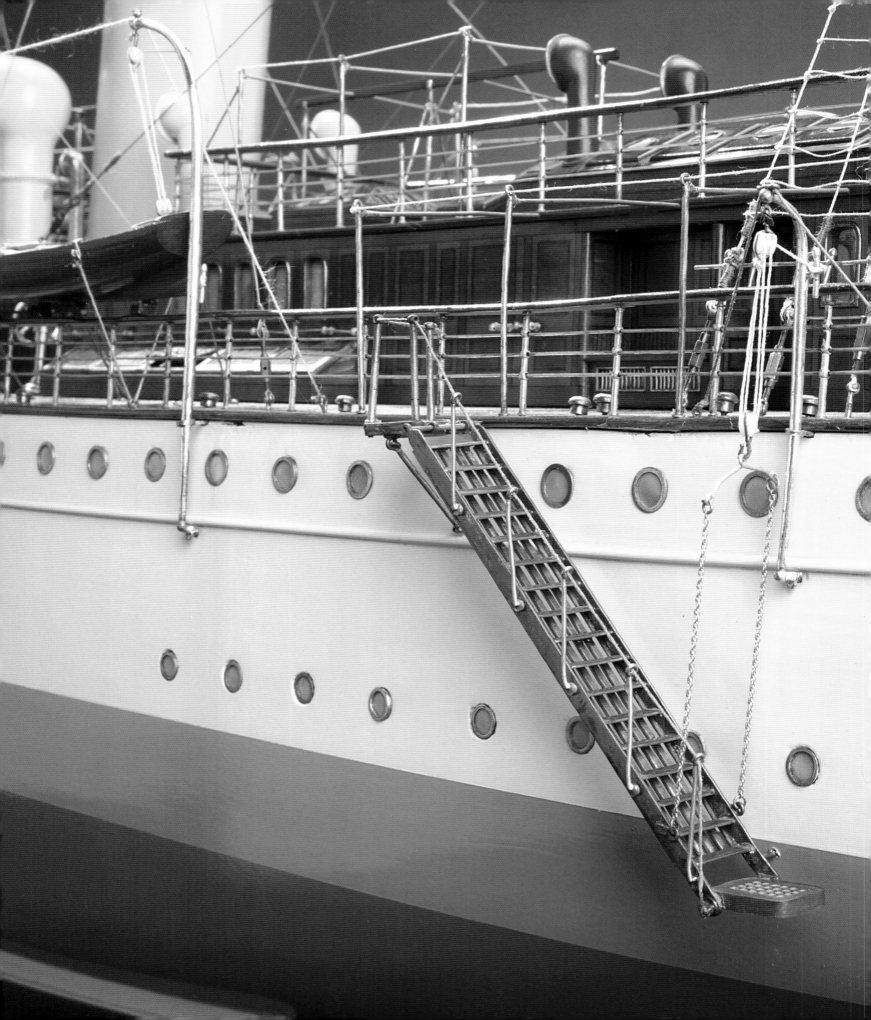

# Pleasure craft

Detail of no. 46
**British twin-screw steel schooner:** *Mayflower*

## British paddle steamer:
### *Clacton Belle*

Builder's model, scale 1:48
Great Britain, 1890
Wood, metal, silver- and gold-plated fittings
44 × 169 × 42 cm

The *Clacton Belle* was built by W.M. Denny & Brothers of Dumbarton, Scotland, in 1890, as a 200-passenger ferry. She was requisitioned by the British Admiralty for mine sweeping in 1915 and finally broken up in 1929.

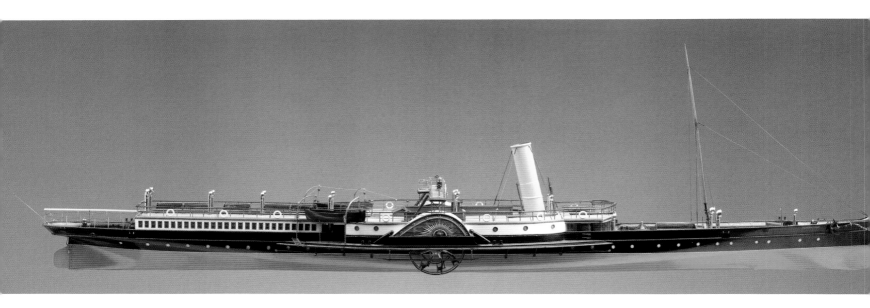

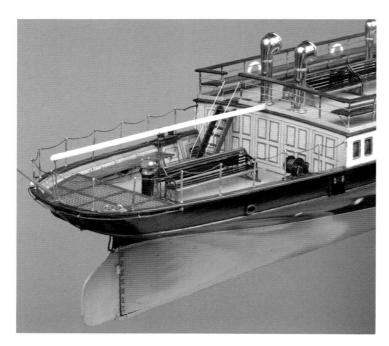

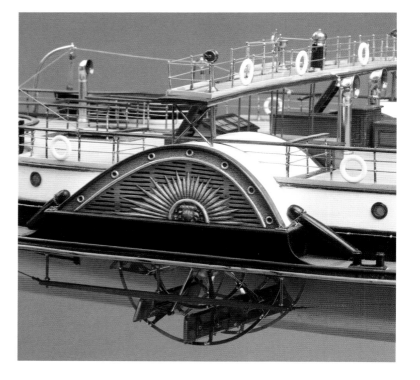

The paddle boxes, with sunburst decoration, are linked by the open bridge above. On the decking (sponsons) forward and aft of the boxes are wooden fenders, in their stowed position. At the stern is an open deck with seating for passengers and a wooden frame for rigging a canvas awning for protection against the elements. The funnel could be lowered either on hinges or by telescopic means so as to be able to navigate under bridges.

## 45
## British high-speed river-cruising launch

Builder's model, scale 1:24
Great Britain, 1920
Wood, metal, glass, leather, wicker
8 × 50 × 12 cm

Launched in 1920 by J. Thornycroft & Co Ltd., this cruising launch had two six-cylinder 70-horsepower engines. It could reach a top speed of 21 knots and was a popular type of vessel on the upper Thames. The launch had a fast, planing hull and lightweight, double-skin wooden planking.

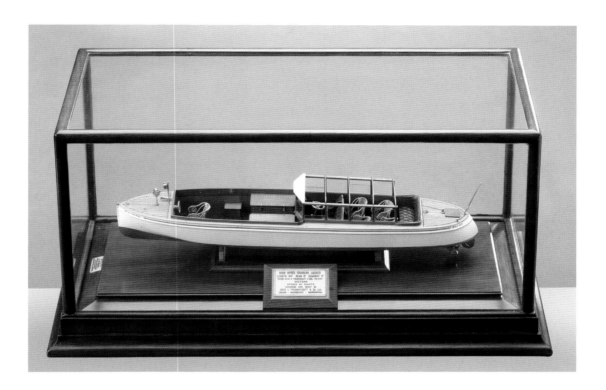

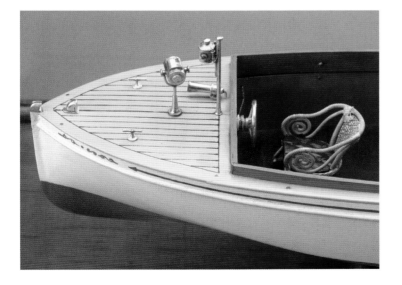

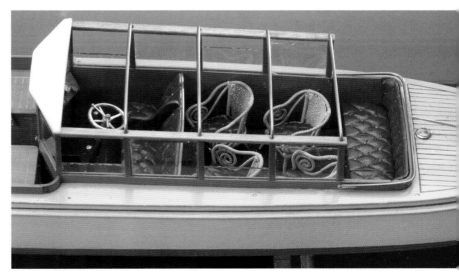

The cabin is made of wood with glass panels and has leather and wicker seating inside. At the bow is a searchlight, horn and a second steering wheel.

## 46

### British twin-screw steel schooner: *Mayflower*

Builder's model, scale 1:48
Great Britain, 1896
Wood, metal, silver- and gold-plated fittings
67 × 162 × 27 cm

Builder's models for presentation to potential clients were frequently made for steam yachts – floating entertainment venues and status symbols of the most prominent kind for the very rich. The *Mayflower*, designed by George Lennox Watson (see nos. 28 and 43) and launched by J. & G. Thomson Ltd., Glasgow, in 1896, was purchased in 1897 by the American banker O. Goelet and from 1902 to 1929 was the American Presidential Yacht. She commonly undertook grand tours to Europe.

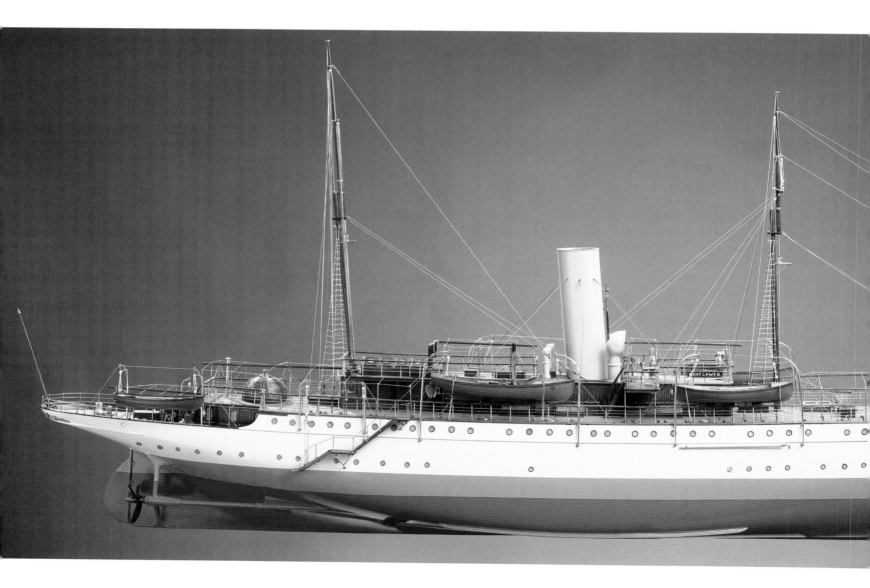

Pleasure craft

The model shows off the graceful lines of the hull, with its fine clipper bow and overhanging cruiser stern. Below the water, a pair of bilge-keels amidships provided extra stability when underway, whilst on deck the tall funnel and accommodation present a balanced profile, designed to catch the eye. Such touches reinforced the appeal of these vessels as status symbols of the very rich.

Since these yachts spent most of their time afloat, the accommodation ladders on either side (rigged to davits for storage when underway) were the primary means of embarking and disembarking. Here guests would be received as they arrived in their own steam barges and launches, typically at the high-society sailing and racing regattas that were held around the world.

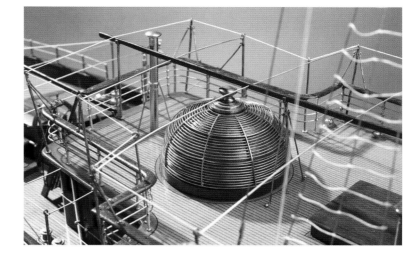

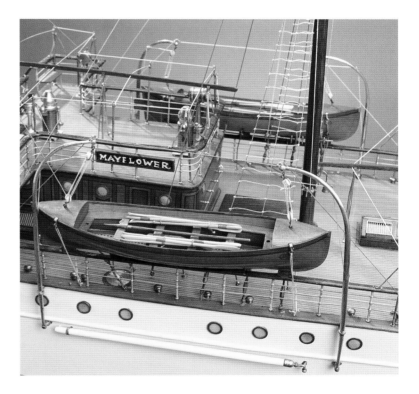

The large spherical dome on the upper deck provided additional light to the large spaces below – the dining saloon or the grand cabin. Made from wood and glass, it had a brass or bronze frame that protected it from weather or accidental damage.

The bridge is fully equipped with navigational instruments to allow control on deck as well as inside the charthouse. The two self-righting lifeboats (with air chambers at the bow and stern) are rigged to davits either side for quick and easy access in an emergency.

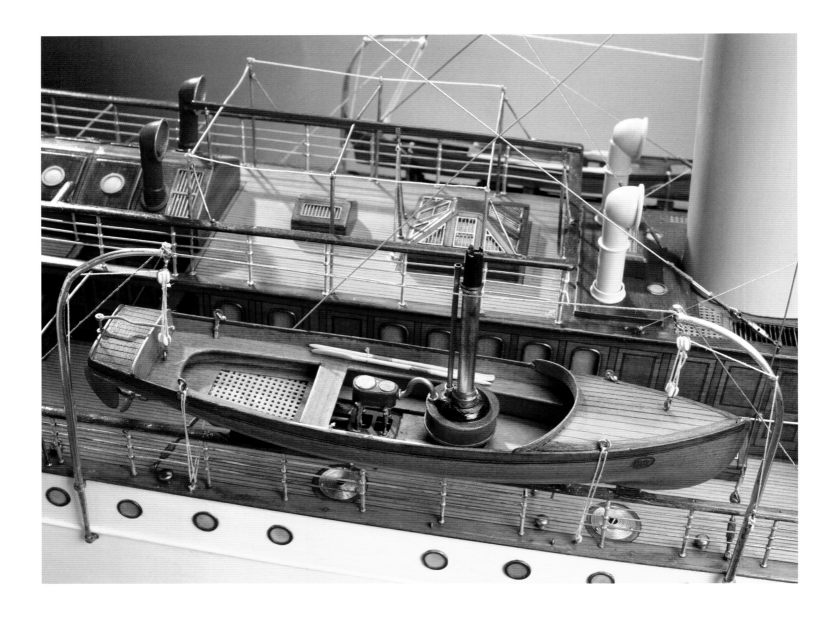

The design and finish of these vessels was very important as it portrayed the wealth of the owner. Most hulls were painted white to reflect the heat of the sun and keep the accommodation below cool. It was also common to decorate the bow with a figurehead and the stern with carvings that sometimes incorporated the yacht's name and port of registration. Typically there was a small dinghy at the stern which could be launched quickly in the event of an emergency or might be more convenient for small errands, since launching the steam launch required considerable preparation and time was needed to raise steam.

However, the large steam launch was the primary way for getting to and from the shore – bearing in mind that most of these yachts cruised waters where quayside and harbours did not exist, or were on moorings at the various regattas. The launch is powered by a two-cylinder steam engine with boiler.

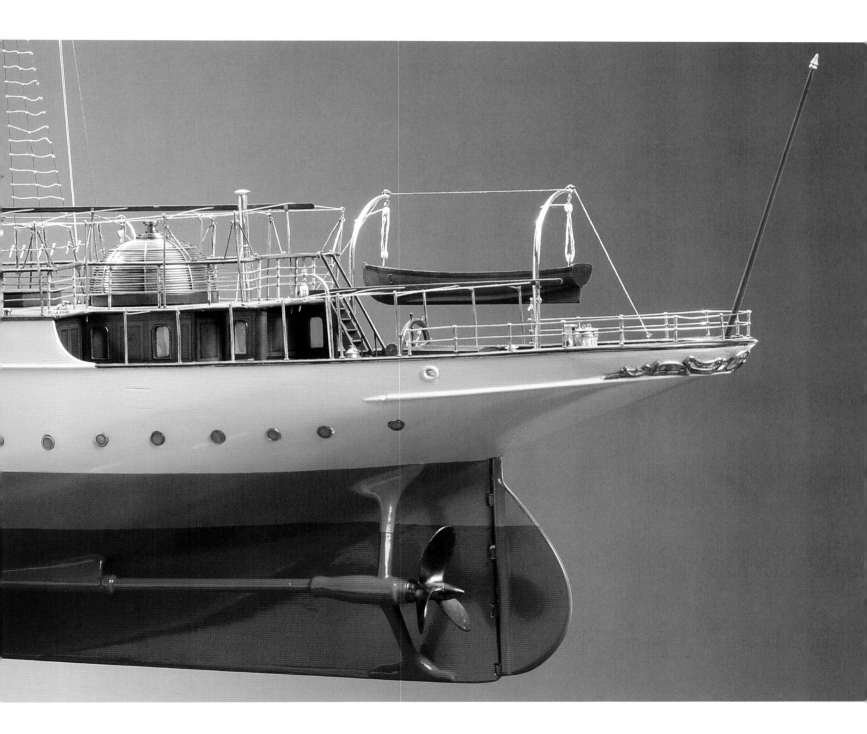

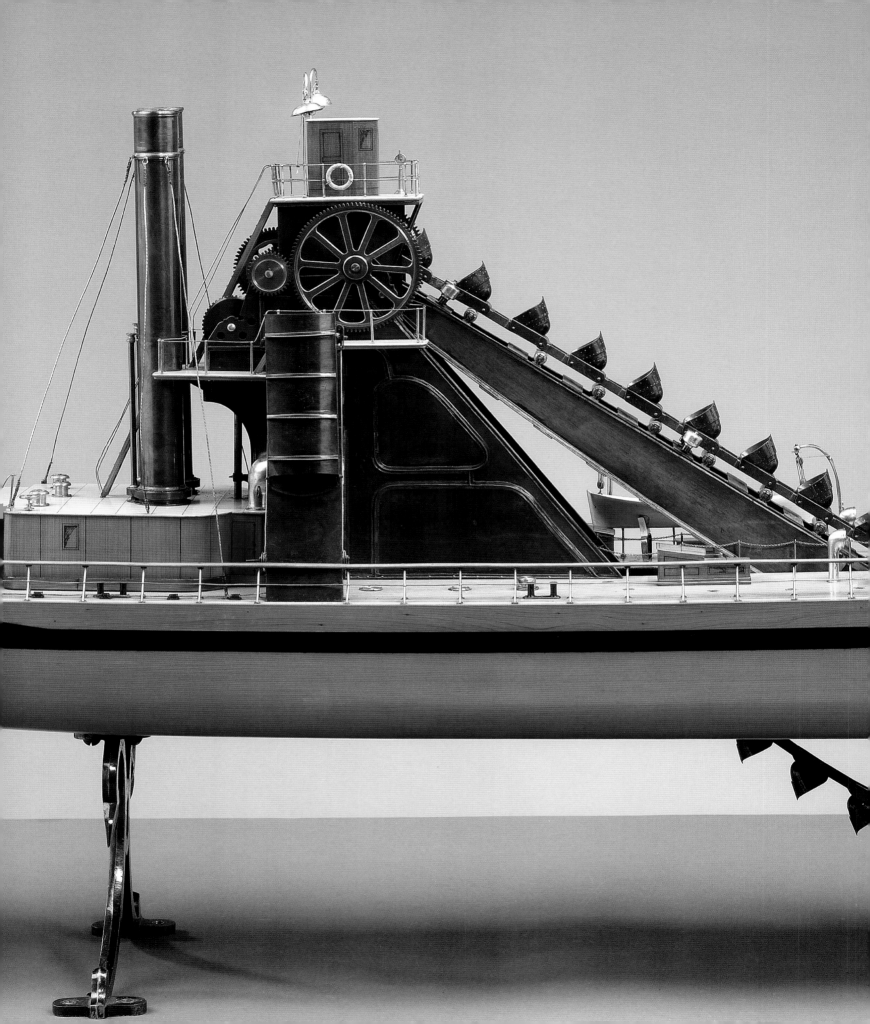

# Service vessels

Detail of no. 48
**British dredger: *Lyster***

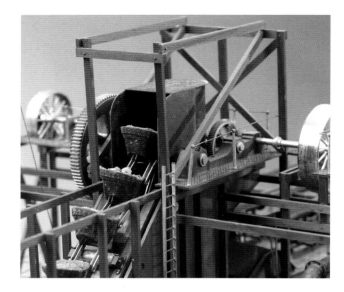

## 47
## Steam gold-dredger

Builder's model, scale: 1:48
Great Britain, *c.* 1890
Wood, metal, glass, sand
65 × 127 × 46 cm

Gold dredgers were used to recover high-value minerals such as gold and tin from the sea or river bed. This example was used around the world – in North and South America and in African lakes. Operating along a series of troughs in the river or sea bed, they moved in a forward direction only. The waste material was conveyed by pipes some distance away from the hull, so as not to dredge the same material twice.

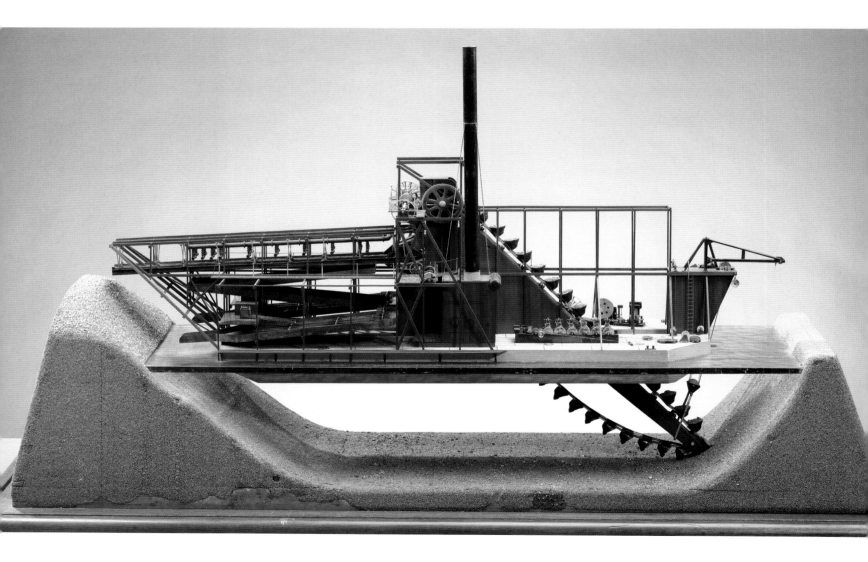

The model shows the complex processing of the material that the dredger brought up in the buckets. It was washed and then passed through a series of angled trays and filters. The finer filters were mats made of cocoa fibre.

The steam engine, mounted on deck, provided power to drive both the large belts that operated the bucket conveyor-belt and the high-pressure pumps used for the filtering process and the removal of the waste material.

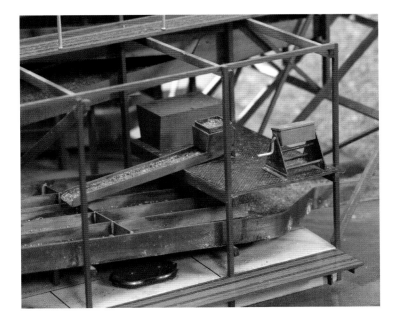

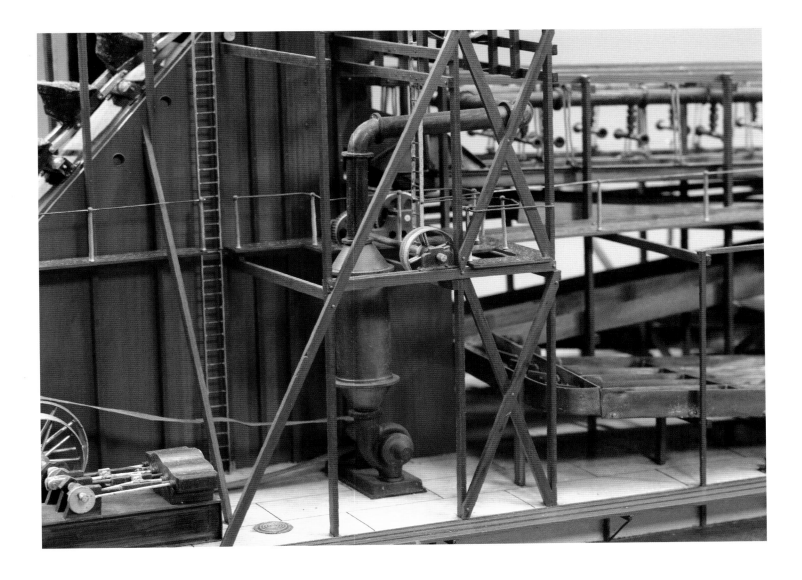

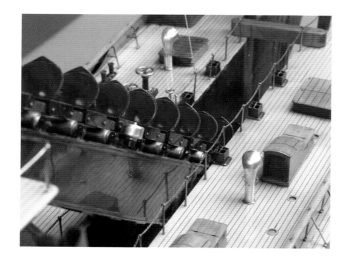

48

## British dredger: *Lyster*

Builder's model, scale: 1:48
Great Britain, 1896
Wood, metal
36 × 108 × 30 cm

Dredgers are used for deepening harbours or rivers estuaries by excavating the sea or river bed. This model illustrates a bucket dredger, which scoops the silt or gravel in the area being dredged and discharges the contents into a lighter or hopper secured alongside (see no. 49).

The *Lyster* was built in 1896 by William Simons & Co. Ltd., Renfrew, for the Mersey Docks and Harbour Board, and was active until 1931.

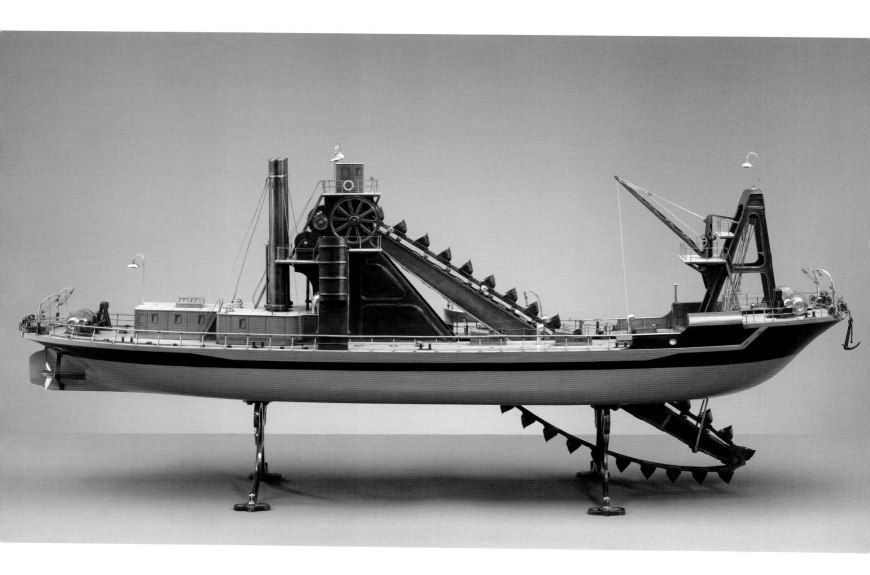

Service vessels

When the buckets reached the top of the gantry the material was released into a chute – located just below the large toothed wheel – which then conveyed it over the side into a waiting hopper.

The large gantry mounted on the bow was used for raising and lowering the conveyor belt with buckets. The conveyor belt had to be raised into the hull when the dredger was underway.

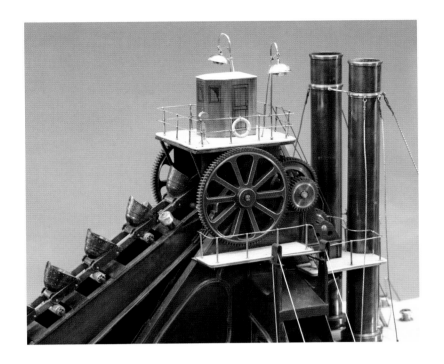

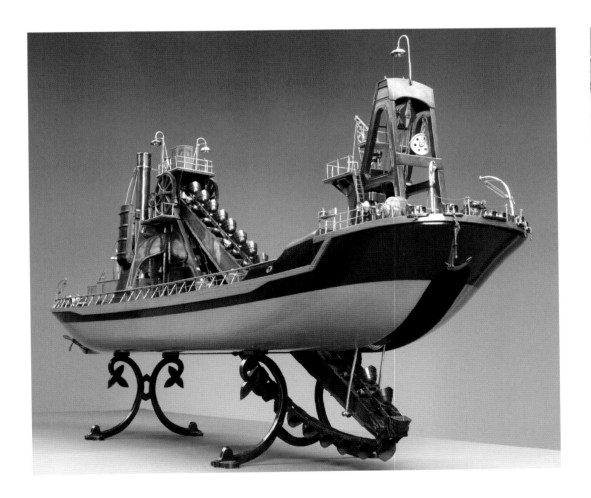

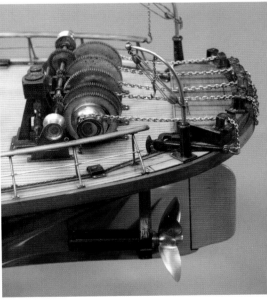

A series of anchors and chains, operated by a large steam windlass, held the vessel in position while it removed aggregate from the sea or river bed.

## 49
### British mud hopper: *T.C.C. Hopper No. 1*

Builder's model, scale: 1:48
Great Britain, 1903
Wood, metal
50 × 116 × 25 cm

Hopper barges are used in partnership with bucket (see no. 48) or suction dredgers. Once the material has been extracted from the river bottom or sea bed, the dredger discharges it into the hopper barge moored alongside. The material is then taken by the hopper either to be used as aggregate ashore or dumped out at sea.

This model illustrates one of a series of mud-hopper barges that were built for Tees Conservancy Commissioners in 1903 and were operational until 1920.

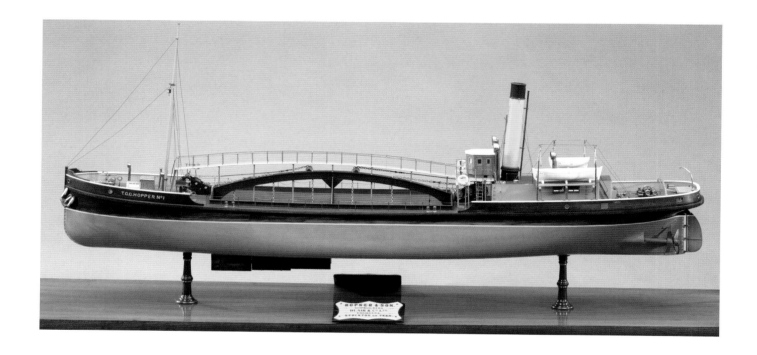

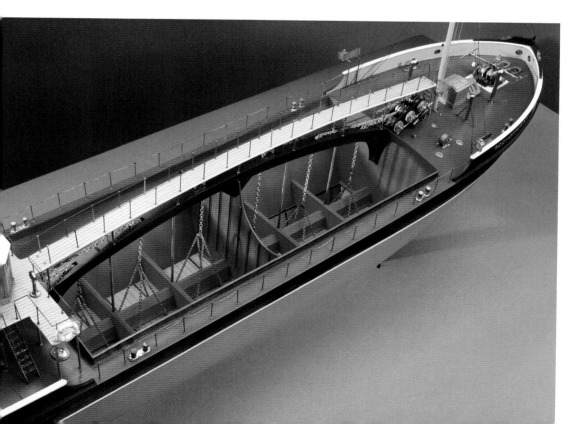

The model illustrates the method of dumping at sea using a series of release doors on the underside of the hull, operated by chains and a steam winch. One set of doors is open, the other is closed.

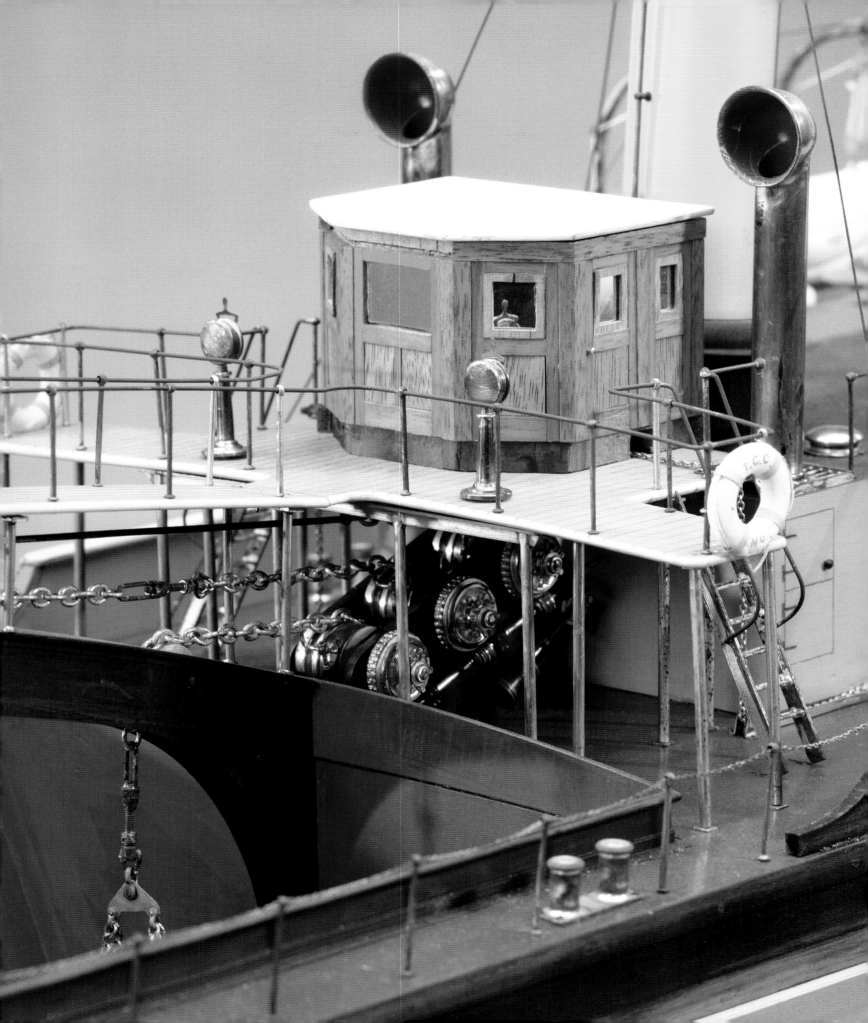

## 50
## British armed tug

Builder's half-model, scale 1:48
Great Britain, 1919
Wood, metal, glass, silvered mirror
52 × 89 × 14 cm

The half-model of a tug is mounted on a surface-silvered mirror to produce the impression of a full-hull model. This technique was introduced during the late nineteenth century, probably on grounds of cost as well as to save space in offices and on exhibition stands.

This model is thought to represent one of three ocean-going rescue tugs built for the Royal Navy in 1918, namely the *Saint Fagan*, *Saint Faith* and *Saint Hilary*. They were built specifically to tow large German ships back to Europe from the United States, where they had been immobilized by their crews during the First World War.

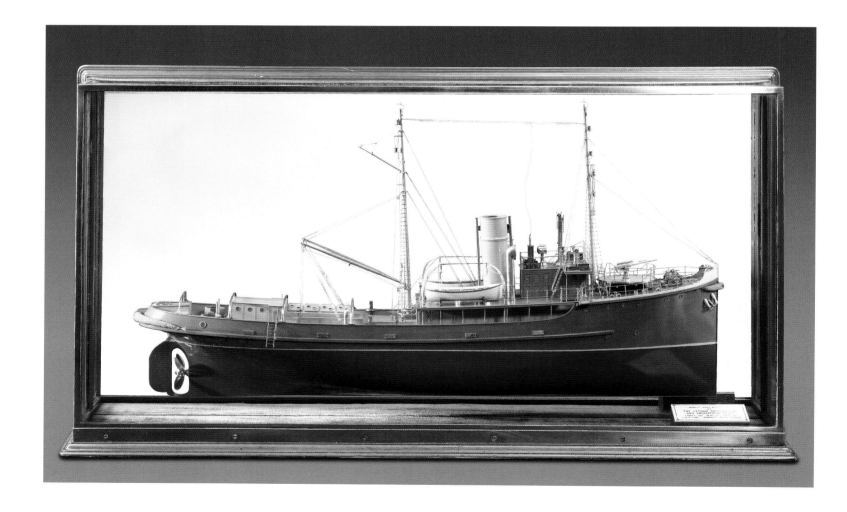

Service vessels

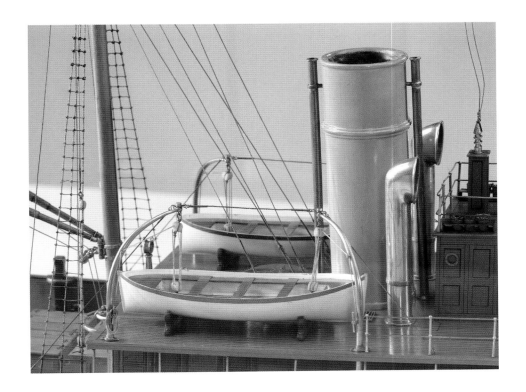

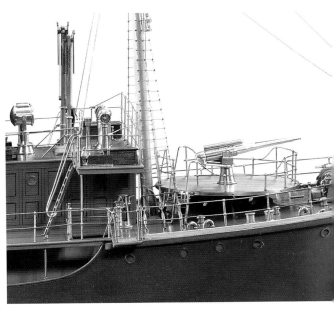

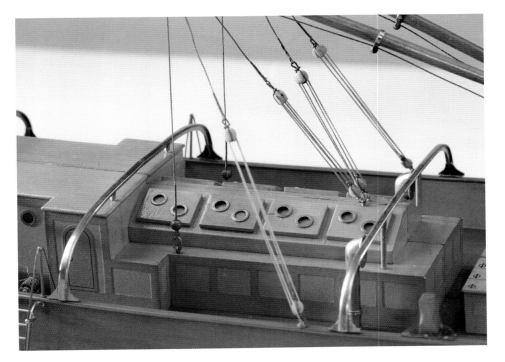

The tug was to see service during wartime, so a twelve-pounder anti-aircraft gun was mounted on a platform just forward of the bridge and the hull was finished in a grey colour. Objects of interest on the bridge include a large searchlight – for locating survivors in the water – and a pair of semaphores for communicating with other vessels at sea.

The large metal 'horses' straddling the accommodation were there to prevent the tow ropes – should they temporarily slacken or fall between the vessels – from snagging the various fittings on deck.

## 51
## British Admiralty floating dock: no. 58

Builder's model, scale 1:48
Great Britain, 1957
Wood, metal
38 × 152 × 32.5 cm

A floating dock is a watertight structure capable of being submerged in order to receive a vessel by admitting water into the chambers of its double bottom. Once the vessel is within the area of the dock the water is pumped out, both dock and vessel rise and repairs can be carried out in the dry. Floating docks have many advantages over fixed (graving) docks, for example lower build costs and the avoidance of unforeseen difficulties arising during construction; also the pumping can be in proportion to the size of ship docked, whereas a graving dock has to be emptied completely for large and small vessels alike. Moreover, as the ship is lifted high and dry, not sitting in the damp conditions of a graving dock, repair work

Service vessels

such as painting and welding can be carried out to a higher standard.

The present model represents a floating dock built by Furness Shipbuilding, Teeside, for the British Admiralty and launched in 1957. The dock measures 500 feet in length by 66 feet in the beam and has a lifting capacity of 8,082 tonnes. On completion it was towed by the tug *Growler* to the Gareloch, Scotland, where it replaced an older floating dock. It was later in use at the royal dockyard at Devonport in Devon, then in the Shetland Islands – servicing Sullom Voe tugs and Shetland Islands Council ferries – and lastly in Norway, where it is thought still to be in use.

These floating docks were unpowered and needed to be towed by tugs to the place where they were required. This dry dock carries numerous instructions and warnings relating to valves and outlets for vessels coming alongside. At various positions along the length of the dock there are also vertical draught marks, indicating the depth of the dock floor below the water and the trim necessary to provide a stable, horizontal work space.

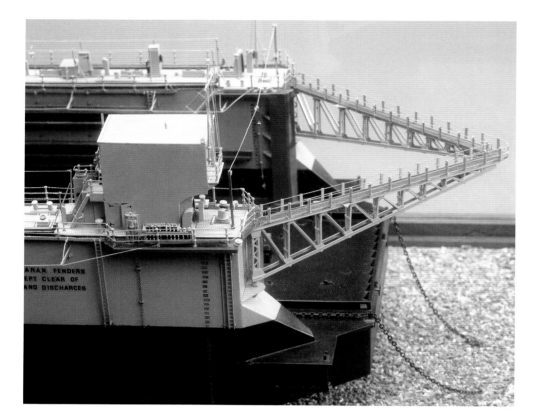

To enable access from one side of the dock to the other whilst work is continuing on a vessel, at one end of the dock there are two large gangways on hinges which can be swung across to meet in the middle. There are several sets of anchors at either end of the dock to hold it in position before, during and after flooding as well as during maintenance. The pumping operation is overseen from the pump house, in which the controls for the valves and the release of compressed air are located.

To position and protect the vessel when the dock is flooded are two tiers of fenders along the dock walls. Once the dock is raised by pumping out the flooded compartments, the vessel settles on the three rows of wooden keel blocks along the dock floor.

Each of the two cranes is able to lift and carry materials from and along the interior of the dock as well as from and to vessels alongside. They run on rails and are capable of lifting loads in tandem.

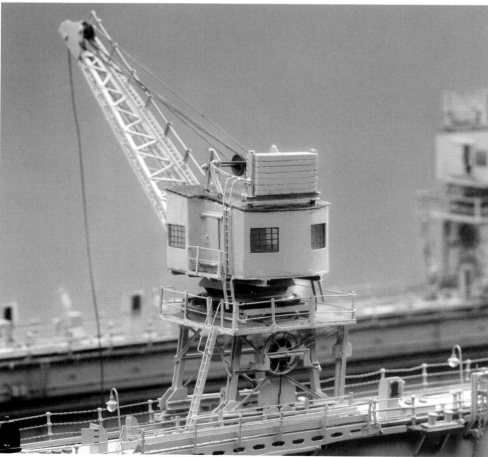

Service vessels

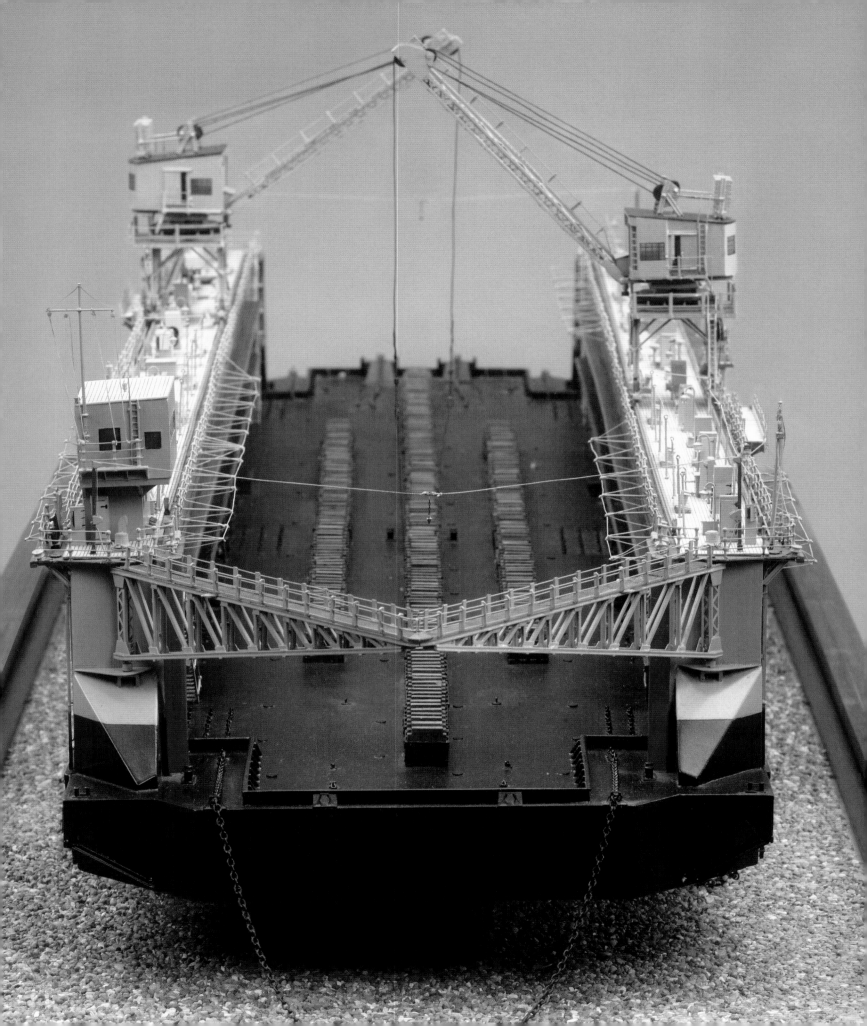

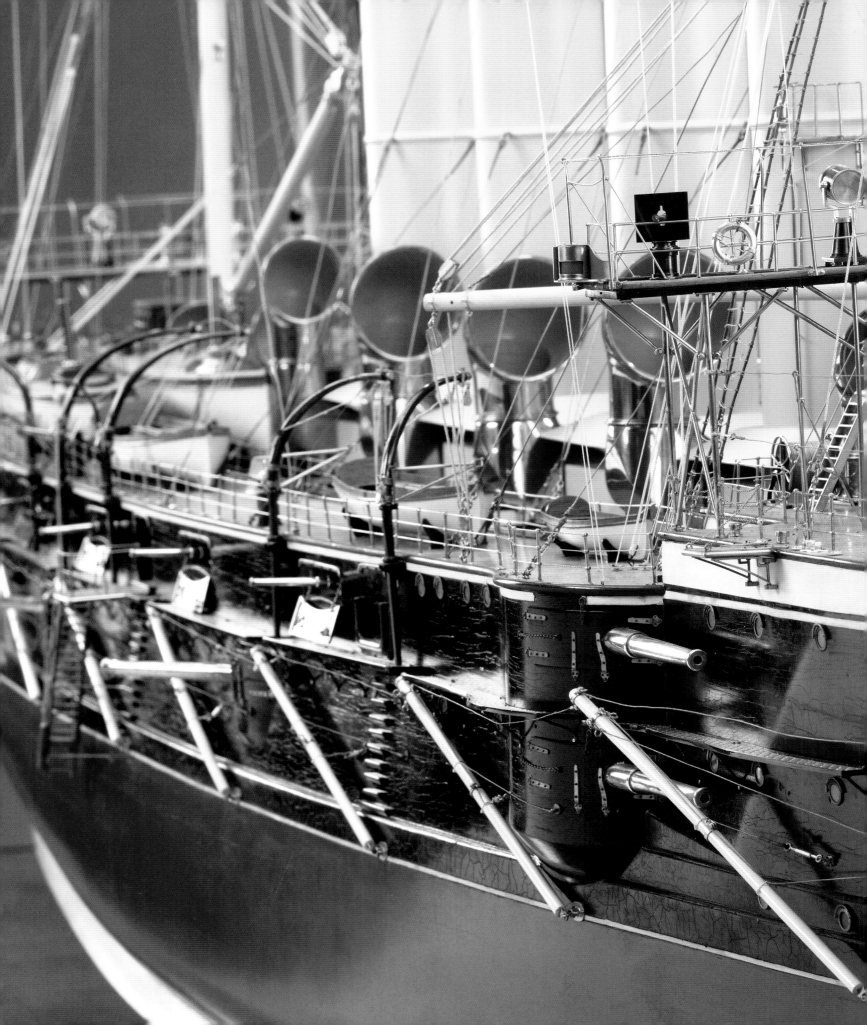

# World War I warships

Detail of no. 52
**British armoured steam cruiser:**
*HMS Hogue*

52

## British armoured steam cruiser: *HMS Hogue*

Builder's model, scale 1:48
Great Britain, 1900
Wood, metal, ivorine, silver- and gold-plated fittings
133 × 306 × 56 cm

The copper-coloured ventilation cowlings face forward and direct fresh air down below to the engine rooms and accommodation. Along the side of the hull is a variety of secondary armament, including twelve 6-inch quick-firing guns mounted in casemates. The series of booms above the waterline are rigged out away from the hull to support the anti-torpedo nets.

Some of the most impressive builder's models ever produced came from the shipyard of Vickers at Barrow-in-Furness, one of the few British companies to have a specialist shop producing models for both design and exhibition. At the standard scale of 1:48 it was possible to produce a very detailed model, complete with all the fittings carried on the actual ship.

The cruiser *HMS Hogue* is a typical example of a warship from the turn of the century, with the deck and superstructure crowded with state-of-the-art weaponry and equipment.

Launched by Vickers Sons & Maxim Ltd., Barrow-in-Furness, in 1900, the *Hogue* was one of six First Class cruisers with a hull armour-plated with a 6-inch thick Krupp steel belt covering an area 231 feet long by 11 foot 6 inches deep, from the main deck to five feet below the water line. Her main armament was two 9.2-inch guns, with a secondary armament of twelve 6-inch quick-firing guns and two 18-inch torpedo tubes below the waterline. From 1900 to 1906 she was with the Channel Fleet; other commissions included North America, the West Indies and China. On 22 September 1914 the *Hogue* was torpedoed by the German submarine *U-9* while trying to rescue survivors from *HMS Aboukir*. Sadly, it took only ten minutes for the *Hogue* to sink and as a consequence ships of this type were withdrawn from future patrols.

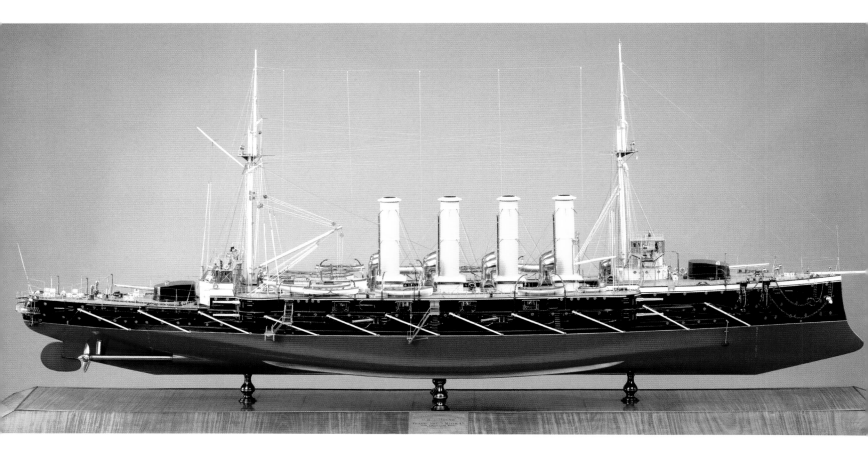

World War I warships

The forward 9.2-inch gun is mounted in an armour-plated turret. Below the barrel is the steam capstan, used for working the anchor cables and mooring ropes.

The bridge control at the stern is complete with searchlights and semaphore signalling. The copper lifebuoy mounted on the ship's side could be launched by hand and was fitted with a self-activating smoke flare.

The complement of ship's boats, stowed just aft of the funnel, ranged from small cutters through to the larger steam pinnace. The white booms mounted on the hull would support an anti-torpedo net, which could be swung out from the hull when the ship was at anchor and vulnerable to attack.

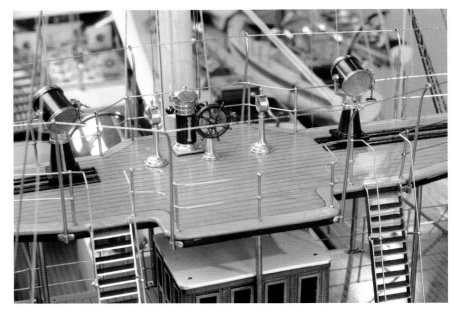

On the mainmast top there is a searchlight; a yard crosses below.

The aft bridge (top right) was used as a secondary steering position. The navigational equipment includes a compass binnacle and the wheel as well as two telegraphs for communication with the engine room. There are two searchlights on either side.

A bow view shows the forward bridge and a 9.2-inch gun mounted on the forecastle deck whilst the underwater hull reveals a ram bow. The anchors are stowed alongside the hull and their cables are led forward through hawse pipes up on to deck to a steam capstan, by which the anchors were raised and lowered.

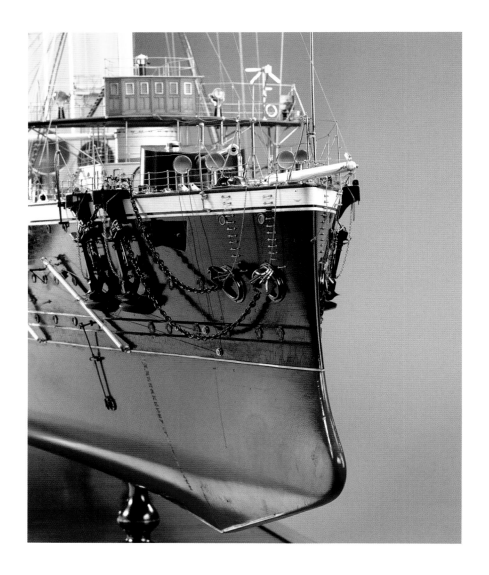

The stern walk was an area used by the senior officers. The name of the ship is on a plaque attached to the rails.

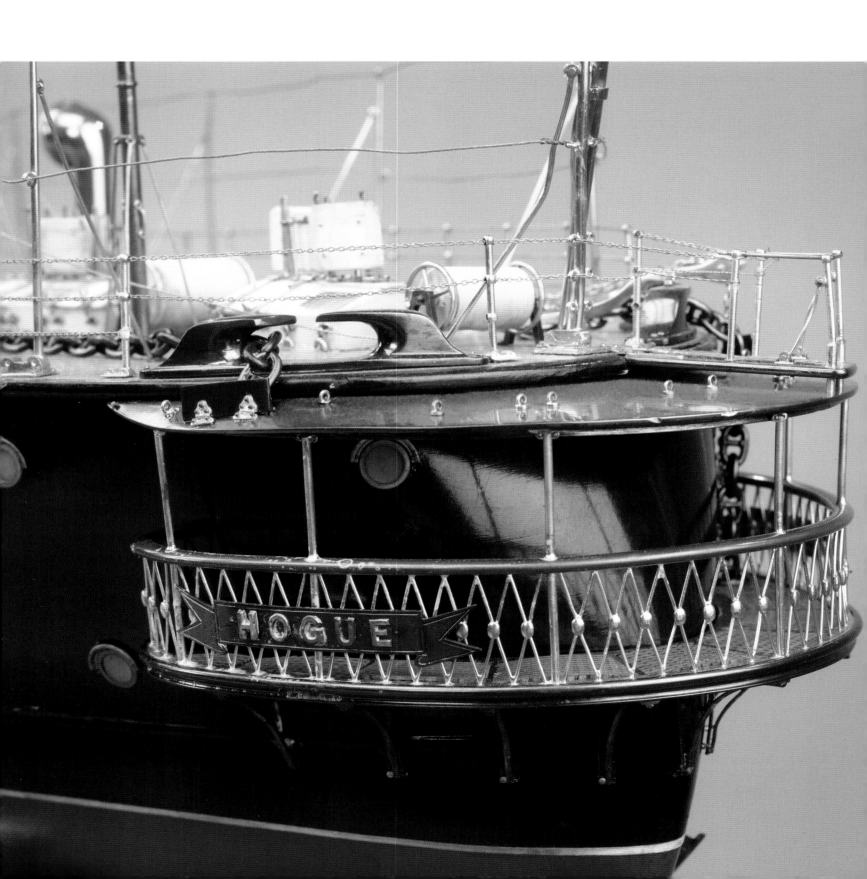

## 53
## German torpedo-boat destroyers: *G132–G136*

Builder's model, scale 1:48
Germany, 1906–07
Wood, metal, silver- and gold-plated fittings
48 × 132 × 13 cm

The long, sleek hull was capable of high speeds, up to 27 knots. In addition to the main rudder at the stern, a small rudder was mounted at the bow for slow-speed manoeuvring when in port. The ship was painted black to reduce its visibility, especially at night.

This model represents the later stages of the development of ships designed to carry and use the Whitehead torpedo, purchased by the German Navy in 1882. These deadly pieces of ordnance figured significantly in the arms race of the build-up to the First World War. With their high speed and low profile they could be used to carry out surprise attacks on the capital ships within a larger fleet, in some cases under the cover of darkness.

Before 1914, three German shipyards specialized in the construction of torpedo boats, Schichau at Danzig, Vulkan at Stetting and Germania at Kiel. The torpedo boats were not given names, only the initial letter of the shipyard followed by a number running from 1 to 197 and then starting again at 1 (for example S90, V156 or G137). The displacements of these boats ranged from 60 to 300 tons, with a hull length from 60 to 205 feet, and they were capable of maximum speeds of 18 to 27 knots.

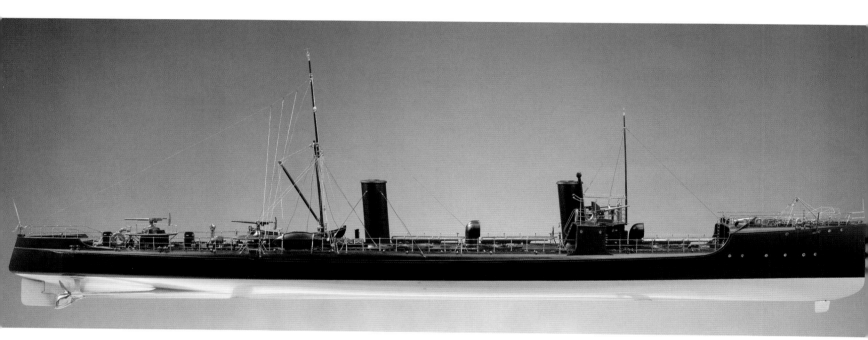

The two guns are mounted on circular platforms above the deck. In this way the guns and the crew who fired them were kept clear of the sea, constantly breaking on deck. The rounding of the hull where it meets the deck was designed to prevent the build-up of water on deck, which would have affected the ship's stability and operation.

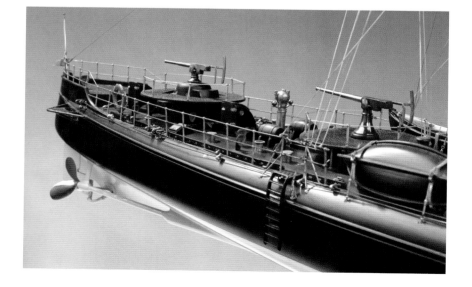

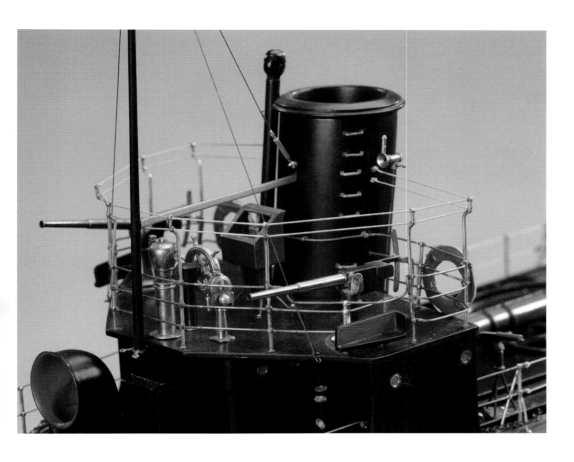

The bridge, mounted forward of the first funnel, is complete with two quick-firing guns and a covered, weatherproof chart-table directly behind the wheel.

The two single 17.7-inch torpedo tubes are mounted along the centre line between the two funnels. The railings would be de-rigged, the launching-tubes would pivot round, and the torpedo would be fired over the side towards the target.

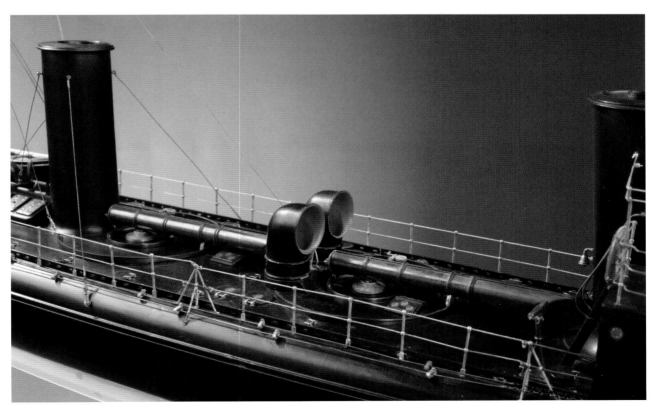

54

**British destroyer:**
*HMS Hope*

Builder's model, scale 1:48
Great Britain, 1910
Wood, metal, silver- and gold-plated fittings
50 × 127 × 26 cm

*HMS Hope* was built by Swan, Hunter & Wigham Richardson Ltd.,
Newcastle-on-Tyne, and launched in 1910. Measuring 246 feet in length
by 25 feet in the beam, she was powered by three Parsons steam turbines,
making her capable of a top speed of 27 knots. In 1912 she was assigned
to the British Navy 2nd Flotilla, and from 1914 to 1916 was part of the
Grand Fleet. From 1916–17 she was stationed at Dover and then in
the Mediterranean, and was sold for breaking up in Malta in 1920.

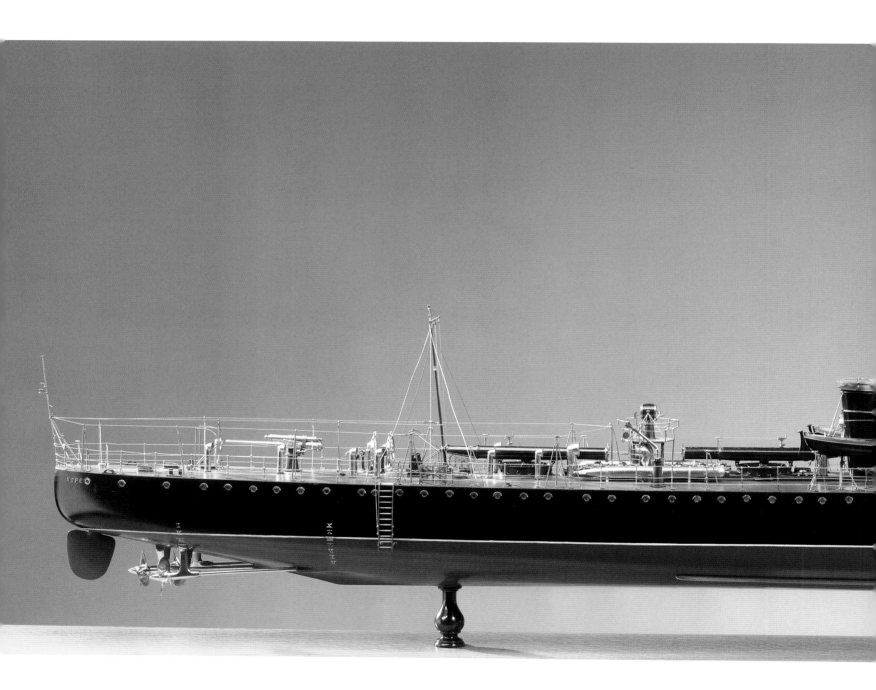

The portholes along the hull indicate the accommodation below decks. The ship's boats – two whalers and a dinghy – are rigged in davits for stowage as well as ease of launching. The *Hope* was armed with 4-inch guns at the bow and stern and with two 21-inch torpedo tubes amidships.

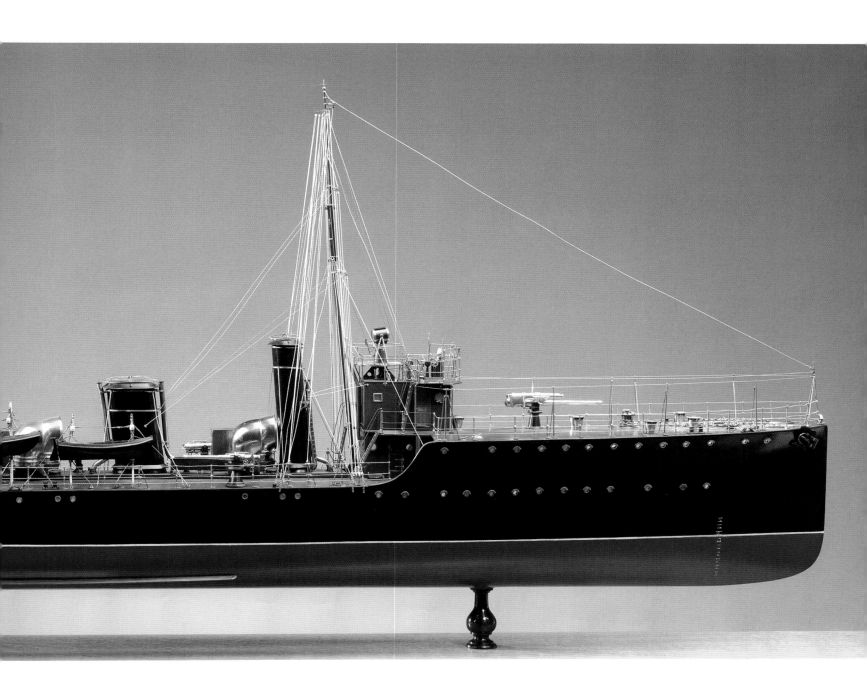

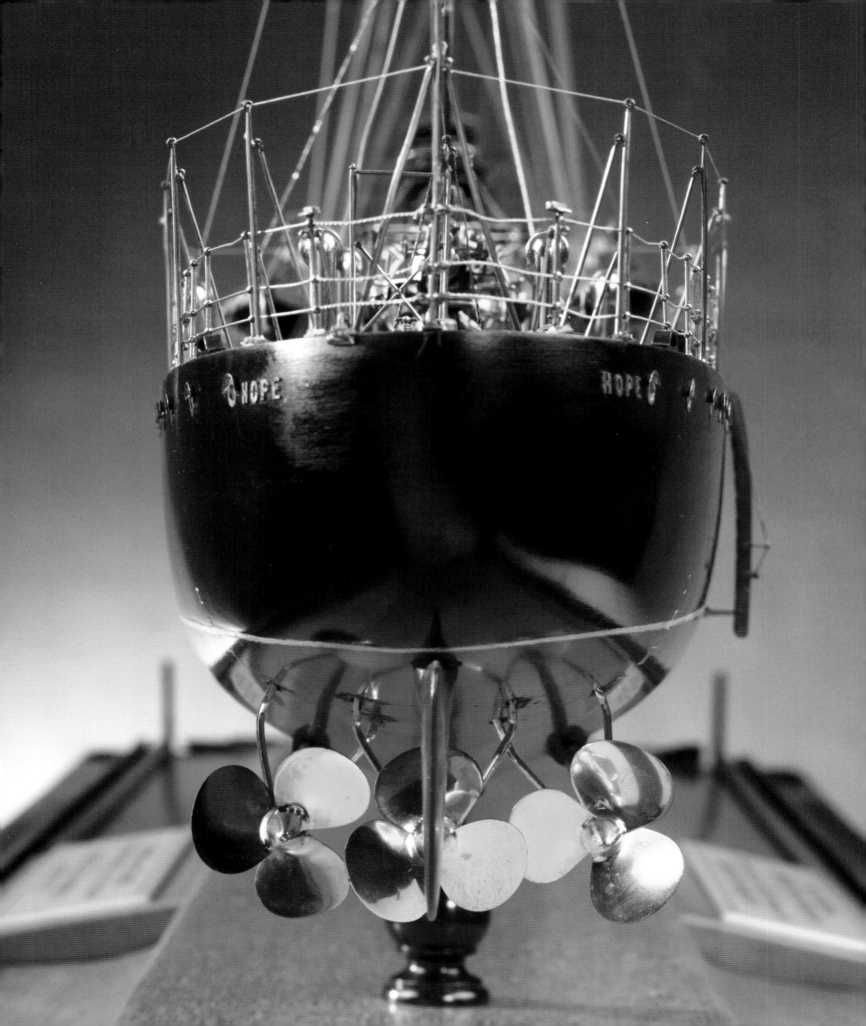

These fast destroyers were fitted with triple three-bladed propellers powered by steam-turbine engines. Above the normal stanchion railings are supports for rigging a canvas awning which would provide shelter from the elements when the ship was at anchor.

The double wheel would have been operated by up to four crewmen in an emergency, in the absence of hydraulic assistance. The 4-inch gun, mounted on deck, has a mechanism above the gun barrel to absorb the recoil when the gun has been fired.

The stern of the hull was designed to allow space for the propellers, the shafts of which were angled to achieve maximum bite. The elliptically shaped rudder was mounted aft of the propellers so as to achieve maximum manoeuvrability at all speeds.

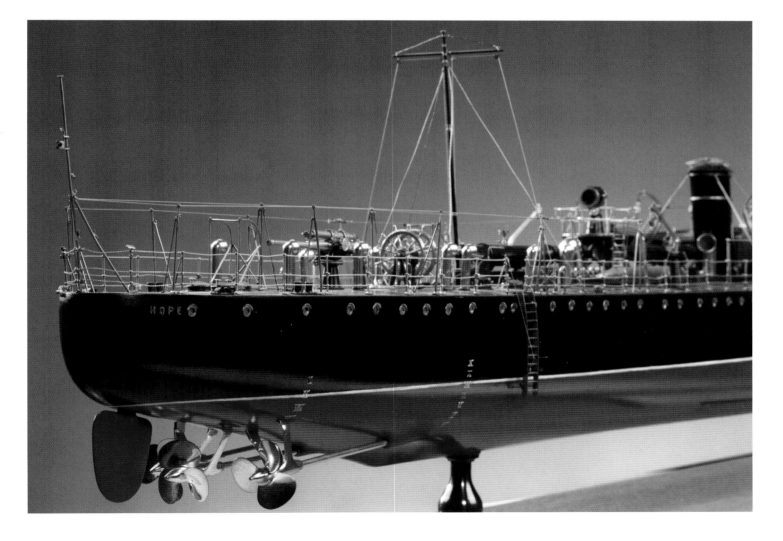

55

## British minesweeping sloop:
## *HMS Orby*

Builder's model, scale 1:48
Great Britain, 1918
Wood, metal, silver- and gold-plated fittings
69.7 × 171.5 × 22 cm

*HMS Orby* was one of twenty-two such vessels built under Britain's Emergency War Programme. Officially rated 'Fleet Sweeping Vessels (Sloops),' they were designed to confuse the enemy by their appearance. In the first place they had a resemblance to standard cargo ships. Secondly, the ships were built with vertical stems and sterns and a largely level main deck, while their superstructure was symmetrical, so that it would be difficult to distinguish bow from stern. Their direction of travel would not be apparent, for instance, to a U-boat commander, who had to fire his torpedo not directly at but into the course of his target. This class were built in two groups: ten, including the *Orby*, had their masts forward of the funnel; on the remaining twelve the mast was aft of the funnel.

*HMS Orby* was built by Swan Hunter & Wigham Richardson Ltd., Newcastle-upon-Tyne. Like others of her class, she was fitted with two single 4-inch guns and 40 depth charges and had a range of 3,000 nautical miles at a speed of 12.5 knots. Until 1917 sloops were used exclusively for minesweeping duties; subsequently they were reassigned to convoy duties. The *Orby* was sold in 1922 for breaking.

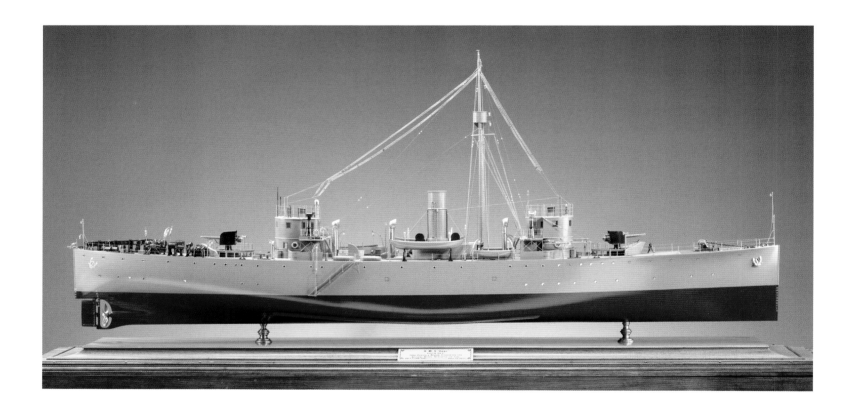

The forward bridge has an enclosed chart table above and twin Aldis lamps – shuttered lamps used for signalling between ships in the fleet – mounted on pillars on the deck below. The two tall ventilation cowlings behind provided fresh air below decks.

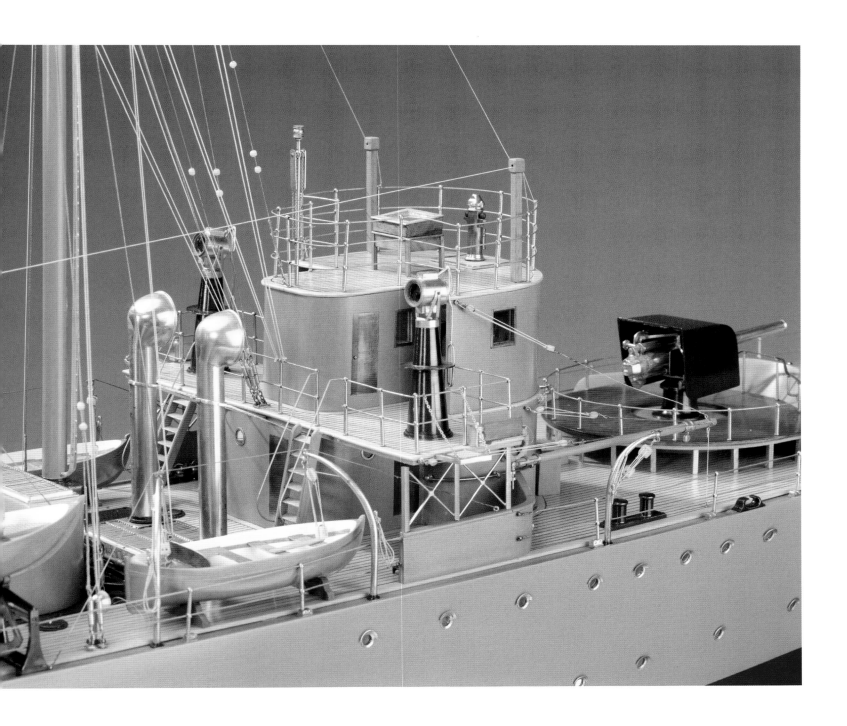

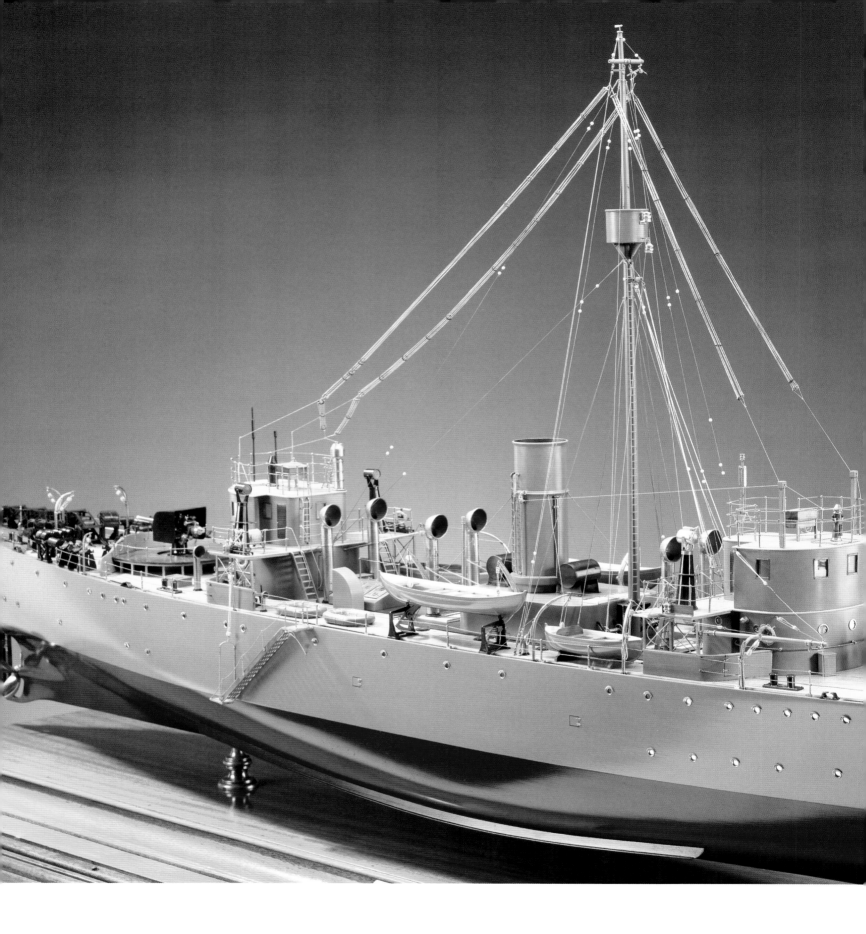

World War I warships

The bridges mirrored each other either side of the funnel; either could serve as the ship's command centre. This ship was also fitted with a pair of 4-inch guns, at the bow and stern.

At the stern a fake anchor was painted on the hull above the rudder and propeller to give the impression that this might be the bow. On deck are depth charges, high explosives thrown or rolled over the side that would detonate once they reached a set depth, thus destroying the submarine the ship's hydrophones had detected.

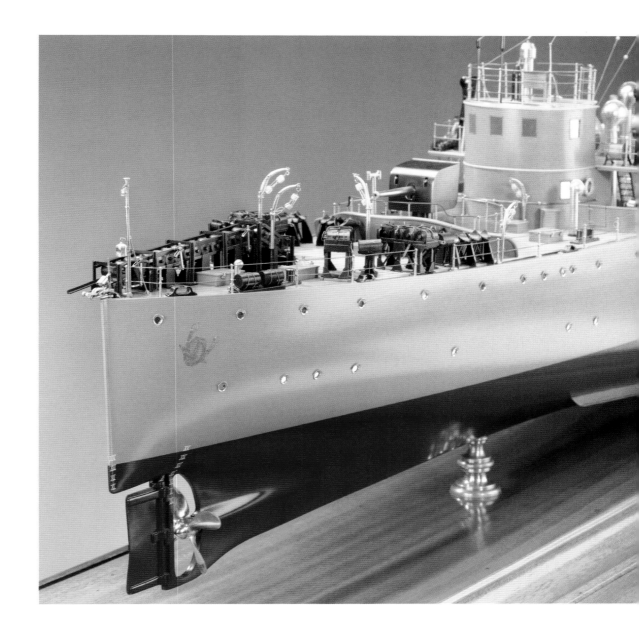

**British armed motor launch:**
*Mimi*

Builder's model, scale 1:16
Great Britain, 1914
Wood, metal, silver- and gold-plated fittings, paper
70.2 × 78.8 × 20.3 cm

The *Mimi*, a high-speed launch, had a fast hull
which was powered by twin propellers. She
was capable of speeds of up to 19 knots.

The rope fender with 'puddings' runs all the
way round the boat, providing protection for the
hull when coming alongside. The cockpit or seating
area is protected by a canvas awning against the
extremes of heavy rain or searing heat.

Built by Tom Bunn, subcontracted by J. Thornycroft, Twickenham, London,
in 1914, the armed launches *Mimi* and her sister vessel *Toutou* served on Lake
Tanganyika for the British Navy in 1915–16. They were each fitted with
two 136-horsepower petrol engines producing a speed of 19 knots and with
armament consisting of a three-pounder gun at the bow and a Maxim
.303 machine-gun aft. Lake Tanganyika, the longest lake in the world,
dominates central Africa and was of strategic importance during the
First World War, forming the boundary between the Belgian Congo and
German East Africa. The lake was policed by the German gunboat *Hedwig
von Wissmann*. The two motor-boats and a force of twenty-eight men were
shipped to Cape Town by sea, then travelled 3,000 miles by rail, and finally
were hauled 150 miles through the wild by steam traction engines and
oxen. Once launched on a tributary of the lake, the two vessels disabled
the German steamer *Kingani* in a brief action and took it as a prize (it was
renamed *Fifi*), then went on to sink German gunboat *Hedwig von Wissmann*.

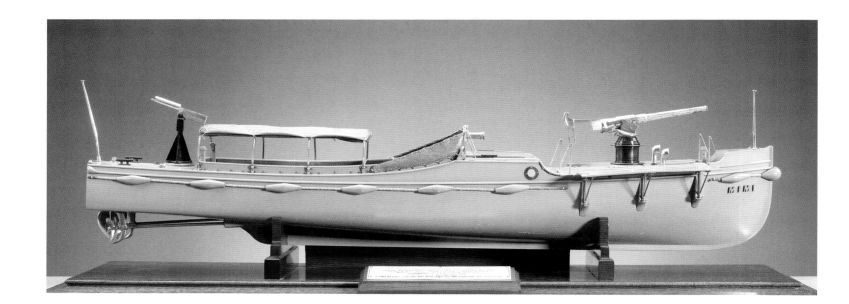

The canvas 'dodger' rigged on the edge of the cockpit protects the engine controls and steering equipment. There is a hand-cranked horn on the port side which can be operated from inside the canvas screen.

The hinged wooden platforms on either side of the bow would be raised from their stowed position to provide additional space for the crew to operate the gun through a 180° arc of fire. The quick-firing three-pounder gun is fitted on a pivoting mount fixed to the reinforced foredeck.

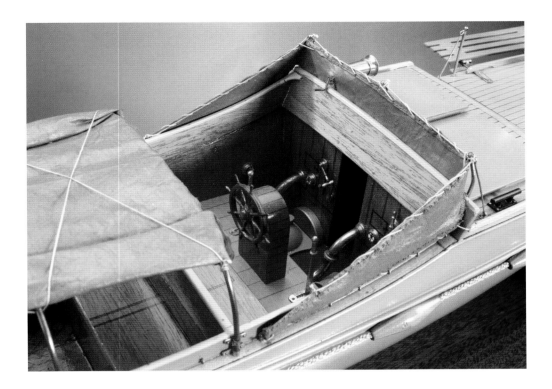

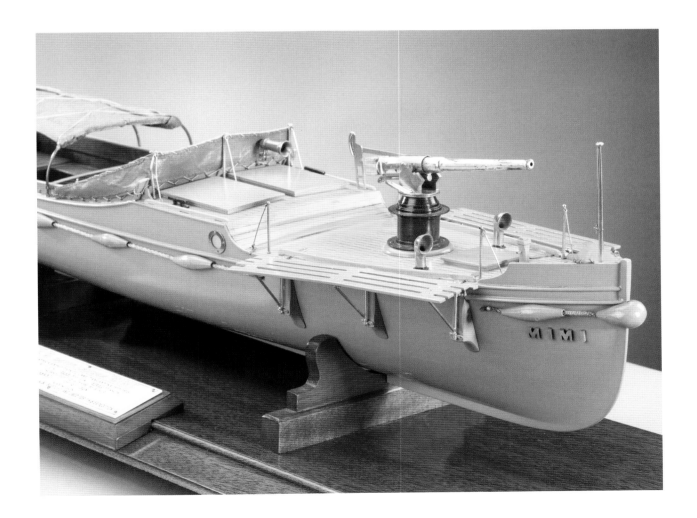

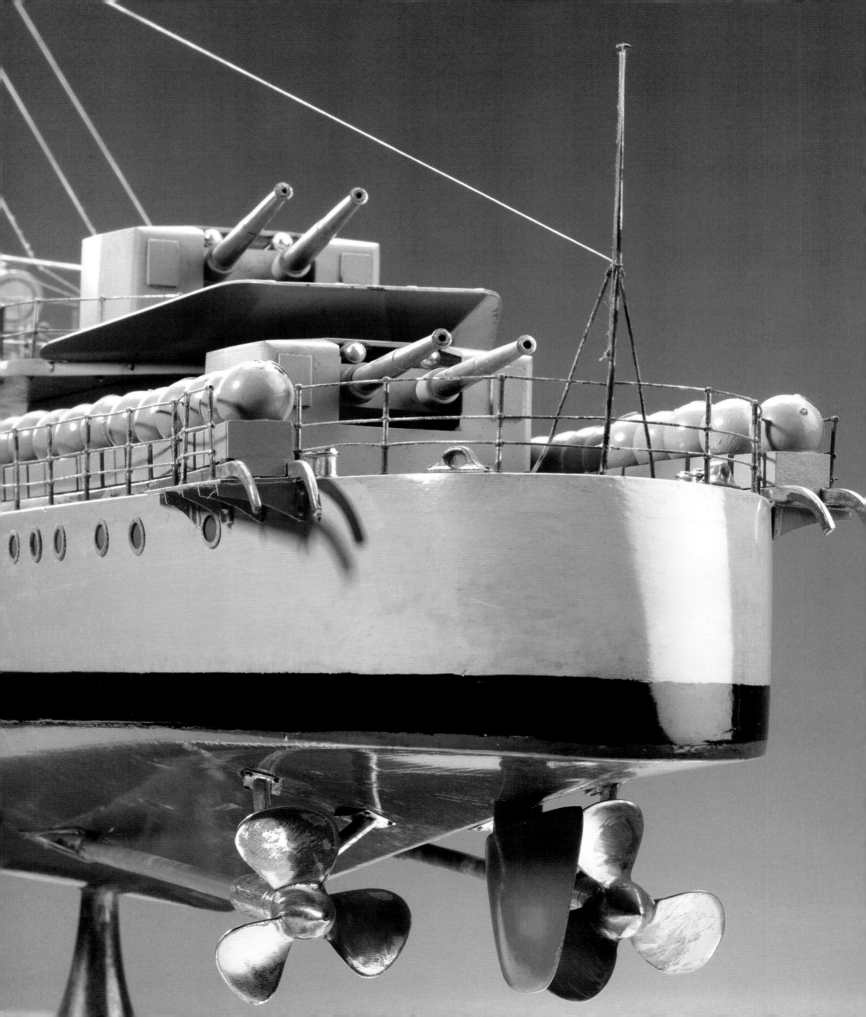

# World War II warships

Detail of no. 59
**British destroyer**

# British escort aircraft carrier: *HMS Activity*

Builder's model, scale 1:48
Great Britain, 1942
Wood, metal
42 × 160 × 38 cm

*HMS Activity* was laid down as a fast, refrigerated merchant ship to have been named *Telemachus*, but was requisitioned by the Royal Navy in 1941 and converted to an escort carrier, entering service at the end of 1942. She saw service in the Western Approaches and carried out convoy escort duties in the North Atlantic and Arctic, and in 1944 her aircraft, together with those from *HMS Tracker*, were responsible for the sinking in the Barents Sea of U-boat *U-288*, during convoy JW-58. On September 12, 1945 *HMS Activity* participated in the Victory Assembly at Singapore. In 1946 she was sold for mercantile conversion, renamed *Breconshire*, and traded for twenty years for the Glen Line between the Far East and Europe. She was broken up in Miihara, Japan, in 1967.

The lightweight and relatively stable Fairey Swordfish aircraft were flown from these anti-submarine escort carriers and were armed with bombs, depth charges and, later, 3-inch rocket projectiles. Protruding from the deck is the flight-deck control centre whilst below, along the hull, are several of the thirty anti-aircraft guns the ship carried.

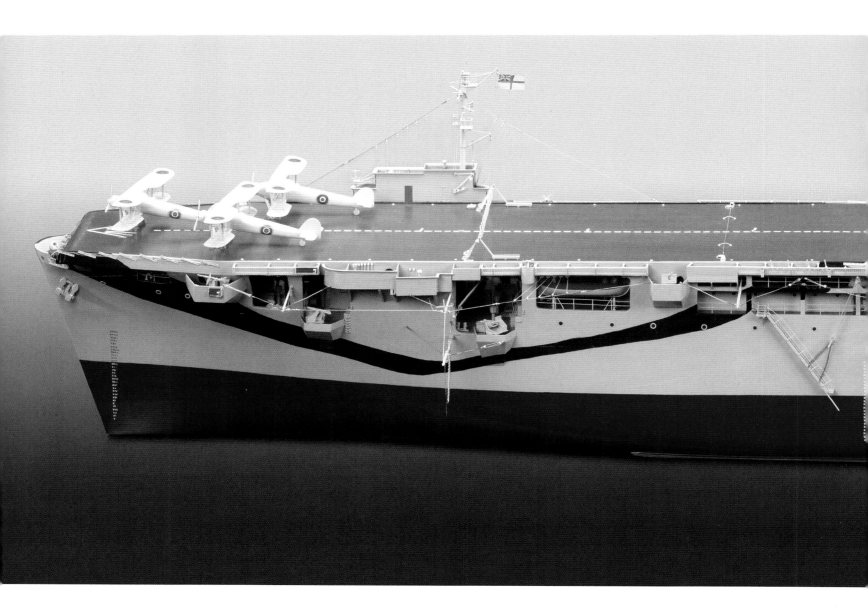

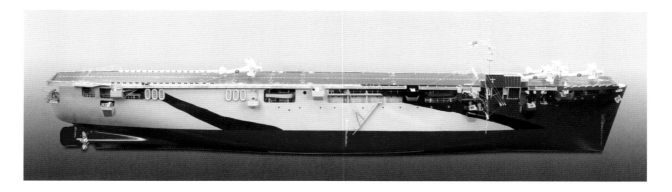

The portside view shows that the multi-coloured dazzle-painted camouflage, which was conceived to break up the ship's profile at sea (thus confusing the enemy when they tried to identify it from a distance through a submarine periscope or binoculars on a surface warship), intentionally differed from that of the starboard side. Most of the ship's equipment, including guns and ship's boats, was located below the flight deck, to avoid obstructing operation of the aircraft.

Draught marks at the bow, amidships and at the stern were used to trim the hull in order to provide a near horizontal and relatively stable flight deck for the aircraft. The white flaps on the flight deck towards the stern could be raised as windbreaks to protect the aircraft from gusts that might blow them over the side.

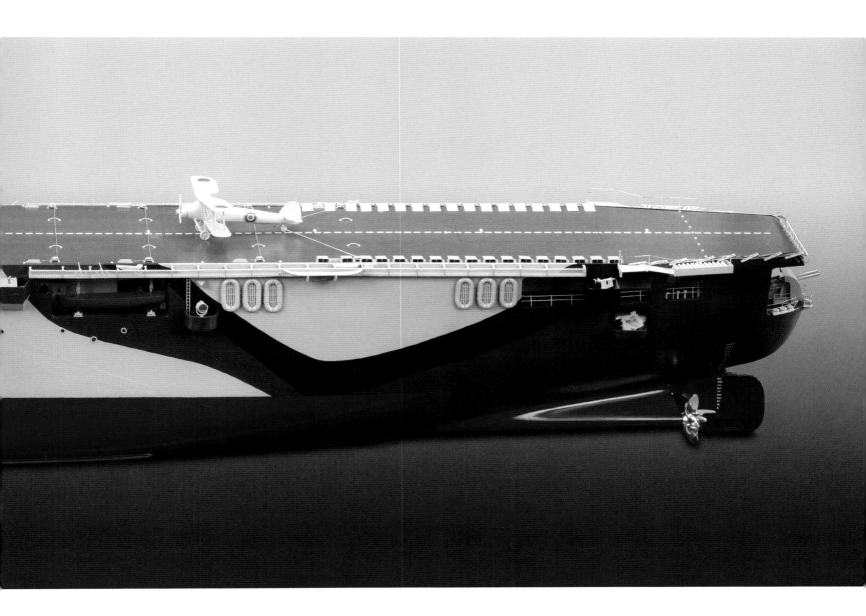

58

**British escort aircraft carrier:**
*HMS Vindex*

Builder's model, scale 1:48
Great Britain, 1943
Wood, metal, silver-plated fittings
49 × 165 × 26 cm

While still being built by Swan, Hunter & Wigham Richardson Ltd. in 1943 as the merchant ship *Port Sydney*, the hull was taken over by the British Navy and converted into the escort aircraft carrier *Vindex*. She became the first specialist night anti-submarine carrier. Fitted with quick-firing and anti-aircraft guns, she carried twenty single-wing Fairey Fulmar aircraft. In August 1943 she was sold to the Western Approaches for trade protection and convoy duties. She also took part in the Russian convoys, and joined the British Pacific fleet as a replenishment carrier. In August 1947 she was sold and converted back to a refrigerated cargo liner, named *Port Vindex*, operating between Britain, Asia and Australia. As well as transporting a standard cargo of grain, she once carried five tons of gold and the Greek crown jewels. She was scrapped at Kaohsiung, Taiwan, in 1971.

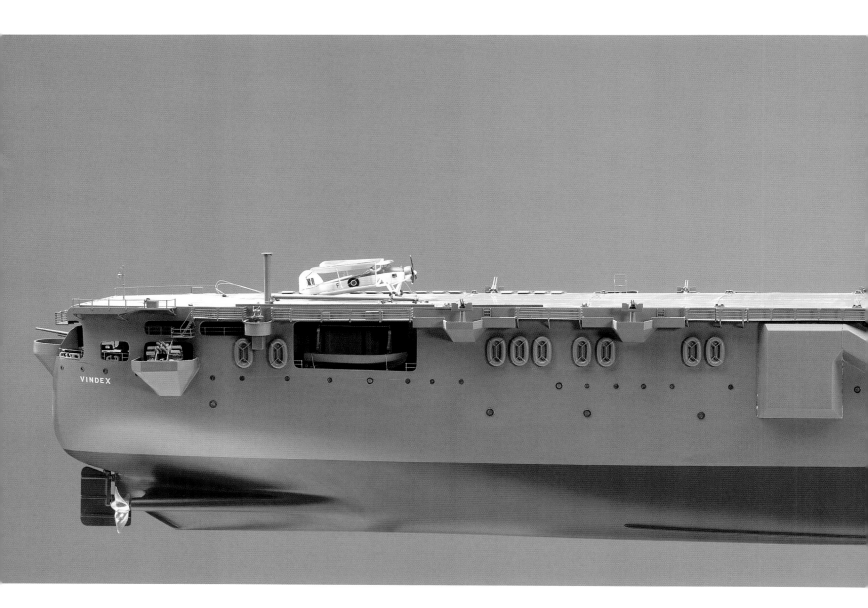

These converted merchant ship hulls required some 2,000 tons of ballast to compensate for the top-heavy weight of the steel flightdeck. The aircraft were stored with their wings folded in a hangar below the flightdeck, accessed by a large lift at the stern. The large square flat fitting amidships is the exhaust outlet for the ship's diesel engines, substituting for a funnel, which would have created an obstruction on deck.

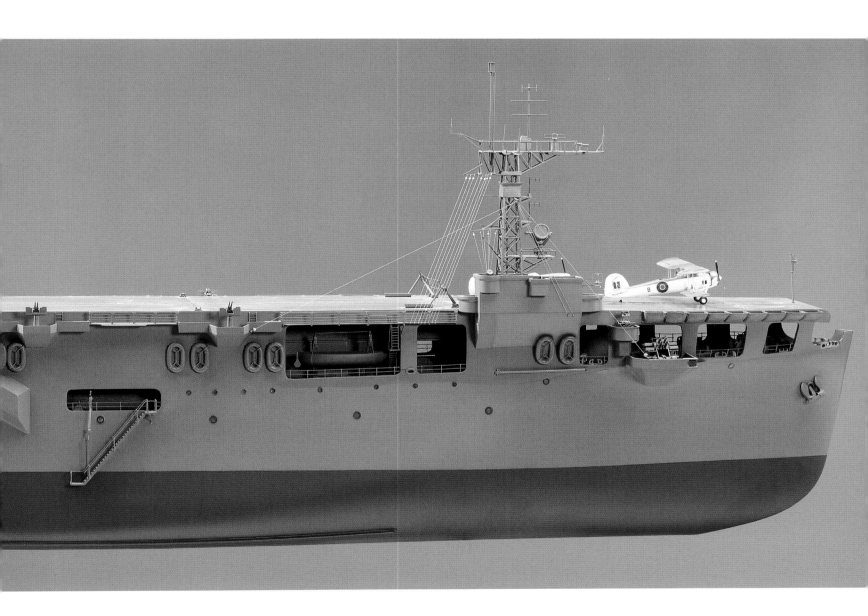

This bow view at flightdeck level shows the anti-aircraft guns and life-saving rafts along the hull and gives a glimpse inboard, where the anchor handling gear and ship's boats were located.

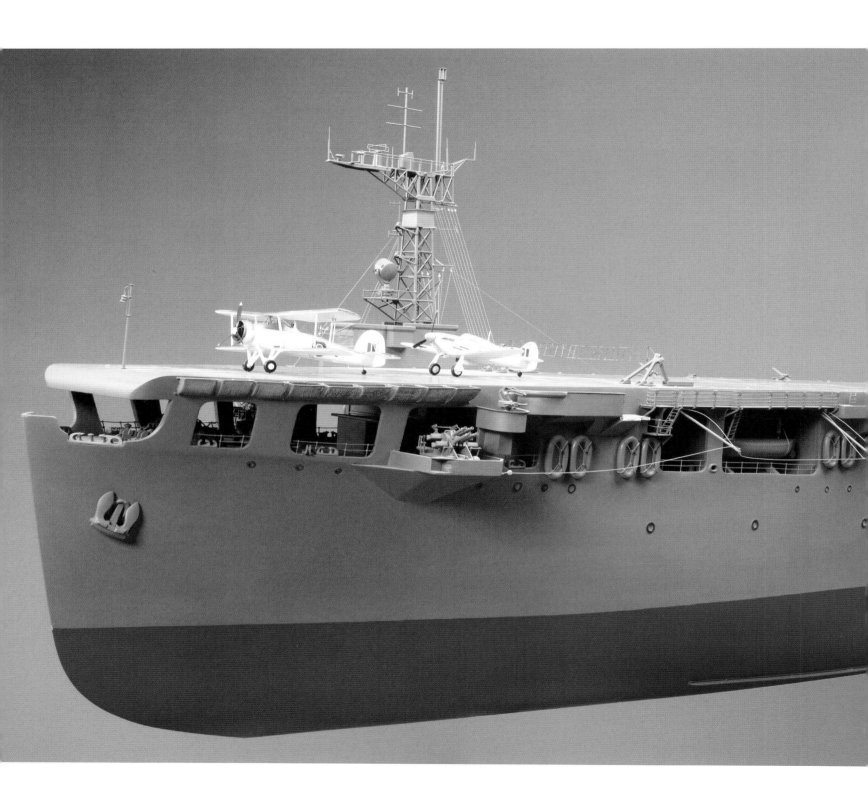

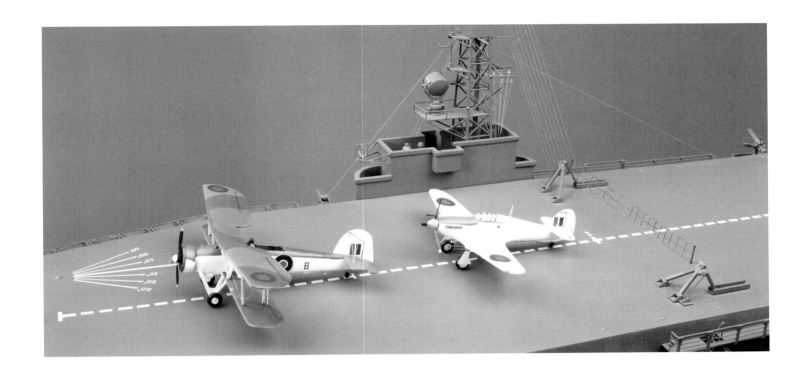

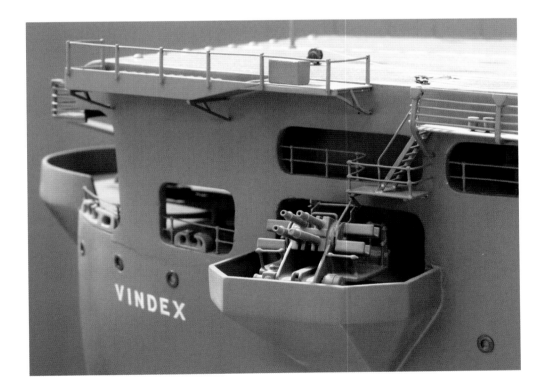

The single-wing Hawker Sea Hurricane – never actually carried operationally on *HMS Vindex* – provided cover against air attack. The crash net, rigged up astern of the two aircraft parked on the forward flight deck, prevented landing aircraft from crashing into stationary aircraft should they fail to engage the four arrester wires. If the pilot missed the wires and there were no aircraft parked on the forward flight deck, he would simply fly through and circle round for a second attempt.

The detail shows one of the ship's anti-aircraft guns – two-pounder 'pom poms'. On the flight deck can be seen the first of several lines of arrester wires that would snag the hooks mounted under the tails of the incoming aircraft.

## 59
## British destroyer

Builder's model, scale 1:48
Great Britain, 1937–39
Wood, metal, silver-plated fittings
46 × 153 × 11.4 cm

Models were often made to illustrate a proposed design, for they were the perfect vehicle for illustrating the lines of the hull as well as the layout of the various fixtures and fittings. This is a conceptual model, proposed by Yarrow and Co. Ltd., Glasgow, of a 40-knot armed destroyer incorporating existing features from the I, J and Tribal classes of British destroyers. Destroyers were used notably for escort duties, minelaying and throwing depth charges, and attacking enemy warships of all types.

The ship was to be laid out with two twin 4.7-inch guns forward of the bridge and similar pairs of guns at the stern. Aft of the funnel were to be two sets of torpedo tubes, and besides the guns at the stern were to be mines on rails ready for launching. The portholes indicate the accommodation below decks. The high and flared bow with forecastle would enable the ship to plough through difficult seas at a good operational speed.

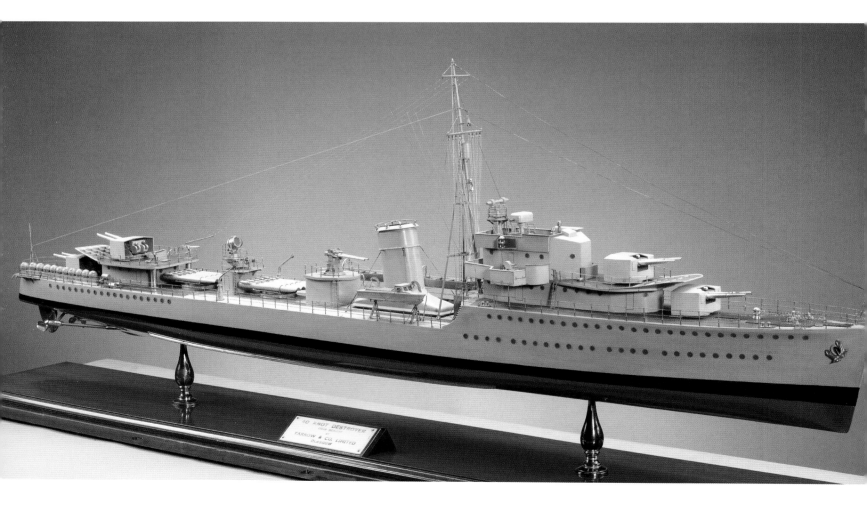

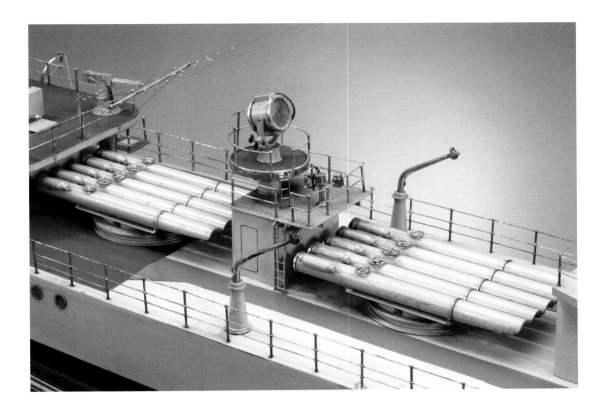

Two sets of five 21-inch torpedo tubes were to be fitted amidships, together with a searchlight on a raised platform, used for communication or to illuminate the sea at night.

On rails on either side of the of the 4.7-inch guns on deck are mines, together with their rectangular sinkers underneath, ready for launching over the stern. The twin screws on angled shafts are connected via a gearbox to the main engines.

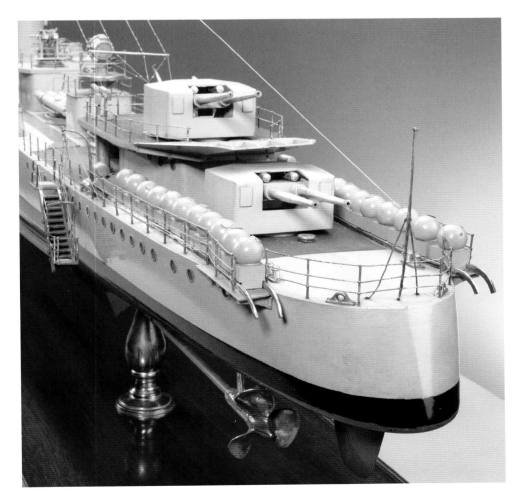

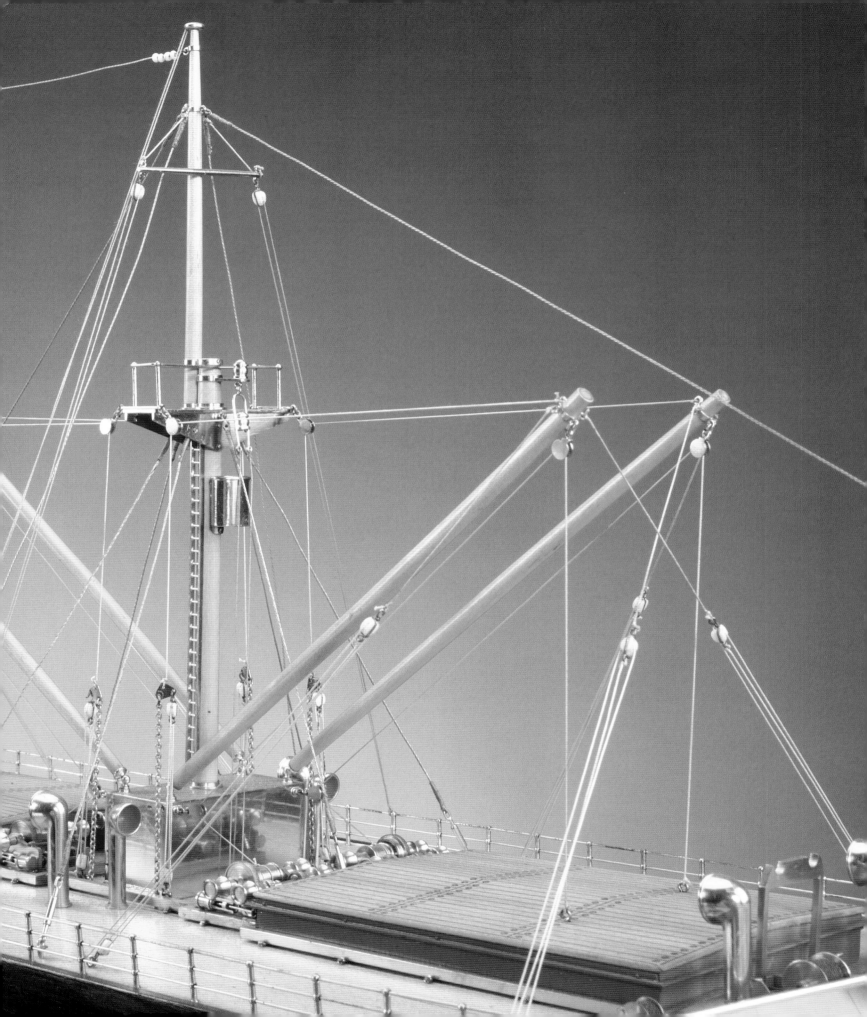

# General cargo, fishing and passenger vessels

Detail of no. 67
**British cargo ships: *Rodsley,
Rawnsley, Rookley* and *Reaveley***

60

## British turret-decked steamer: *Clan Alpine*

Builder's model, scale 1:48
Great Britain, 1899
Wood, metal, silver- and gold-plated fittings
74 × 238 × 33 cm

Turret-decked steamers were designed to take advantage of the reduced harbour dues charged for cargo below the waterline. The wider lower hull is mostly cargo space while the ship's machinery and the crew accommodation were all above, in the narrower 'turret' deck on top of the main hull.

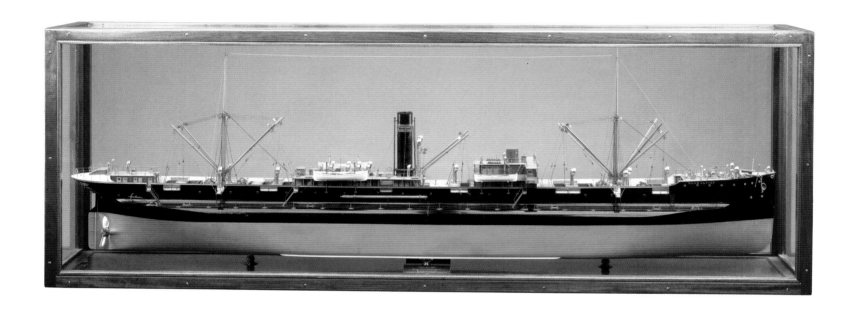

On deck is an array of equipment such as circular cowlings giving ventilation below decks, a large windlass for the anchor gear and, situated between the two anchors, a steam-powered capstan for handling the mooring ropes when coming alongside a quay or working in the docks.

There are cargo hatches either side of the masts and another, smaller hatch just forward of the funnel. An unusual feature of this model is that the cargo hatches are shown partially open with the boards removed. This was obviously done in order to highlight the advantage of the turret-deck system in providing improved cargo space and access.

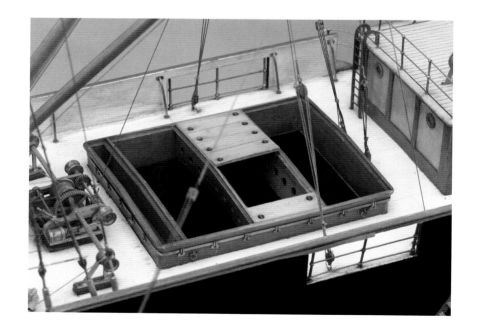

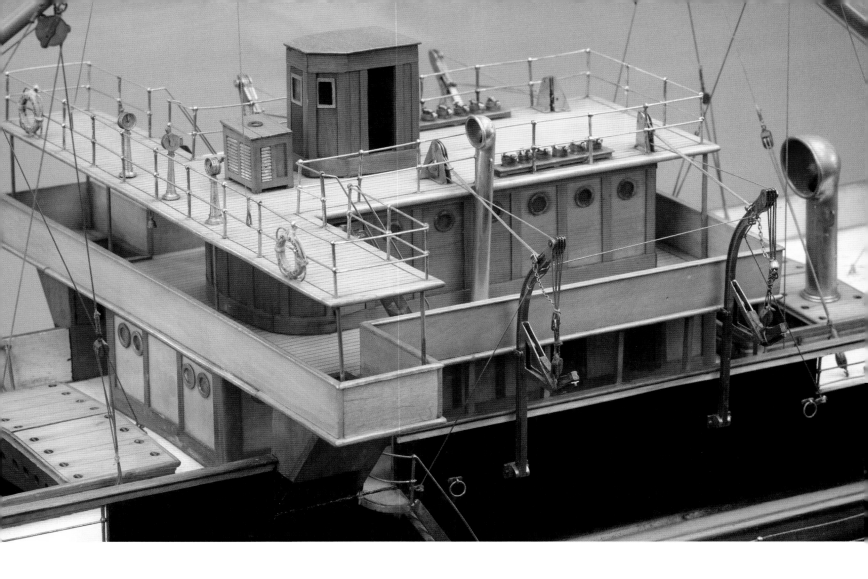

The bridge is fully equipped with navigational and steering equipment. The small louvred cupboard just forward of the wheelhouse holds instruments for making weather observations. Two rows of fire buckets are shown, since the outbreak of a fire on board a ship could have fatal consequences. The davits in which the lifeboats were stowed were specially designed so that the boats could be launched over the extended hull.

The draught marks painted on the rudder blade just aft of the propeller were used for trimming the ship during the loading and unloading of cargo. Because there was limited space on deck, equipment such as the smaller kedge anchor was stowed on the lower hull.

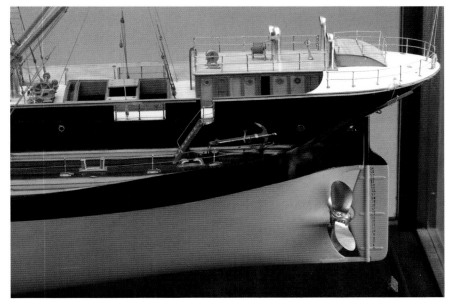

# British cargo ship: *Chantala*

Builder's model, scale 1:96
Great Britain, 1913
Wood, metal, silver-plated fittings
33.3 × 131.5 × 16 cm

Originally named named *Shahristan*, this passenger-carrying cargo ship was built by Richardson, Duck & Co. Ltd., Stockton-on-Tees, for the Anglo-Algerian Steamship Co. (1896) Ltd. and managed by F.C. Strick & Co. Launched in 1913, she was bought on completion by the British India Steam Navigation Co. and renamed *Chantala*. Three years later, off the Algerian coast, 15 miles north of Cape Bengut, she was torpedoed by the German submarine *U-34*. The torpedo hit the engine room, killing the fourth engineer and eight firemen. The rest of the crew fled for safety in lifeboats. The submarine later surfaced, sending a boat to loot the ship of its valuable cargo and to set time bombs to destroy *Chantala* completely.

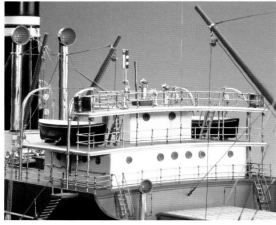

The bridge included accommodation for officers as well as the pilot house, and also carried lifeboats. At the end of the bridge wings are the navigation lights – green to starboard, red to port.

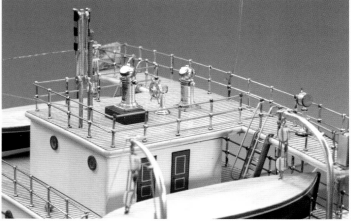

The bridge deck is shown complete with the navigation equipment of the day, including binnacles with compasses, semaphore signalling paddles, the wheel, and engine-room telegraphs for transmitting orders down to the engine room.

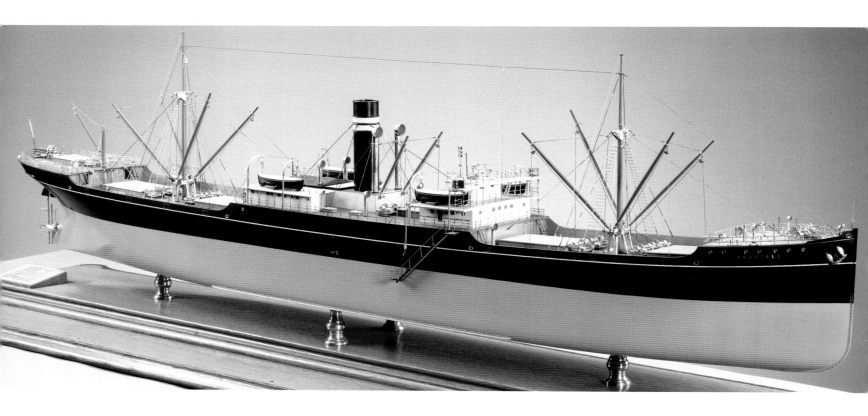

Some of the crew were accommodated in the forecastle at the bow of the ship. Equipment was also kept there and there was a workshop for the day-to-day maintenance of the ship.

The cargo derricks were operated by steam winches at the foot of the mast and could load and unload cargo from either side of the ship. The mast was supported by shrouds with ratlines (rope ladders), used for access and maintenance.

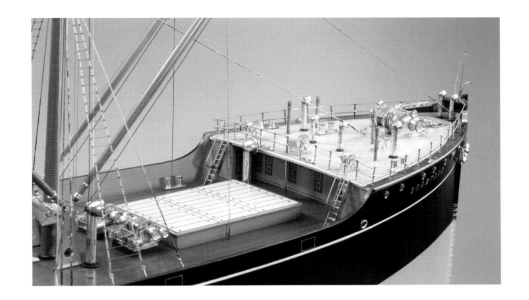

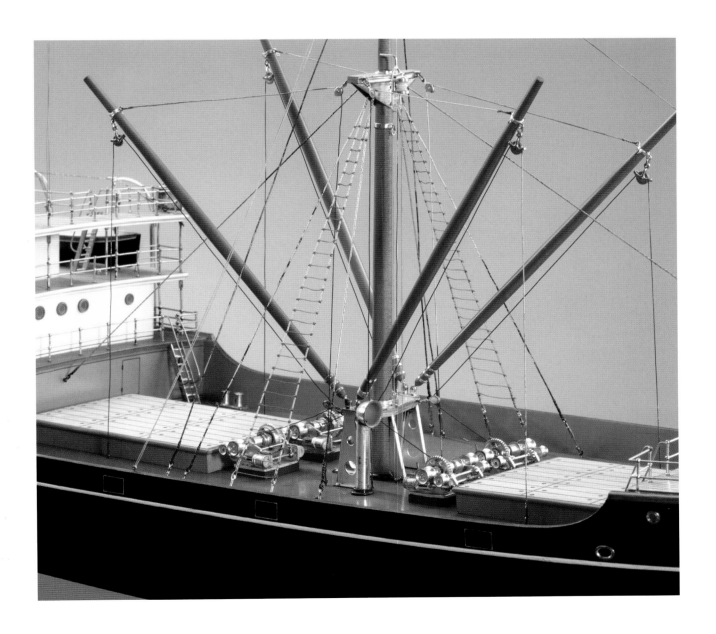

62

**British cargo ship: _Plawsworth_**

Builder's model, scale 1:96
Great Britain, 1917
Wood, metal, silver-plated fittings
40.2 × 133 × 15.3 cm

The _Plawsworth_ was built by Richardson, Duck and Co. Ltd., Stockton, for the Dalgliesh Steam Shipping Company Ltd. in 1917. On July 13, 1918, under the command of R.T. Deans, it was attacked by a submarine and sunk by torpedo 105 miles west by north from Bishop Rock. As was typical at this period, no warning was given, though in fact only one life was lost.

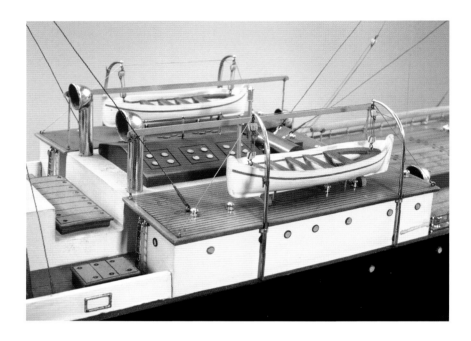

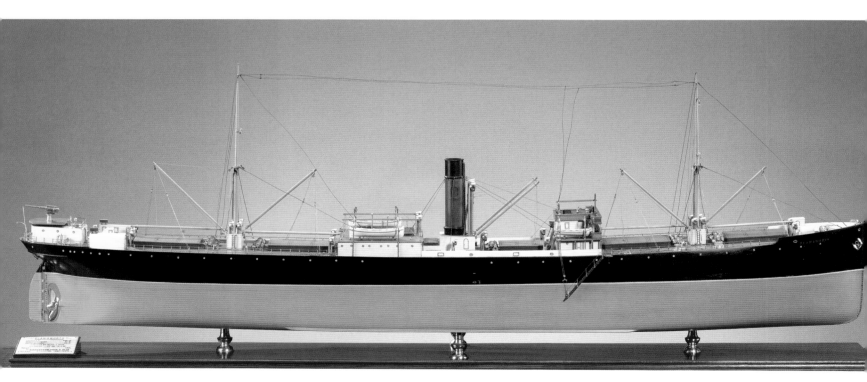

General cargo, fishing and passenger vessels

There is a wooden companionway rigged over the side of the hull. This was used to provide access to the pilots who would guide the vessel in and out of the local port. It could also be used when the ship was afloat for the crew to go ashore or when the vessel was alongside a quay or dock.

As is typical of builder's models, some of the details were drawn on in ink – such as hatch covers and windows on the bridge (which have been shaded in the top right-hand corner to indicate glass).

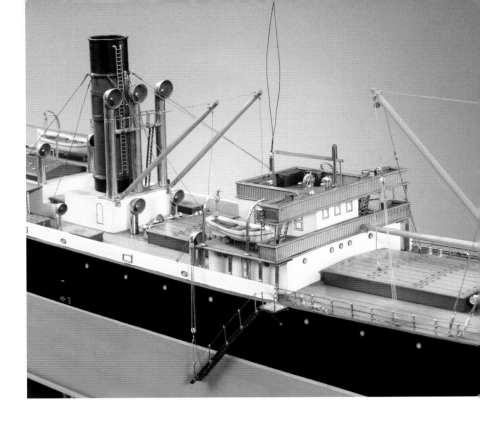

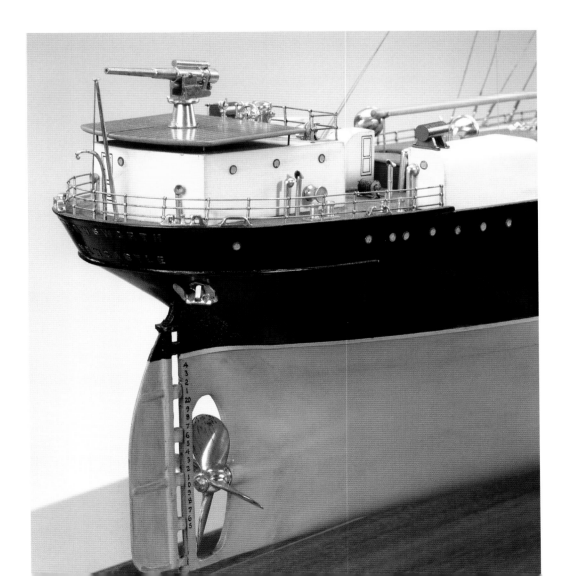

A specially designed and strengthened deck was mounted over the accommodation at the stern to take the load of a gun.

The hull is also fitted with a stern anchor, that would be used in tidal waters together with the bow anchor to stop movement when the tide turns.

63

## British passenger and cargo ships: *Longships* and *Goodwin*

Builder's half-model, scale 1:48
Great Britain, 1917
Wood, metal, gold-plated fittings,
surface silvered mirror
61 × 213 × 27.9 cm

Built by the Caledon Shipbuilding and Engineering Co. in 1917 for the Clyde Shipping Co. Ltd., Glasgow, in 1917, *Longships* and *Goodwin* each measured 270 feet in length and 37 feet in the beam, and could accommodate 47 passengers and 31 crew. They could reach a speed of 14.8 knots.

The *Goodwin* was requisitioned by the Admiralty from 1917 to 1919, when it was armed with 4-inch guns and used as a decoy ship under the aliases *Ballantrae*, *Moderley* and *Underwing*, and again in 1940. From June 1943 to the end of the Second World War she served as a convoy rescue ship. She was broken up in 1955. *Longships* was also requisitioned for war service by the Admiralty in 1917. In December 1939, on a passage from Belfast to Plymouth, she was stranded on the Seven Stones Reef off the Isle of Scilly, and sank on 1 January 1940.

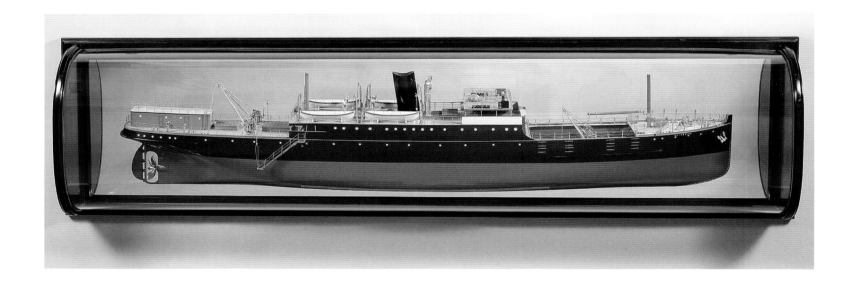

## British cargo tramp steamer: *Menin Ridge*

Builder's model, scale 1:96
Great Britain, 1924
Wood, metal, ivorine, silver-plated fittings
17.5 × 97 × 12.8 cm

Tramp steamers would sail from port to port around the world picking up cargo as and when they could. This particular ship regularly carried coal from Barry, South Wales, to various locations in Europe. Built by the Scottish firm of Burntisland Shipbuilding Co. Ltd. and launched in 1924 as the *Pentirion*, she measured 298 feet in length by 44 feet in the beam and had a tonnage of 2,474 tons gross.

Renamed the *Menin Ridge* in 1930, on 24 October 1939, whilst on a voyage from Djidjelli to Port Talbot with a cargo of iron ore, she was torpedoed and sunk by the German submarine *U 37*, about 80 miles west of Gibraltar. There were five survivors from the crew of twenty-five.

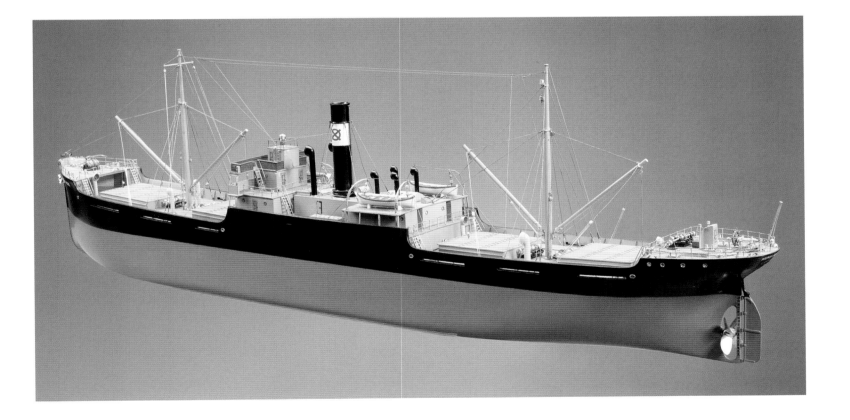

## 64

## Spanish trawlers:
## *Galerna* and *Vendaval*

Builder's model, scale 1:48
Great Britain, 1927
Wood, metal, silver-plated fittings
60 × 143 × 30 cm

Steam fishing trawlers of this type were built in large numbers between the two World Wars. Trawlers of this size were designed for deep-sea and long-distance work, and sometimes also would carry fish from other, smaller trawlers back to port for sale at fish markets. The *Galerna* and the *Vendaval* were designed and built by Hall, Russell & Co. Ltd. of Aberdeen and launched in 1927. Owned by the Spanish company of Pesquerias y Secaderos de Barcalao de España, they measured 216 feet in length by 34 feet in the beam, and had a tonnage of 1,164 tons gross. They were fitted with all modern conveniences, including wireless communications and electric lighting – enabling working on deck at night. The *Galerna* was unusual in being under single ownership for all her working life, before being broken up at El Ferrol in northern Spain in 1965.

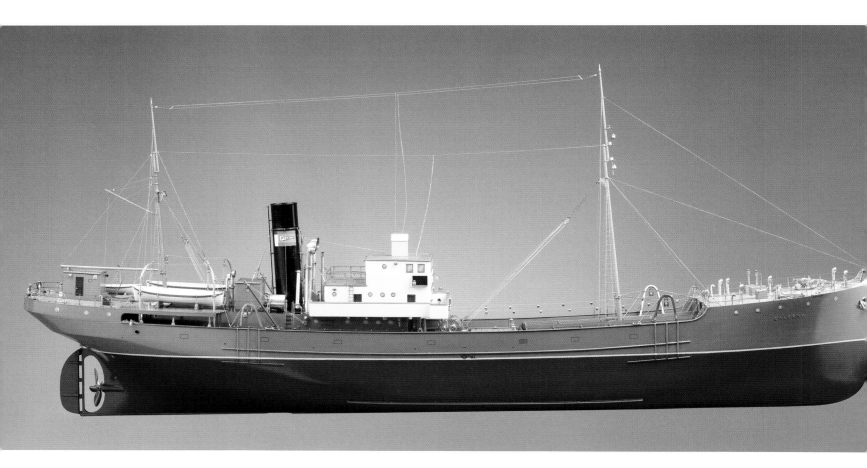

General cargo, fishing and passenger vessels

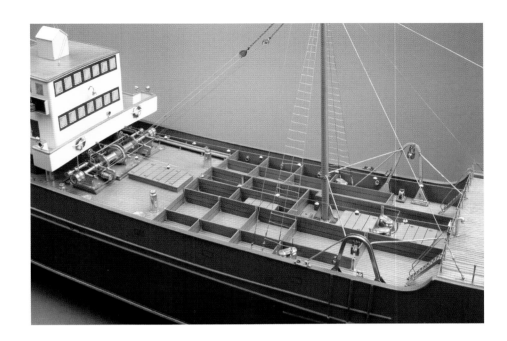

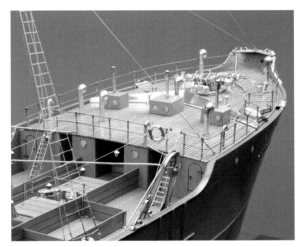

The nets were hauled aboard the main deck using tackles rigged to the foremast. The knot on the so-called 'cod' end of the net was released and the catch deposited in the various sorting pens on deck. The fish were then gutted and cleaned and sent down below to be packed in boxes with ice. The large arch-shaped 'gallows' on the sides were fitted with a metal sheave through which the net cables (warps) were worked.

In the bow a sheltered foredeck housed cabins for some of the crew as well as space for stores and equipment.

At the stern a spare propeller was stored at the foot of the mizzen mast; there was also a spare anchor, lashed to the deck cabin, as well as a towing hook (for towing smaller trawlers that might be in trouble) on deck between the two lifebuoys.

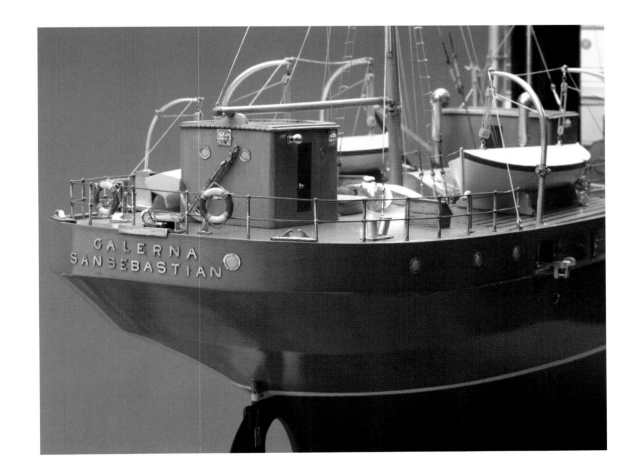

# Japanese liner: *Chichibu Maru* (renamed *Kamakura Maru*)

Builder's model, scale 1:96
Japan, *c.* 1930
Wood, metal, gold-plated fittings
64 × 188 × 31 cm

Built by the Yokahama Dock Co. Ltd. in 1928–30 for the Yokohama–San Francisco run, the *Chichibu Maru* was, until 1939, Japan's largest passenger ship and the pride of her fleet. She had seven decks and could accommodate 817 passengers, twenty lifeboats and two motorboats. She was renamed *Titibu Maru* in 1938 and *Kamakura Maru* in 1939. In 1942 she was used as a troop transport ship and as a hospital ship for the Japanese Navy. She was scheduled to be converted to an escort carrier (38 aircraft) in the following year, but was sunk on April 28, 1943 by torpedoes from US submarine *Gudgeon*, some 30 miles south-west of Naso Point, Panay (Philippines). The then *Kamakura Maru* was on a voyage from Manila to Singapore, unescorted – probably relying on her speed to keep clear of submarines. She sank in twelve minutes.

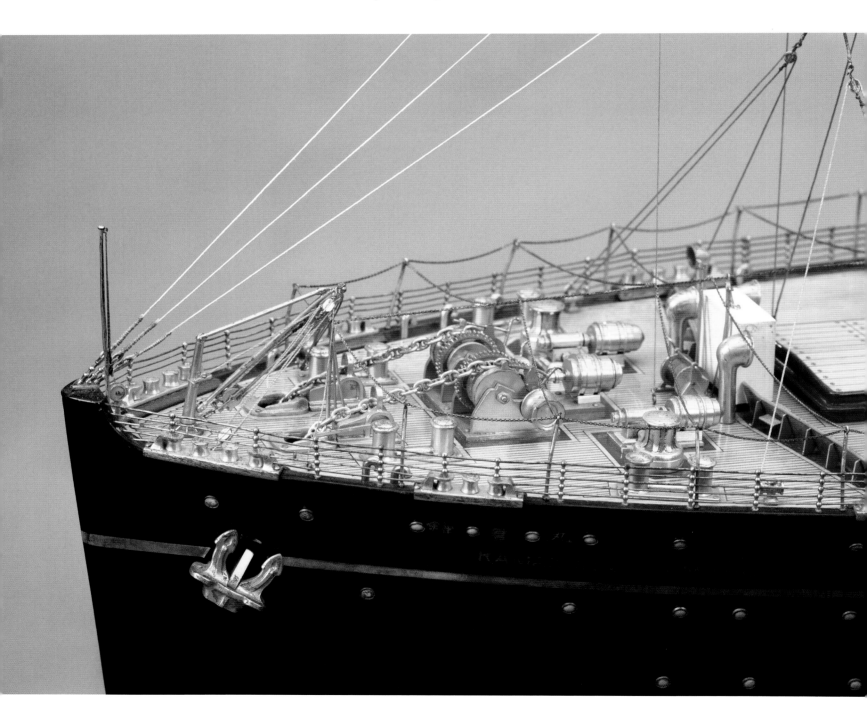

The *Chichibu Maru* exemplifies the Japanese builder's style of modelmaking, in which there is much more gold plating of the metal fixtures and fittings than, for instance, in the British style, in which silver plating predominated (and would tarnish over a period of time). The model was originally built as the *Chichibu Maru* but the name and port of registry on the bow and stern were later overpainted to conform with the ship's new name.

Passenger ships had by law to carry large numbers of lifeboats, the design of which generally followed the European double-ended type. The *Chichibu Maru* was fitted both with these and with launches of traditional Japanese design.

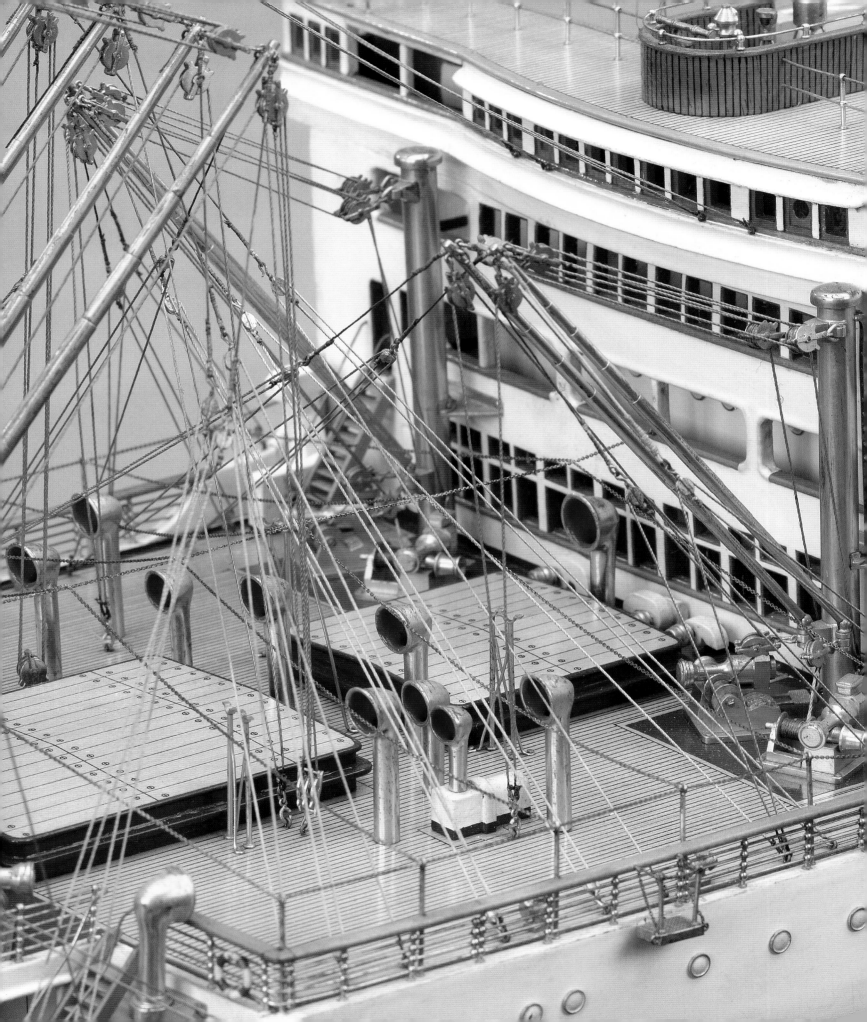

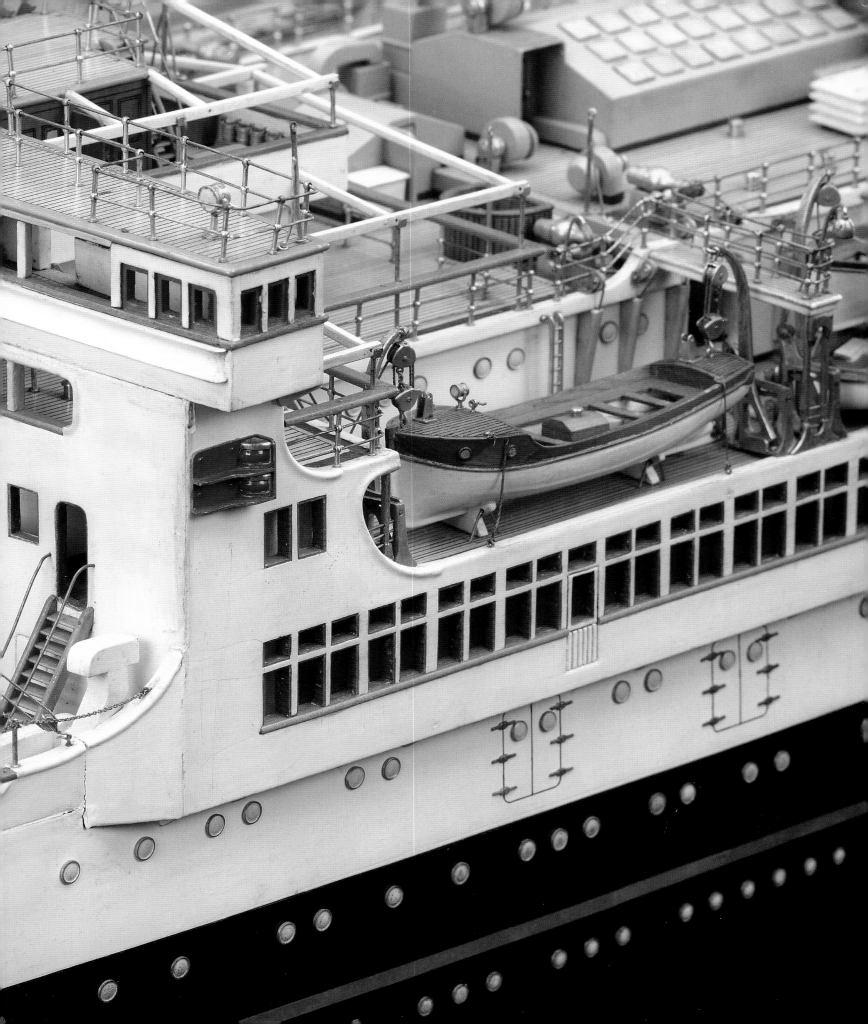

## 66

### British cargo ship: *Glamis*

Builder's model, scale 1:48
Great Britain, 1936
Wood, metal, silver-plated fittings, silvered glass
90.5 × 110 × 34.5 cm

Built by the Caledon Shipbuilding and Engineering Co. Ltd. and launched in 1936, the *Glamis*, working on the east coast of Scotland, was requisitioned for war service on September 5, 1939. She was then employed until June 1942 sailing between north-western English ports and Northern Ireland. Returning to the east coast she ran from Leith or Methil in the Firth of Forth to Scapa Flow. Between August and December 1943 she traded in the Irish Sea and ran between Liverpool and the Isle of Man. She was de-requisitioned for a short time, but in preparation for D-Day she was once again requisitioned, in April 1944, and subsequently sailed out of the Solent to Normandy. When the Allied forces had advanced further into Europe and the port of Antwerp was re-opened, she moved up the River Scheldt. In July 1945 she returned to Dundee, then was sold abroad in 1961, passing through six owners and five new names before being deleted from Lloyd's Register in 1995, ultimate fate unknown.

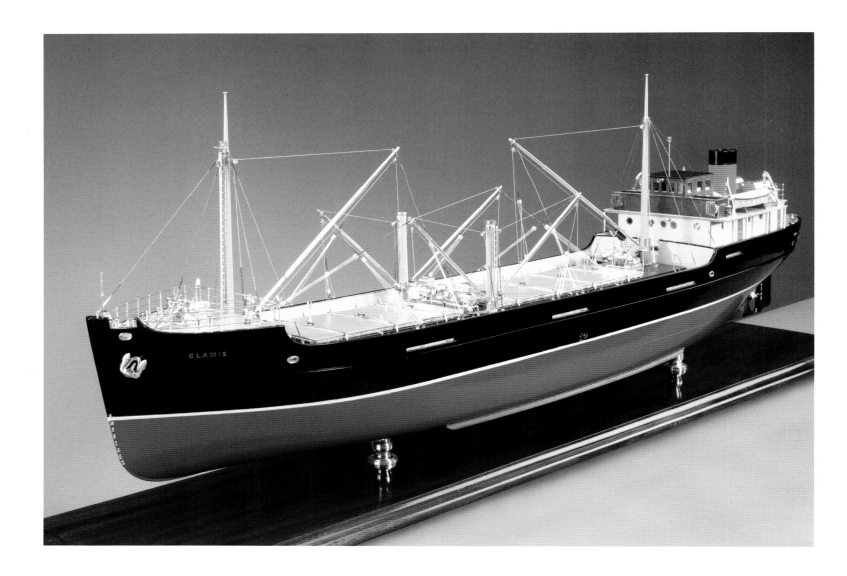

General cargo, fishing and passenger vessels

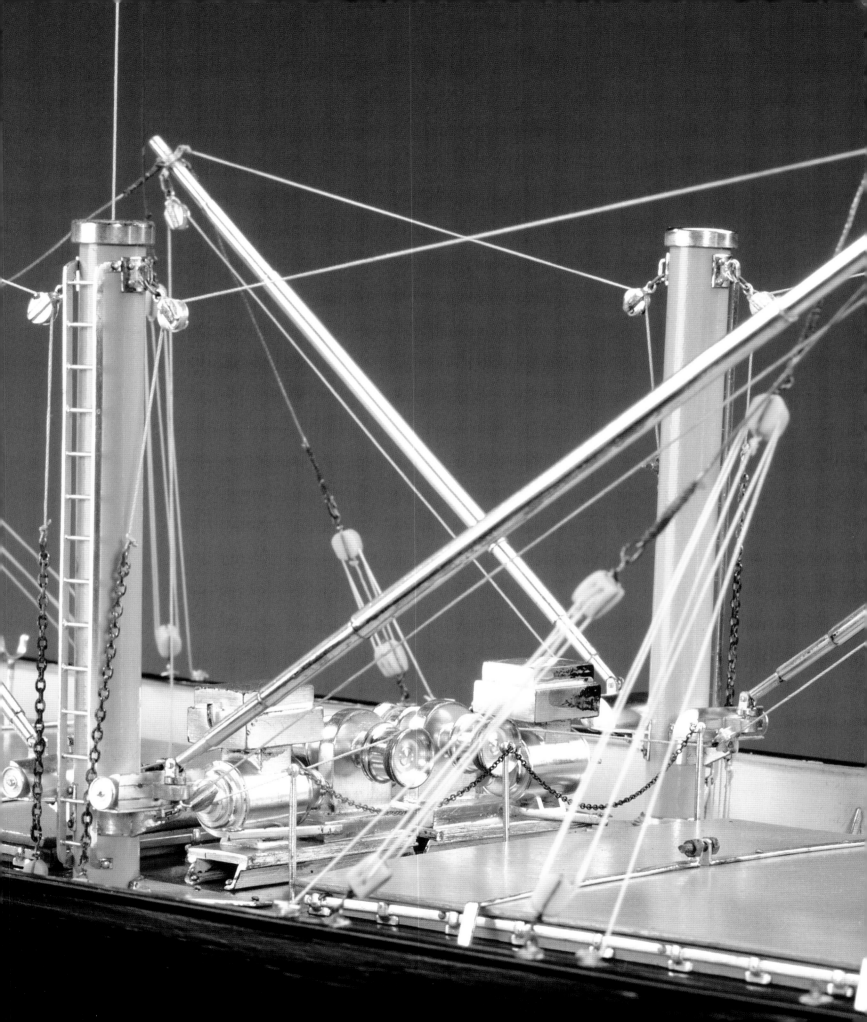

## 67

## British cargo ships: *Rodsley, Rawnsley, Rookley* and *Reaveley*

Builder's model, scale 1:96
Britain, 1939–40
Wood, metal, gold-plated fittings
34.2 × 139.2 × 16.2 cm

This was the model for four single-screw economy motor cargo ships, the *Rodsley, Rawnsley, Rookley* and *Reaveley*, built to the orders of Stephens, Sutton Ltd., Newcastle-on-Tyne, by William Doxford & Sons Ltd., Sunderland, in 1939–40. Over the next three decades *Rodsley, Rookley* and *Reaveley* continued working, each being sold and re-sold to various shipping companies around the world, but *Rawnsley* was bombed by aircraft off Crete whilst on passage from Haifa to Souda Bay in 1941. She was taken in tow to Makryallo Bay for beaching but, owing to bad weather, had to be anchored at Hierapetra Bay, where she sank.

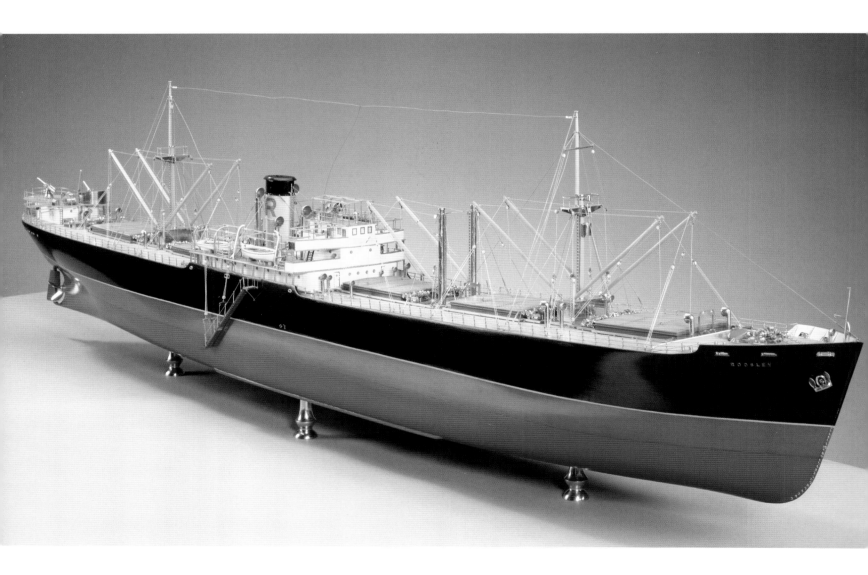

In the tradition of the house flag, dating back to the nineteenth century, funnels on steam ships were used to display company insignia and colours. In this case the red R stands for the Red Ship Company, run by Stephens, Sutton Ltd.

The draught marks (in feet) fore and aft indicate the depth at which the bow and stern sit in the water. These were observed during loading and unloading in order to check the trim of the hull, which it was essential to maintain, as it affected both the stability and operational performance of the ship.

During both the First and Second World Wars merchant ships were armed with guns to protect themselves against attack by enemy surface ships and submarines. Since this class of ship was built during the Second World War, the gun emplacements were designed in from the beginning. This class of ship was fitted with 2.5-inch twelve-pounder quick-firing guns, mounted on specially strengthened areas of the deck.

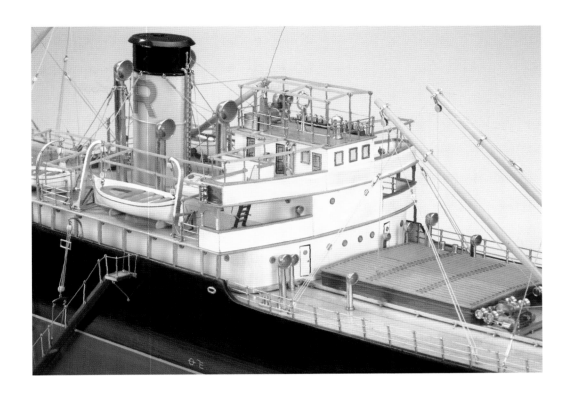

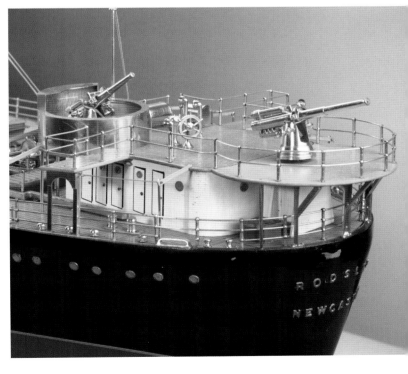

## British trawler: *Lammermuir*

Builder's model, scale 1:32
Great Britain, 1950
Wood, metal, gold- and silver-plated fittings
45.3 × 130.3 × 20 cm

*Lammermuir* was the world's first diesel-engined deep-sea fishing trawler. She was built by John Lewis & Son Ltd., Aberdeen, in 1950, and was towed to Sunderland for the fitting of her Doxford engine and completion. She was a trawler of the type known as 'side-winder', the nets being operated over the sides of the ship as opposed to being towed astern. Fishing from Hull in 1951, she became caught up in the dispute at that time between Britain and Norway over fishing limits and coastal boundaries in the North Sea, and her skipper was fined for fishing inside Norwegian waters. The trawler was later sold to owners in the Faroe Islands and renamed *Jegvan Elias Thomsen*; she was scrapped in 1976.

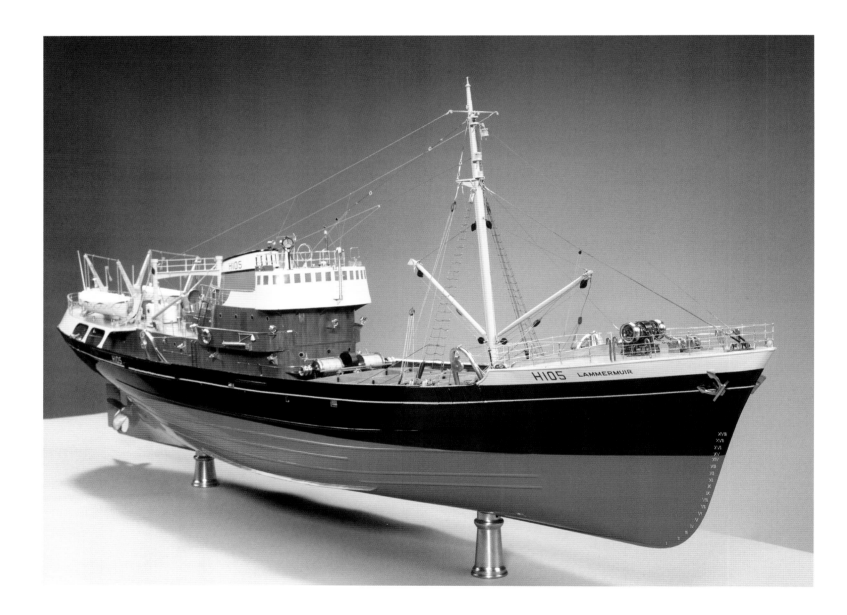

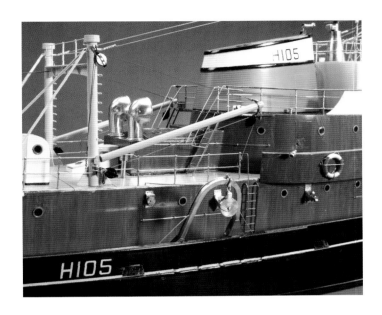

The registration markings (H105) denote that this vessel was registered at the port of Hull on the east coast of the British Isles. Such marks originally appeared on the sails of the numerous fishing vessels working out of the various ports around the British Isles.

The warp (cable) of the nets was held in position by the large metal sheave suspended from the arch-shaped gallows protruding over the side.

Between the wooden sorting pens on deck are metal cargo hatches, painted black, down which the fish were sent to be stowed. The large motorized windlasses just below the bridge were used for operating the steel cables (warps) for shooting and retrieving the nets.

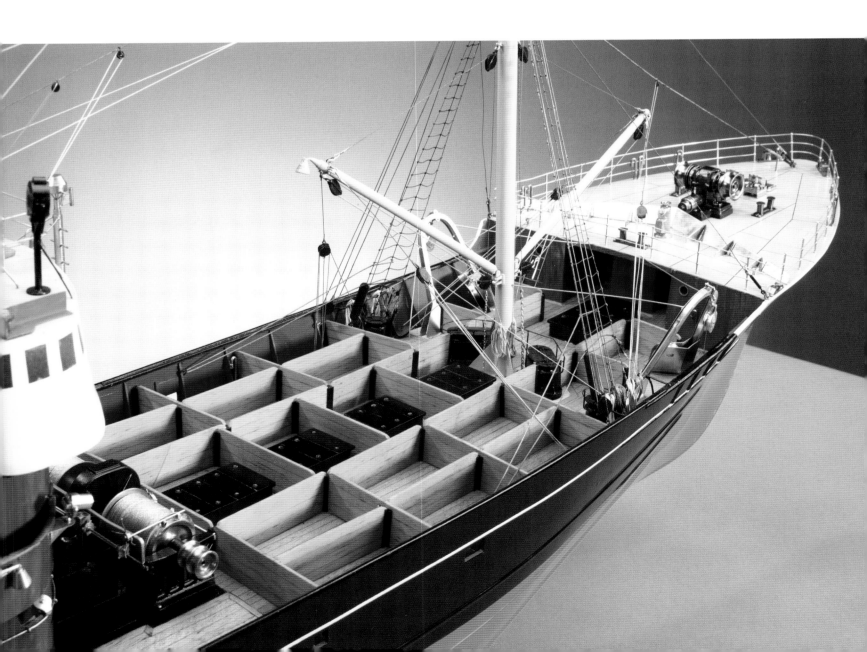

## 69

**British cargo vessel**

Builder's plating half-model, scale 1:48
Great Britain, 1936–40
Wood, gesso, Indian ink
20.6 × 157 × 15.3 cm

Before the invention of computer-aided design (CAD), plating models were used as a three-dimensional method to lay out, or 'joggle' the individual plates on both riveted and, later, welded hulls. A wooden half-model was constructed from several layers of planks, normally yellow pine, glued together horizontally or 'bread and butter' fashion, and these were carved and sanded to a fine smooth finish. Then, in the drawing offices in the shipyards under the guidance of the naval architect, the various plates

and other hull fittings were drawn on in ink. In this procedure the individual plates could be designed to fit the complex curves of the frames, and also to accommodate other fittings and features whilst not compromising the structural integrity of the hull. Once the layout had been agreed, precise measurements could be taken from the model together with the plans and passed to the plating shop for the manufacture of the full-size plates.

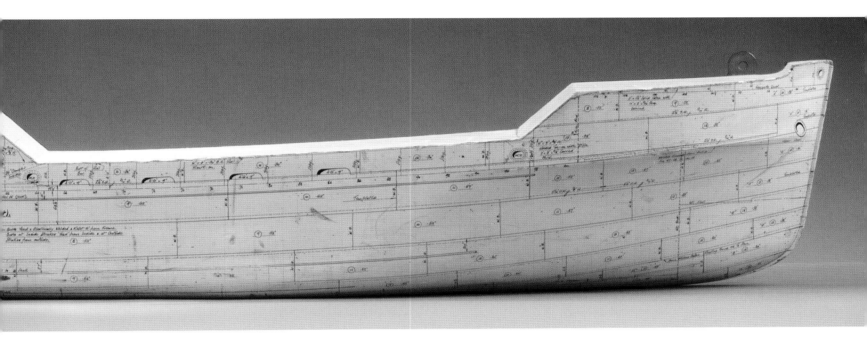

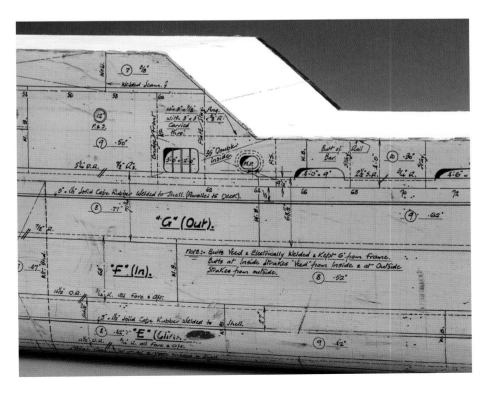

The mid section of the hull which includes detailed dimensions of the plates as well as notations on specific areas such as the scuppers for freeing the deck of water and fairleads to allow ropes through for mooring. Notice also that each horizontal layer of plates, also known as `strakes', have been annotated A–G from the keel up; the inner layer (F) is overlapped by the outer layer (G). Each plate is individually numbered from the stern to bow as well as every other internal frame which is faintly drawn on in pencil vertically.

## AUTHOR

SIMON STEPHENS is Curator, Ship Model and Boat Collections, The National Maritime Museum, Greenwich, London

## ACKNOWLEDGEMENTS

Special thanks for their assistance in the preparation of this volume are due to: Hannah Cunliffe, Sherry Phillips, Rina Prentice, Bob Todd, Major Grant Walker and David Wistow.

First published 2009 by
Skylet Publishing
in association with the Art Gallery of Ontario

© 2009 Skylet Publishing / Art Gallery of Ontario
Text and images of works of art © 2009
The Thomson Collection, Art Gallery of Ontario

Photographs of the ship models were taken by Michael Cullen, Peterborough, Ontario, and Prudence Cuming Associates, London (UK), assisted by Anastasia Apostolou and Paul Wilson.

ISBN    9781903470 8 24
        9781903470 86 2 (5 volume boxed set)

### FRONT COVER

Detail of no. 4
British third-rate two-decker 70-gun warship:
*Edinburgh*

### BACK COVER

British destroyer (V & W class): *Velox*
Builder's model; scale 1:48
Great Britain, 1917
Wood, metal, silver- and gold-plated fittings
24.5 × 99 × 7 cm

Distributed in Canada by University of British Columbia Press
www.ubcpress.ca

and in the United States by the University of Washington Press
www.washington.edu/uwpress/

and in Europe and elsewhere by
Paul Holberton publishing
www.paul-holberton.net

Produced by Paul Holberton publishing, London
www.paul-holberton.net

Designed by Philip Lewis

Origination and printing by e-graphic, Verona, Italy